W9-BUZ-917

Ex Libris

Mabel L. Biggs

COMPOSITION

COMPOSITION

A PAINTER'S GUIDE TO BASIC PROBLEMS AND SOLUTIONS

BY DAVID FRIEND

WATSON-GUPTILL PUBLICATIONS/NEW YORK

PITMAN PUBLISHING/LONDON

Copyright© 1975 by David Friend

First published 1975 in the United States and Canada by Watson-Guptill Publications,
a division of Billboard Publications, Inc.,
1515 Broadway, New York, N.Y. 10036

Library of Congress Cataloging in Publication Data
Friend, David, 1899–
 Composition, a painter's guide to basic problems
and solutions.
 Includes index.
 1. Composition (Art). 2. Painting—Technique.
I. Title.
ND1475.F74 1975 751.4 74-26545
ISBN 0-8230-0874-6

Published in Great Britain by Pitman Publishing, Ltd.
39 Parker Street, London WC2B 5PB
ISBN 0-273-00907-9

All rights reserved. No part of this publication
may be reproduced or used in any form or by any means—graphic,
electronic, or mechanical, including photocopying, recording, taping,
or information storage or retrieval systems—without
written permission of the publishers.

Manufactured in the U.S.A.

First Printing, 1975
Second Printing, 1977

Contents

Foreword

It may appear unusual for a neurosurgeon to write a foreword to an art book; it is because my colleagues and I have acquired a special view of creativity and artistic sensitivity as the result of recent neurophysiological findings. These findings are, put simply, that the brain is double, in the sense that each cerebral hemisphere is capable of functioning independently and, moreover, each functions in a manner different from the other. The implications of these facts, for educators in general and for art educators in particular, are far reaching.

We have not the space here to review all the vast array of facts which have led to our conclusions. I have dealt with them elsewhere in a series of articles entitled "The Other Side of the Brain,"* which emphasizes how little neurologic attention has hitherto been given to the right cerebral hemisphere. This historical oversight is largely because it is the left cerebral hemisphere (in most persons) which does all the reading, writing, calculating, and talking. Briefly, our conclusions can be summarized by saying that each cerebral hemisphere is specialized for a particular type of information processing that is less available to the other. The left hemisphere specializes in verbal and analytical processing, whereas the right hemisphere specializes in nonverbal and configurational processing.

Since education is effective only insofar as it affects the working of the brain, we can see that a school program narrowly restricted to verbal or analytical approaches will educate almost solely the left hemisphere, leaving half of an individual's high-level potential unschooled. Such a one-sided approach, unfortunately quite common, may even be responsible for some of the antisocial activity of individuals who have not found other, more constructive outlets for their need to make some mark upon the world. The right hemisphere must receive equal consideration and cultivation if humans are to live as balanced, whole persons.

Many educators have intuitively recognized the need for more creative and artistic activity in the general school system. Art educators have a particularly important role to play in this attempt to equalize education. In the light of recent scientific findings, artists no longer need feel the slightest inhibition in resisting the myth that rationality is superior to sensitivity, or in pointing out that this myth leads to a half-brained educational product.

More specifically, art educators can implement their creative, aesthetic inclinations by adopting in practice an approach conforming more directly to their ideals. Of art curricula, at all school levels, the following question can be asked: How can our teaching methods best be improved for the immediate, effective encouragement of the right hemisphere?

As an individual interested in fine art and as a parent concerned about the cultural development of my own children, there are some other, more specific questions that seem pertinent. Is not the present training in the "scientific" basis of art (the theory of color, the nature of materials, the mechanics of perspective, etc.) as well as the disciplines of drawing and painting, clearly directed toward only one, the left hemisphere? Does not the learning of a panoply of technical skills tend to postpone rather than accelerate the cultivation of the right hemisphere? Would it not be better to start with the simplest medium and the most primitive skills, not proceeding to other media and skills until the habits of aesthetic creativity are established? Should not these habits include, in particular, an intense awareness of the structural requirements for the overall unity of a work?

To those educators who have considered such questions and successfully dealt with them, even though they may not yet know how such questions are related to the brain, goes our enthusiastic endorsement. But what of the vast number of teachers and prospective teachers who would like to have specific teaching aids to assist them in the achievement of a balanced brain development?

One source is David Friend's earlier book, *The Creative Way to Paint*. In that book he avoids the pitfalls mentioned above. The painter's creative process, which requires bilateral hemispheric activity, has been simplified and organized for immediate application by art beginners, from children in late primary grades to adults on the community level.

In this book, *Composition*, David Friend tackles what is not only the most glaring weakness in student painting, but the artistic problem most obviously related to the right hemisphere. This is the establishment of an organic overall configuration in which no one of the parts is critical, or solely sufficient to convey the meaning, but all of whose parts are mutually contributory. The teaching of composition is here simplified by postponing for future specialization the problems of three-dimensional illusions. Instead, he concentrates almost exclusively on the problems of configuration as it appears in two dimensions, where artistic sensitivity can be more easily cultivated and controlled in progressive stages. By providing a smoothly progressive learning sequence, and by aiming at the highest compositional achievement with the greatest economy of means, David Friend has provided us with an invaluable assist toward the development of the other side of the brain.

Joseph E. Bogen, M.D.
Ross-Loos Medical Group
Los Angeles, California

*Bulletin of the Los Angeles Neurological Society, vol. 34, nos. 2-4, 1969.

Acknowledgments

I express my indebtedness and grateful appreciation to: Dr. Philip C. Beam, Curator, Homer Collection, Bowdoin College, Brunswick, Maine; Dr. Klaus Demus, Kunsthistorisches Museum, Vienna; Dr. Fedja Angelewski, Staatliche Museum, Berlin; Mr. Donald Allen, Art Reference Bureau, Ancram, New York; Mr. David J. Johnson, Prints Division, New York Public Library, New York; Dr. Jean L. Finch, Chief Librarian, Ms. Irene Deitsch and Mr. Robert Owen, Assistant Librarians, Stanford Art Library, Stanford, California for special photographic reference assistance.

George Braziller, Inc., for permission to quote from John W. McCoubrey's *American Tradition in Painting*; and Dr. Frank J. Malina, Founder-Editor, Leonardo, for permission to use material for my article, *Advanced Training Simplified for Amateur Painters*.

Mr. Donald Holden, Editorial Director, who encouraged my search for examples of the genesis of works of art to support the treatment of the text; Ms. Diane Casella Hines, Associate Editorial Director, who nudged me onward; and Ms. Susan Davis, Associate Editor, for her sensitive editorial work and for seeing the book through to publication.

Mr. Sandi Governali, for his kindness in rendering the diagrams; and Ms. Cindy Hagman and Ms. Kathy Hagman for typing the manuscript.

Dr. Joseph E. Bogen, Ross-Loos Medical Group, Los Angeles, California, for providing a singularly significant Foreword.

Finally, for my wife, Florence, I reserve my deepest gratitude for her invaluable suggestions and advice during the preparation of the manuscript.

Introduction

Composition is *not* a compartmentalized subject to the painter. It's the structural component of the *creative process*. This process integrates two different kinds of actions that alternate continuously between *freedom* of expression and structural *control* of the visual elements until both actions are gradually unified as one whole.

When composition is approached in this way, it can, as I've found in my teaching experience, produce the most satisfactory and surprising results in drawing and painting. Simultaneously, it offers one of the greatest opportunities for enriched, esthetic experience essential to the fulfillment of life.

The Approach of the Book

The approach of the book is to relate this concept of structural control to the beginner's compositional problems in a practical, meaningful way. To start, beginners need to cope with the *fewest* number of factors to bring a drawing into equilibrium as a work of art. The usual broad range of techniques, media, and procedures has been streamlined to an organic sequence of compositional considerations on the two-dimensional picture plane. In this way, you're encouraged to establish an essential foothold in creative composition as quickly as possible, in preparation for future specialized development in the control of three-dimensional illusions.

The Specific Aim of the Book

A good deal of the magic that transforms a painting into a work of art lies in successful unification. Pulling together the parts or elements of a painting is the crucial and most baffling problem to beginners. Perhaps the term "integration" describes it better—integration of all component parts of a picture into a series of *rhythmic relationships* to form an artistic whole.

The aim of the book is to help you grasp and apply the unifying process of relationships by learning how to interlock and relate all parts of a picture with sensitivity and feeling to form one pleasing artistic whole.

Learning by Doing

After an introduction to each of the stages in composition, you're given the opportunity to solve problems that challenge harmonious unification even for professionals. You'll find a variety of projects to test your ingenuity that start quite simply and accelerate progressively. In many cases, they represent actual problems that the masters faced in improving their composition. Yet, you'll be surprised to find them well within your power to solve. Thus, you'll learn by *doing*. You'll find that every project is followed by and related to a case history that's an analysis of a pictorial composition by a professional or master, old or new. Also included is a special lesson to be learned from each assignment.

Learning to Integrate Compositional Relationships

The crux of the integrating process is the successful control of the interplay of diverse visual elements—colors, shapes, light and dark tonal values, lines and textures. In some cases, one brushstroke may change the relationships of *all* the visual elements. How then can they be brought under control and harmonized?

Which visual element should be stabilized first? Is there one element that might be termed "basic"? If so, how early in the drawing stage can that element be stabilized? What kind of relationship will stabilize it? What element might be established second? How do you stabilize the second element without destroying the unity of the first? How do you pull all the elements together?

These problems do not deter the professional. After years of trial and error, the professional is able to juggle all the visual elements at one time, switching from one to another at will, yet keeping them all under control. For the puzzled amateur, however, not knowing how to proceed to the next step in the face of confusing kaleidoscopic changes in a painting necessitates an orderly sequence to control relationships.

In this book, you'll learn to stabilize and integrate all visual elements one by one, beginning with shape relationships. Simultaneously, you'll develop cumulative pictorial relationships as each stabilized element is integrated with the preceding ones. When applied in the projects, this sequence will enable you to control complex relationships and pull them together into a unified drawing or painting.

Sensing Relationships

You'll find that developing your ability to see and sense a variety of relationships will be a delightful experience. Even now you'll probably make the correct choice of the better composition between Figures 1 and 2 by Käthe Kollwitz.

Even without being alerted to the compositional problems discussed in Chapter 3, Negative Space, and Chapter 7, Empty Space, many of you will sense the answer to the following experiment. Look at Figures 3 and 4. Both paintings are technically skillful. Nevertheless, one composition is dynamic and the other static. You don't need special talent to distinguish which composition is alive.

You'll soon find that you have an intuitive mechanism to aid you, and, you'll be given the means to *confirm* your intuition. If ever you're in doubt, you'll find tests to check for sensitive relationships.

With your mental attitude under control, you'll make rapid strides in improving your overall skill in composition. Your *technical* skill in drawing and painting will improve too, because you'll concentrate on it at a specific time, consistent with a total program of creativity.

Your Personal Potential

Your frame of mind can definitely affect the quality of results. How much you achieve will depend upon your ambition. Your answers to two questions are vital:

First, what do you expect to accomplish through composition? If you're merely seeking hints and suggestions to overcome the feeling of monotony in some of your drawings and paintings, your results will probably be limited.

Second, how good a nonprofessional artist do you wish to be? Are you ready to succeed, to rise far above

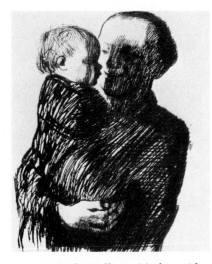

Figure 1. *Käthe Kollwitz: Mother with Child in Arms. Etching, 267 x 219 mm. Photo: Prints Division, The New York Public Library, New York. Most people will choose the better composition between this and Figure 2. You have much more innate sensitivity to artistic relationships than you are aware of or believe.*

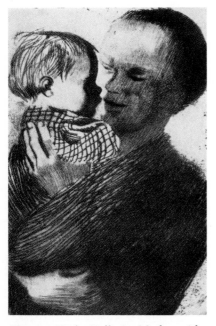

Figure 2. *Käthe Kollwitz: Mother with Child in Arms. Etching, 7 5/8" x 5 1/8" (195 x 131 mm). Photo: Prints Division, The New York Public Library, New York. A good composition is usually developed in stages. Compare this with Figure 1.*

the present-day rank and file of amateur artists?

This may sound pretentious, but it isn't meant to be. I'm serious. It was the great inventor Thomas A. Edison who said, "Most people don't use even one-tenth of one percent of their dormant abilities." Scientists, among them Margaret Mead, estimate the figure at about 5 percent. All of them agree that we use only a tiny fraction of our abilities.

Perhaps it's hard to believe that we have an enormous—nearly 95 percent—potential for improvement. It's simply too good to be true. But the fact remains that you *have* tremendous possibilities. We all have.

Are you already anticipating the pleasures to come or have I brought your inner doubts to the surface? Research psychologist, J.P. Guilford, past president of the American Psychological Association, provides reassurance with his statement that innate creative and artistic capability is present in varying degrees, in every person. Dr. Joseph E. Bogen, neurologist and brain surgeon, points out that the cultivation of the creative, artistic right side of the brain has been largely neglected in education.

You don't need to envy the professional who has greater skills, for you're not trying to compete with him or her. Neither are you attempting to reach that level of attainment. With limited time at your command, it would be almost impossible to attain the broad range of skills of the professional, even though it may be desirable.

Even though you may be a beginner with meager skills, there's no reason why you can't follow the same path that the professional takes to compose a drawing or painting. Nor is there any reason why you shouldn't achieve fulfillment. No matter how limited your skills, you have more than enough *inborn capability* to achieve fulfillment. You must measure your success not against others, but by evaluating the degree of improvement in relation to your own potentialities. You can see that even a 5 percent improvement will mean an enormous, almost unbelievable boost in your artistic fulfillment.

You'll have plenty of doubts and fears from time to time. This is where *you* come in. Are you willing to overcome them? The choice is yours. Why not take Bogen, Edison, Mead, and Guilford at their word? Be bold and daring. Discover your real potential

talent. Approach art as an exciting adventure. Find vital things about yourself, about people around you, and particularly about the world that revolves around *you* as the center. Most important of all, open your mind to things unseen. Learn to use your imagination.

Harness Your Creative Energy

The process of pictorial composition, then, is something more than isolated cues in the arrangement of subject matter. You as an individual must become deeply involved in learning what creativity means, how the creative art process functions, how to adjust to it, and how to uncover your innate artistic ability. The fundamentals of creative art are detailed in my earlier book, *The Creative Way to Paint*, also published by Watson-Guptill.

I visualize *you* as a unique, creative individual activating currents of energy that vitalize drawings and paintings. Let's harness this energy in the series of adventures in pictorial composition that lie ahead of you in this book. The degree of power and imagery you learn to unleash, together with the sensitively related elements you learn to control in composition, will be the key to success in creative drawing and painting.

Figure 3. *(Above right) Jan de Bray: Governors of the Children's Charity Home. Oil on canvas, 146 x 184 cm. Frans Halsmuseum, Haarlem, Holland. Compare this painting with Figure 4 by squinting with one eye and looking at the whole area of each painting, including the background. Without thinking about or looking at details too closely, which one do you intuitively feel is composed more satisfactorily?*

Figure 4. *(Right) Frans Hals: Governors of the Saint Elizabeth Hospital. Oil on canvas, 67 7/8" x 100 1/2" (1,725 x 2,554 mm). Frans Halsmuseum, Haarlem, Holland. As you compare this with Figure 3, notice that squinting your eye lets you see the distribution of lights and darks as a whole more easily. The same holds true in judging whether the background area has been considered spatially with the same care as the figures and foreground were.*

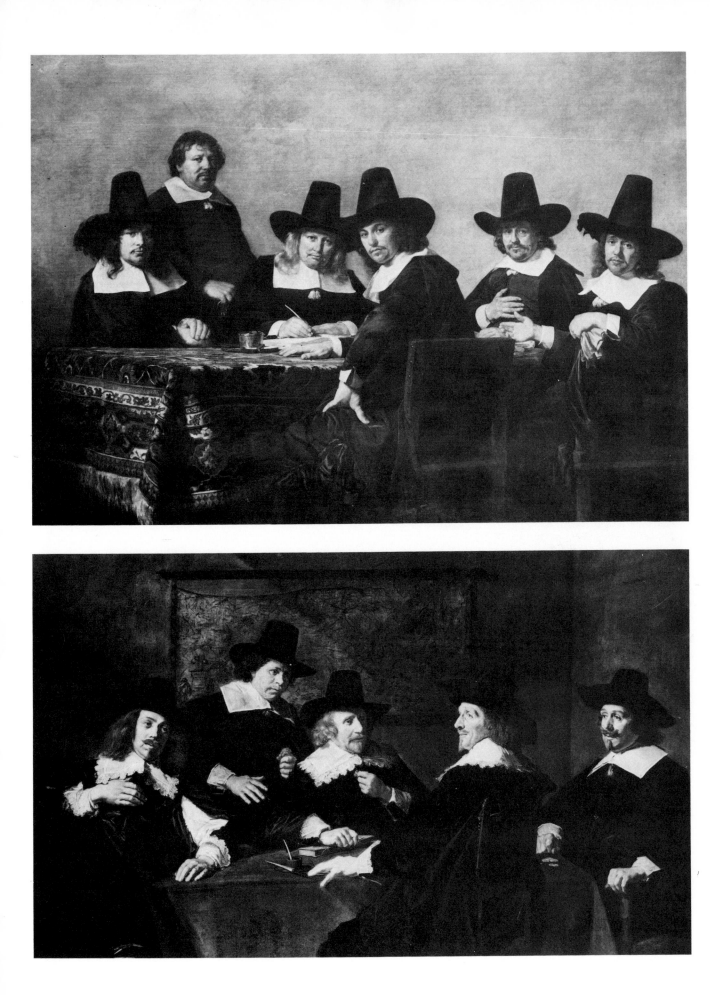

Two-Dimensional Shape Relationships

1

Living in a three-dimensional world, we're accustomed to seeing and thinking in terms of three dimensions. It's quite understandable, therefore, that much art instruction in composition aims to improve the rendering of volume and perspective to create the illusion of three-dimensional depth.

Unfortunately, something equally vital is being neglected. Because a painting is basically a flat surface, its composition functions *simultaneously* on the surface in two dimensions, as well as providing the illusion of three dimensions.

It may surprise you to learn that when artists talk about balancing, harmonizing, or unifying the shapes and other elements in a painting, these relationships are basically *two-dimensional*.

To judge by the vast number of paintings produced each year, little or no serious attention is being devoted to two dimensions. Yet the *quality* of paintings can rise dramatically when two-dimensional relationships are understood and applied.

That's why we're going to approach composition as the interaction of two-dimensional relationships of shape, color, light and dark tonal relationships, texture, and line (representing objects and their backgrounds).

The illusion of three dimensions will probably be present in most of the drawings and paintings you do in your assignments. But we're going to *bypass* discussion of how to improve volume, perspective, and all other devices in three-dimensional illusion.

You'll discover that structuring a painting in two dimensions can become an exciting experience once you acquire a special way of looking at paintings. That isn't difficult to do, but it does require practice because you're probably not used to it.

It's vitally important, therefore, to develop *two-dimensional surface perception*—the ability to see a picture as a flat rectangle covered with flat shapes, without being confused by the other visual elements. That's one of the intuitive skills you used in judging the pictures illustrated so far. You

were sensing shape relationships in two dimensions.

What Does Two-Dimensional Really Mean?

Many readers may have only a vague idea of what the term "two-dimensional" means. The confusion usually arises because there's no such thing in nature. It's only a theoretical term. There's nothing in nature that has length and width, *but no depth*.

Even a sheet of drawing paper, which has length and width and only a slight degree of thickness, is a three-dimensional object.

However, the *surface* of drawing paper or canvas is two-dimensional. And it's on this surface that I suggest you concentrate. Think of paper or canvas as nothing but a rectangular two-dimensional shape (Figure 5).

Draw a line across the surface of this two-dimensional shape. If you allow your imagination to function, the line *could* appear to you as the horizon; thus, your visual perception creates the *illusion* of three-dimensional depth. In Figure 6, section *A* can be the sky and section *B* the earth, if you wish.

But in two-dimensional surface perception, *A* and *B* are only two rectangular shapes. They're easily seen as such when they're separated (Figure 7).

We return to Figure 6 and add a number of *triangular* two-dimensional shapes. The three-dimensional illusion of, perhaps, a pyramid on the horizon against the sky (*A*) and a road reaching to the distant horizon (*B*) is more obvious (Figure 8).

However, the aim here is for you to visualize the shapes not as a landscape, but as flat, two-dimensional pieces that fill the entire flat surface of the two-dimensional canvas or paper (Figure 9). Again I separate them to help you see them as flat, two-dimensional shapes.

Now we're ready for the real job ahead: to look for two-dimensional shape *relationships*. Let's consider Figure 8 once again. If we look at it as

a whole, we can distinguish two distinct *geometric shape motifs*: the triangle and rectangle. Let's study them in Figures 10 and 11. In Figure 10, I've subordinated the dominant triangular shapes so that you can visualize the rectangular geometric motif more easily. We can see that rectangular shapes *A* and *B* have a nice relationship, mainly because of their unequal size. But there's another built-in relationship: rectangles *A* and *B* are integral parts of the rectangular shape of the whole surface of the paper or canvas.

In Figure 11, I've subdued the rectangular shapes to show that the triangular geometric motif is really the dominant one. Notice that one of the triangular shapes lacks a corner—but it doesn't matter. We still feel the shape as strongly triangular. Also notice that the upper right-hand corner contains two triangles, one within the other. The smaller one is bordered on one side by the horizon line. The larger one is formed by excluding the horizon line.

Most important, there's a variety of triangles over the entire surface; no two are alike in shape or size. This is no accident. On the contrary, it's something to strive for, to avoid monotony. Because of the variety of triangles and the spatial sensitivity of one to another. we can say that a *rhythmic relationship* exists among them, something akin to the rhythmic relationship of waves as they surge to the shore. No two waves are alike, but they keep repeating a pattern. Rhythm denotes movement, a certain vitality, a feeling of aliveness.

Finally, by contrasting the rectangular shape motif with the triangular shape motif, we create even more variety and movement.

A Psychological Problem

I've shown you how to look at an emerging sketch—a pyramid at the end of a long road. The subject matter is three-dimensional, but we've studied it in two dimensions as a composition on a flat surface. We established that the sketch consists of balanced, rhythmically related, two-dimensional shape relationships.

At this point, you may be itching to put some color into the sky and foreground—to get some *feeling* in the picture—especially if you've visited Egypt and been awed by the wonders of this part of the world.

But we purposely withhold such feelings until we get the underlying structure of shape relationships right.

Figure 5. *Think of the surface of drawing paper or canvas as nothing but a rectangular two-dimensional shape.*

Figure 6. *A line is drawn across the surface of this two-dimensional shape. If your imagination is functioning, the line could be the horizon. Thus, your visual perception creates the illusion of three-dimensional depth. If you wish, section A can be the sky and section B the earth.*

Figure 7. *A and B are only two rectangular shapes in two-dimensional surface perception. That's easy to see here when they're separated.*

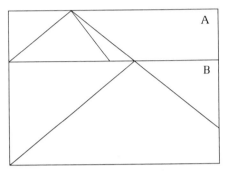

Figure 8. *Here we add a number of triangular two-dimensional shapes to Figure 6. The three-dimensional illusion of a pyramid on the horizon against the sky (A) and a road reaching to the distant horizon (B) is more obvious.*

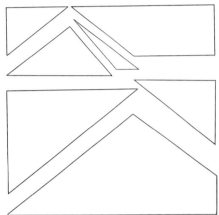

Figure 9. *You should visualize the shapes not as a landscape, but as flat two-dimensional pieces that fill the entire flat surface of the two-dimensional canvas or paper. Here I separate them to help you see them as flat two-dimensional shapes.*

Figure 10. *If we look at Figure 8 as a whole, we can distinguish two distinct geometric shape motifs: the triangle and the rectangle. So that you can see the latter more easily, I've subordinated the dominant triangular shapes here. Rectangular shape A has a nice relationship to rectangle B, mainly because of their unequal size, and rectangles A and B are integral parts of the rectangular shape of the whole surface.*

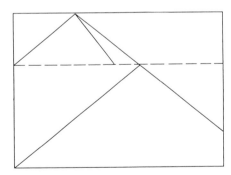

Figure 11. *I subdue the rectangular shapes to show that the triangular geometric motif is really the dominant one. Because of the variety of triangles over the entire surface and the spatial sensitivity of one to another, we can say that a rhythmic relationship exists among them.*

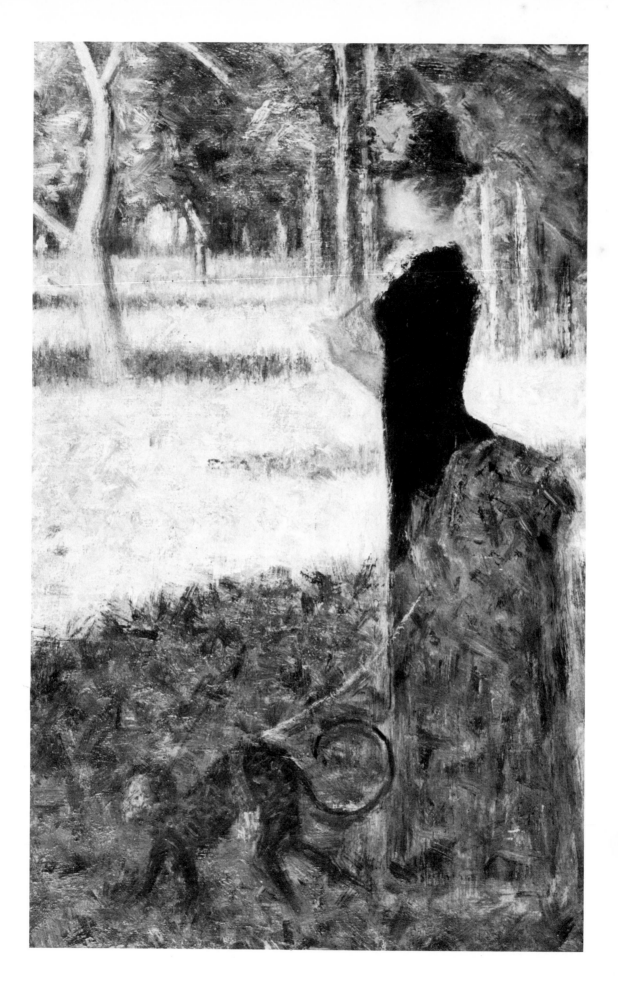

If we pour out our emotions with complete abandon, and then have to change the composition because it doesn't feel right or look right, we'll be unhappy.

More than that, we'll be frustrated. If we like the effect of the feeling we've expressed in color, we'll hate to change the composition—and we'll feel guilty, knowing that the composition needs improving. On the other hand, if we decide to tamper with the composition at this point, there's a good possibility that we'll improve the composition but lose the feeling.

The moral: establish an effective composition *before* you get emotionally involved in the subject.

One more thought. Once the sketch emerges, don't hesitate to adjust the shapes. Make as many compositional trial sketches as the situation requires. The final drawing or painting will only be as strong as the underlying compositional structure.

Illustrating a Practical Case

Now we're ready to study a practical case of two-dimensional surface shape relationships. Although *Woman with a Monkey* (Figure 12) is a preliminary study for Georges Seurat's major painting, *La Grande Jatte* (Figure 83), this little painting is complete in itself.

In Figure 13, you can see how Seurat divided the panel into rectangles, no two of which are exactly alike. I don't expect you to wax enthusiastic just by gazing at a diagram. Not being used to *experiencing* spatial relationships, you may have no reaction.

But Seurat's composition is *powerful*. As you look at the painting, try to sense how the various rectangles dominate the structure. Visualize Seurat developing his composition: expanding the size and shape of some rectangles, contracting others, until the spacing of the four rectangles was brought into perfect equilibrium as a balanced whole.

In time, as you look at any work of art, you'll gain much pleasure in discovering subtle relationships between one part and another. Simple geometric shapes will appear to vibrate with vitality. They'll seem to harmonize with the rhythms of the geometric cosmos as they relate to each other. You'll respond to all this with a deep sense of inner satisfaction, knowing that you can return to savor a masterpiece again and again.

I remember Joseph Wood Krutch, writer and teacher, said that a work of art never grows dim, as a memory does. "Arrested at the moment of its perfection," that instant caught in the work of art is "held in it forever."

Don't worry if you can't *feel* spacing at the moment. It's a sense that will awaken without any conscious help on your part, just by carrying out the assignments listed in each chapter. It's a sense that you'll experience when you least expect it.

Subordinate Subject to Composition

You can see that Seurat *subordinated the subject matter* to conform to the spatial relationships of the rectangles. The front of the lady's dress is exaggeratedly vertical, a vital part of the largest rectangle. In reality, the dress wouldn't be that straight.

Remember that your subject doesn't have to be a predetermined size or shape, or occupy a fixed position in a picture. Your subject must be seen as so many two-dimensional shapes that can be changed. They can be moved around to the best possible spatial positions in the picture *as a whole*. The lesson here is that two-dimensional shape relationships come first.

In contrast with the dominant rectangular motif, the submotif here is the arc or curve. You can see it in the arched back and tail of the monkey, the curve of the open parasol, the curve of the lady's bustle, her arched back, the gentle curve of the upper-left tree, and in the suggested arc across the entire foreground.

However, what counts is the relationship of the monkey's arched back to the lady's arched back—one arches outward and the other inward. Another subtle relationship exists between the gentle curve of the upper-left tree and, in contrast, the dynamic curve of the lady's back. And this curving back is further accentuated in contrast with her very vertical front. The effect of this relationship—a curve next to a straight line—was well understood by Seurat.

Your Intuitive Memory

Let me reinforce what I said earlier. Don't try to fix in your mind all the points I mention for possible use in the future. Just try to experience them. Enjoy them as much as you can; then *forget* them.

This information and experience are recorded automatically on the brain track without determined conscious effort. They'll come to the surface and be incorporated in your composition intuitively at the appropriate time. Moreover, they'll be modified by your personality and become uniquely yours.

Figure 12. *(Opposite page) Georges Seurat:* Woman with a Monkey. *Oil on wood panel, 9 3/4″ x 6 1/4″ (246 x 158 mm). Smith College Museum of Art, Northampton, Massachusetts. Although only a preliminary study for his major painting* La Grande Jatte *(Figure 83), this little painting is complete in itself.*

Figure 13. *(Below) Diagram of Seurat's painting* Woman with a Monkey. *You can see how he divided the panel into rectangles, no two being exactly alike.*

Project 1: Experiencing Shape Relationships

There are two assignments in your first project. Both are designed to help you begin to *experience* shape relationships.

The first one is deceptively simple. It involves comparing one shape with another to find pleasing relationships of geometric patterns, and then changing the shapes that displease you or seem to destroy the unity of the whole.

The second assignment has the same objective, but it's more specific: to experience shape relationships by experimenting with cropping or masking parts of a picture. Cropping is commonly associated with photography. Indeed, good photographers use cropping regularly. However, long before the invention of photography, painters experimented with cropping or masking to achieve maximum results in spatial relationships.

Compare Shapes

Here is your first assignment:

1. Study Figure 14. Note that the sketch contains no light and dark gradations. This means you can concentrate on spatial relationships without being influenced by tonal differences. All shapes are outlined with an even line so you won't be affected by sensitive, varied lines. I have purposely limited visual elements to help you compare geometric patterns of shapes with one another, in groups and as a whole.

How do you react to Figure 14? Is the composition satisfying? Which shapes, if any, disturb you? Why? Do you find a shape too narrow in relation to its neighbor? Is another too wide? Too tall? Too angular? How would you change them to make them more appealing?

2. Do a sketch of the same subject, but do it freely and quickly. The idea is to improve the composition of Figure 14. Don't fill in the shapes with shades of light and dark gradations. Use a 5B or 6B black pencil on a small pad of paper about the size of Figure 14.

3. Study the result carefully. Do you like the sketch better than Figure 14? How can you improve it? For example, are there any shapes that should be closer to one another? Or farther apart?

4. Do a second sketch. Again, do it freely without thinking about it or evaluating it while you're working. Try to keep those functions separate (that's why they're listed as separate instructions).

5. Compare it with the first sketch. Which one has the more pleasing shape-to-shape relationships? How can you improve the second sketch?

6. Now do a third sketch and compare all three. Which one feels best as a unified, complete picture? How does it compare with Figure 14?

Cropping and Masking

You're now ready for another kind of spatial experimentation—*cropping* or masking. Here is your second assignment:

1. Suppose your best sketch was cut down a little from the top or maybe a little from the left or right. Would the new spacing of surface shapes take on more vitality?

2. Instead of actually cutting your best sketch, place a sheet of paper (wider than your sketch) at the top of the sketch. Now slowly—very slowly—move the paper down the sketch. As you move the paper, keep looking at the whole of the remaining picture. Stop at any point that interests you and study the two-dimensional shape-to-shape relationships. Try to determine why the composition interests you.

3. Start over again. This time, place a sheet of paper at the left of your best sketch, moving the paper slowly to the right. Now reverse the procedure. Start at the right and move the paper slowly to the left.

4. Now move sheets simultaneously over the sketch, from the top downward and from the left inward. Then try it from the right inward. Manipulate the sheets in any way your intuition directs.

5. Based on what you've learned through cropping, do one more sketch, freely and without thought. Compare the result with all the other sketches you've made. Which one do you like best? Check the shape relationships carefully to confirm your intuition.

6. Repeat steps 2, 3, and 4, but this time do them with Figure 14. At what point is the composition most pleasing?

7. Finally, compare your best sketch with the most pleasingly cropped composition of Figure 14. Which one do you feel is the more powerful composition? Why?

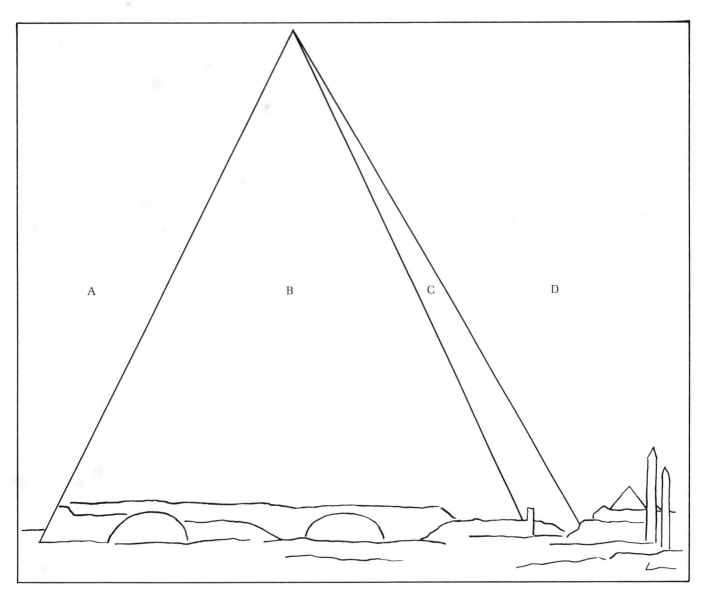

Figure 14. *Diagram of a picture dominated by a large pyramid.*

Case History 1: Robert, Seurat, Rembrandt

The model for Hubert Robert's dynamic painting, *Pyramids* (Figure 15), was the pyramid of Caius Cestius, outside Rome. Cestius, a Roman official, willed that he be buried in a small pyramid built for that purpose.

At first glance, you may be unaware that the shape of the large pyramid is rather odd; it doesn't coincide with those in Egypt. This in no way detracts from our enjoyment of the painting—a romantic conception of the pyramids of Egypt. Even the curved areas and openings at the bottom of the pyramid existed only in Robert's imagination; they're not true to the "real" pyramids.

To help you better visualize the odd shape of the pyramid, I've recon-structed the whole pyramid (Figure 16), based upon the portion shown in Figure 15. You may very well be disturbed by its shape, which is distinctly different from Egyptian pyramids, whose width at the base is much greater than their height. The width of the base of Robert's pyramid, as seen in Figures 15 and 16, is considerably less than the height. This accounts for its sharp, towering peak.

On the other hand, the Italian artist Piranesi, who did an etching of the Cestius pyramid (Figure 156), made the base of his pyramid even narrower in relation to its height than Robert did.

These variations in size and shape—deviations from the actual form, or distortions as they're often called—illustrate artistic license. Any object may be changed, provided that it's harmoniously related to other surface shapes and to the entire area of the canvas.

Impact of Composition

Do you feel the impact of the gigantic pyramid in Robert's painting? How did he achieve this powerful effect? More than one element enters into it.

In Figure 12, Seurat shifted the subject matter *within* the rectangle of the canvas until he arrived at what he considered his strongest composition. But, in Robert's painting, the surface shape relationships are manipulated

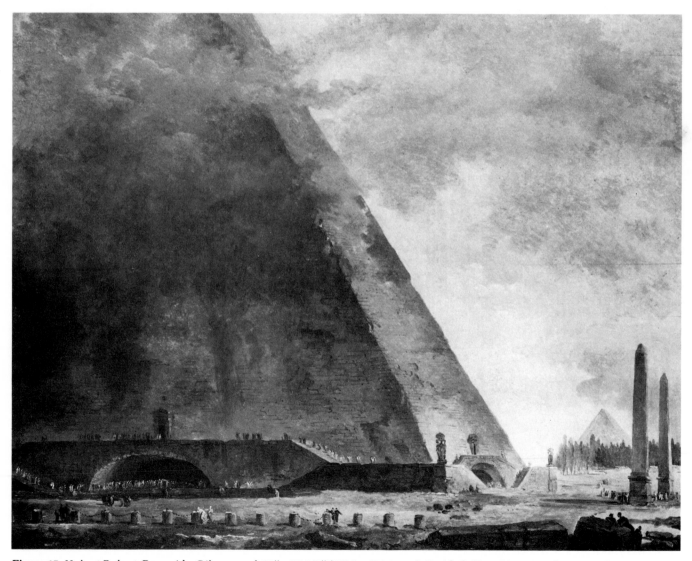

Figure 15. *Hubert Robert: Pyramids. Oil on panel, 24" x 28 1/2" (609.6 x 724.2 mm). Smith College Museum of Art, Northampton, Massachusetts. The model for the painting was the pyramid of Caius Cestius outside of Rome.*

by *cutting down* the size of the subject matter—the large pyramid—and showing only *part* of it inside the rectangle of the canvas.

This raises a number of questions: Is the strength of the composition, due basically to the *spacing* of the two-dimensional surface shapes, altered because of the cut-down pyramid? Definitely, yes. Would the painting appear more dynamic if Robert had shown the *whole* pyramid? In this case what would happen to the surface shapes? Would the spacing be more satisfying? The answer to both questions is *no*.

If you approached Project 1 in a languid state of mind and tried to exclude extraneous thoughts and considerations, chances are that you've already proved these answers through your study of Figure 14, since Figure 14 is the reconstructed drawing of Figure 15, showing the whole pyramid. In your manipulations, you probably came fairly close to Robert's spacing before you were satisfied. Robert's spacing is clearly seen in Figure 17, a tracing of Figure 15. It's definitely a more satisfying picture than Figure 14.

Support Intuitive Decision by Detailed Analysis

Figure 17 is dominated by three geometric shapes: *A*, *B*, and *C*. Something within me responds favorably to their spacing. The shapes seem to have an affinity to each other.

Figure 14 has four shapes: *A*, *B*, *C*, and *D*. They're too sharply defined as triangular motifs. This sensation is caused especially by shape *B*, the largest and only complete triangle outlined in both diagrams. Don't misunderstand me; a complete triangle in a picture isn't necessarily a detriment—but it mustn't stand out at the expense of the whole. As a structural element, it should be spaced and surrounded by other shapes so that it's seen as only part of a unified, harmoniously felt design. A tricky problem, even for a master.

To be more specific about Figure 14, look at shapes *A*, *B*, *C*, and *D* upside down. You'll see them better as shapes that way. Shape *A* has some affinity to *D*; even *B* has some relationship to *D*. Unfortunately, shape *B* overpowers the surface area as a whole. In addition, shape *B* has an awkward relationship to shape *A*. What's definitely poor is shape *C*. It feels cramped between *B* and *D*. It has little or no affinity to its neighbors.

Fortunately, all the triangular shapes vary in size and shape. But

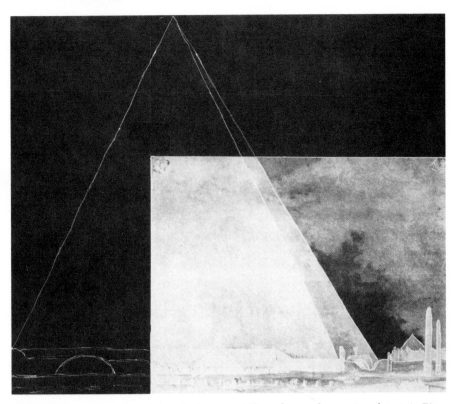

Figure 16. *Reconstruction of the whole pyramid based upon the portion shown in Figure 15.*

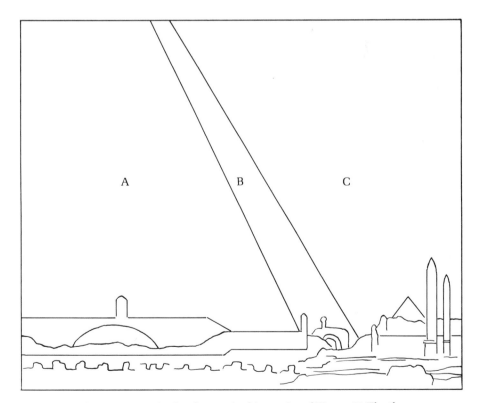

Figure 17. *Robert's spacing is clearly seen in this tracing of Figure 15. The three geometric shapes, A, B, and C, seem to have an affinity for each other. Compare the spacing with that in Figure 14. Which is more satisfying?*

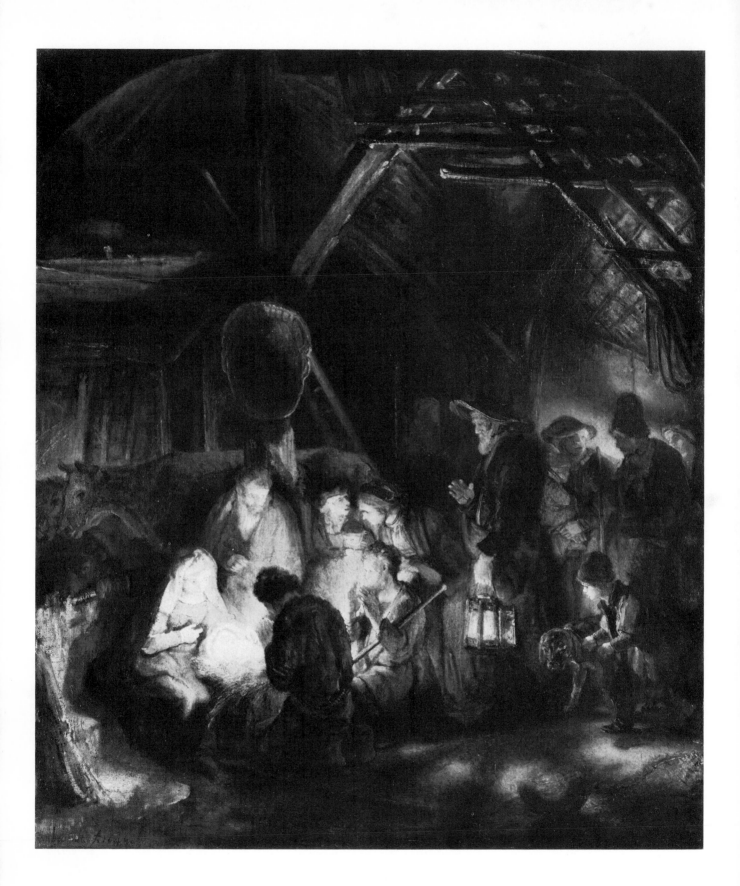

that's not enough. They must relate with spatial feeling to each other and to the entire surface.

Stimulate the Viewer's Imagination

To establish sensitive spatial relationships, you'll find that geometric motifs, such as triangles, ovals, and other basic shapes, needn't be completely inside the rectangle of the canvas. Likewise, the subject matter may look better in a composition when it's partly cut down. This allows the viewer to actively participate by using his or her imagination to complete the subject matter.

There's another reason why this approach is so successful. Look at Robert's painting again to see how all the action is brought forward, much nearer to you. If the whole pyramid were present, it would have to be pushed so far back in the picture that the movement of the figures would be lost.

The small pyramid also plays an important role. With the large pyramid seeming to come forward, the introduction of the small pyramid creates a feeling of expanding space, of three-dimensional depth. Because of the comparative difference in scale, the small pyramid, obelisks, and small figures accentuate the bulk and size of the large pyramid.

Finally, the great importance of balanced light and dark tonal values can easily be verified by comparing the painting with Figure 17.

Figure 18. *Rembrandt van Ryn: The Adoration of the Shepherds. Oil on canvas, 2′1″ x 1′10″ (635 x 558.8 mm). National Gallery of Art, London. The huge triangle occupies the greatest surface area—from the bottom of the painting to the apex in the beams at the top.*

The Triangular Motif

Now I'll show you how the great Rembrandt introduced the triangle as the dominant motif in his composition, *The Adoration of the Shepherds* (Figure 18). At the same time, he demonstrates still another approach to composition that differs from the examples of both Seurat and Robert.

The huge triangle occupies the greatest area of the surface, reaching from the bottom of the painting to the apex in the beams at the top. Are you aware that the lower-right part of the triangle isn't present, that it's *outside* the picture?

Note how the smaller triangular shapes, inside and outside the large dominant triangle, are sensitively related to each other. Not to be overlooked are the contrasting vertical and oval shapes that help unify the whole.

Note particularly that Rembrandt placed the subject matter—the center of interest—intact *within* the lower left corner and at the base of the main triangular motif.

To sum up the differences in composition: In Rembrandt's painting we find the geometric *shape motif cut down* while the subject matter remains *intact*. In Seurat's painting the subject remains *intact* within the *intact* shape motif. In Robert's painting the shape motif and subject matter are *both cut down*.

The Lesson to Be Learned

The lesson is a reminder that a painting, like a play or other art form, is only as strong as its structure.

Every artist worthy of the name works to establish a dominant two-dimensional geometric shape motif as a scaffold for his or her artistic expression. Most important is the care with which all two-dimensional surface shapes are tested in order to establish a unifying spatial relationship to each other and to the whole. Finally, cropping, masking, or blocking out is a simple way for you to do this effectively.

Project 2: Making a Composition Grow

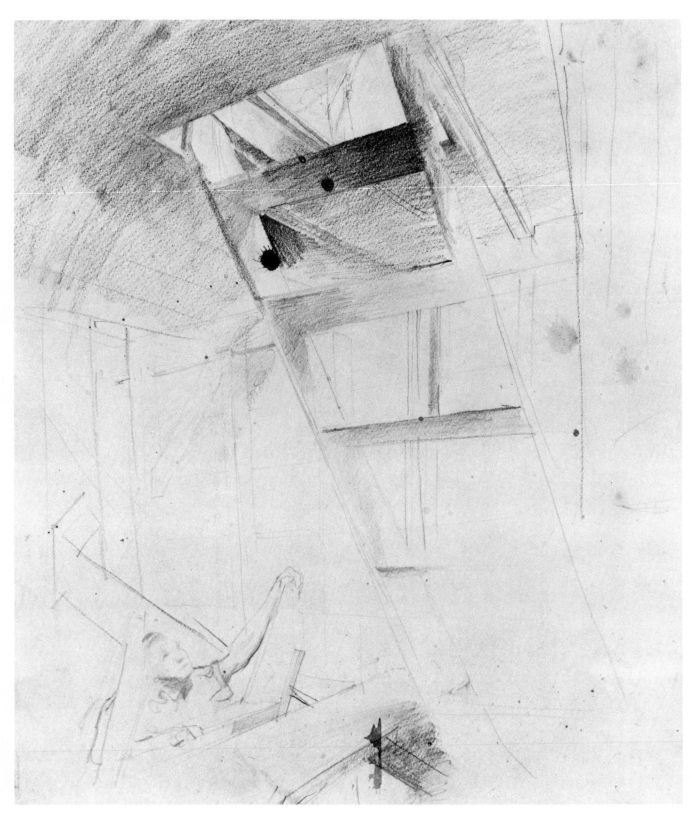

Figure 19. *Andrew Wyeth: The Toll Rope. Pencil, 16 3/4″ x 13 7/8″ (424.4 x 353 mm). Photo: Coe Kerr Inc., New York. Rough sketch showing a ladder reaching up to a skylight.*

Now that you've had some experience in testing how one two-dimensional surface shape feels next to another, and how all the shapes in a picture feel as a unified whole, you're ready for the second project.

To prepare you, I must explain that the assignment is based on the premise that in the process of becoming a good painting, the composition unfolds, grows, and develops *organically* in two areas at the same time: in its organization and in its feeling of aliveness.

As you read the list of actions to be integrated, I must caution you that it not only sounds complicated but is complicated. However, *rest easy*. The integrative process has been systematized and simplified expressly for beginners. As you follow the instructions, you'll find the steps well within your capacity.

The aim of the assignment, in addition to continually improving the quality of shape-to-shape relationships in a drawing, is for you to learn to *coordinate* the following: (1) to unlock your imagination, (2) to develop a composition in stages by means of a series of sketches from memory, (3) to check for the dominant and contrasting geometric shape motifs, (4) to begin to work for light and shade, and (5) to be aware of the role of distortion.

Redesign a Composition

Here is your assignment:

1. You'll need some inexpensive 8″ x 10″ (203.2 x 254 mm) sketching paper; a sheet of black carbon paper; a ballpoint pen (preferably *without* ink) or a hard #3 black pencil; a 5B or 6B black pencil; and possibly a very soft, #1 compressed charcoal stick.

2. Your task is to redesign Figure 19. Change any details you like, to make it uniquely yours, but retain the ladder and stairs in some form, since they're the theme of this project. Your objective is to make your drawing into a more powerful and better balanced composition than Figure 19.

Let your imagination soar. In what situation have you seen a ladder or steps recently that aroused a sensation in the pit of your stomach? What happens to you when firemen place a ladder against a burning building? Think of the ladders used by cliff dwellers many centuries ago in Mesa Verde, New Mexico, where a slip meant falling several hundred feet. Or think of the ladder placed against a tree in order to pick fruit beyond easy reach; the steps leading to the open

door of an international airliner; the spiral stairs inside the Statue of Liberty; the ladder thrown across a break in a frozen pond so a skater trapped in the icy water can be rescued.

3. If you have ideas but feel petrified because you doubt your ability to draw (even as simply as a child does), I suggest you start by *tracing* Figure 19. Place a sheet of carbon paper on top of a sheet of sketching paper and place both under the picture. Trace the four edges of Figure 19 as well as the subject matter. Use an inkless ballpoint pen or a #3 hard pencil.

The idea is *not to copy* the drawing, but to use it as a starting point for a new conception. Don't feel guilty about using the composition of other artists as a springboard for new ideas. This was—and still is—common practice among the masters. Note the figure of Christ in Rembrandt's etching, *Christ Driving the Money-Changers from the Temple* (Figure 20); it's taken from Dürer's woodcut, *Christ Driving the Money-Lenders from the Temple* (Figure 21).

Look at the preliminary sketch and completed painting of *The Judgment of Solomon* by the English painter Benjamin Robert Haydon (Figures 22 and 23). Here, Haydon borrowed the general composition—not just one figure—from Nicolas Poussin's painting of the same title (Figure 24). Finally, note how the painting, *Variation of Velázquez's Las Meninas*, attributed to the French painter Edgar Degas (Figure 25), compares with the original (Figure 26).

4. Keep the changes you make in subject matter simple. Don't get bogged down by concentrating on the details. What we want in a picture is an expression of your deep inner feeling—the "sizzle," imaginatively, even wildly, expressed.

5. Once you've made the changes in the traced drawing, test the outside dimensions by moving sheets of paper, as you did in Project 1. Don't forget to check for the *dominant geometric shape motif*. Is it an oval, a rectangle, a triangle, or what? It's usually the *largest* two-dimensional surface shape.

6. As soon as you've decided what to improve, let yourself go in your drawing. Make some parts darker and keep others lighter. Use the 5B or 6B black pencil.

7. When you've gone as far as you can, take a moment to relax and study the results carefully. Do you like it better than Figure 19? Why? What's the

main geometric shape motif? Is there a contrasting motif? Are the motifs repeated and varied to give the whole a rhythmic effect? Does the subject matter feel cramped? Does the drawing need more space? Or is there too much space? Do the sides of the drawing need to be narrowed further? What about adding more space to the top or bottom?

8. No matter what changes you decide to make, *don't do them on the same sketch*. Instead, do the drawing over again—this time from *memory*. In this way, if you continue to make a series of drawings of one subject, you'll have a record of all the stages leading up to the final drawing—and later to the final painting.

There are so many different ways of doing a drawing; this process will give you the opportunity to compare them. You'll be able to decide which parts of the drawing are better and which need further improvement. Making separate drawings avoids the possibility of covering up and losing a record of precious prior steps.

9. At first you may tense up at the thought of developing a composition by means of a series of sketches. But the moment you start, you'll realize that it's the only sure way of *controlling* your composition as it unfolds. Chances are that you won't remember the details or even the exact shapes when you work from memory. But it doesn't matter. In fact it will be just as well, for the aim is not to copy or to hold onto details rigidly. Start right off *without thinking about it*. Try to work intuitively and see what happens. Go as far as you can.

10. If you're tired or you're not sure how to continue, stop and rest a while. Before you proceed, once again study the drawing for shape relationships. When you've finally finished the sketch, relax and enjoy the result. Let an interval of time elapse—say, a day or two—before you study it once more.

11. Don't hesitate to do the composition over a second time from memory, especially if you like certain parts that you think you may spoil if you continue. In this way you'll always have something to refer to, and you'll be able to afford to take risks with subsequent drawings, since the earlier drawings are intact.

12. Repeat the process until you do a final drawing. You'll recognize the final drawing when you've given it all the expressiveness and drive you can—and find you can go no further, even after time and study.

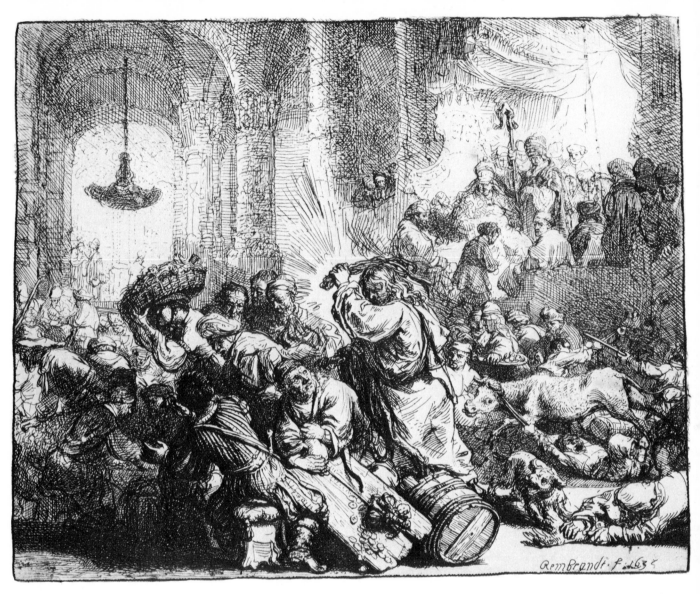

Figure 20. *(Above) Rembrandt van Ryn: Christ Driving the Money-Changers from the Temple. Etching, 5 1/2″ x 6 3/4″ (140 x 170 mm). The Metropolitan Museum of Art, New York. Note the figure of Christ was taken (and reversed in the process of etching) from Dürer's woodcut of the same subject (Figure 21).*

Figure 21. *(Right) Albrecht Dürer: Christ Driving the Money-Lenders from the Temple. Woodcut, 12.6 x 9.7 cm. Photo: Prints Division, The New York Public Library, New York. Note how Rembrandt utilized the figure of Christ in his etching (Figure 20).*

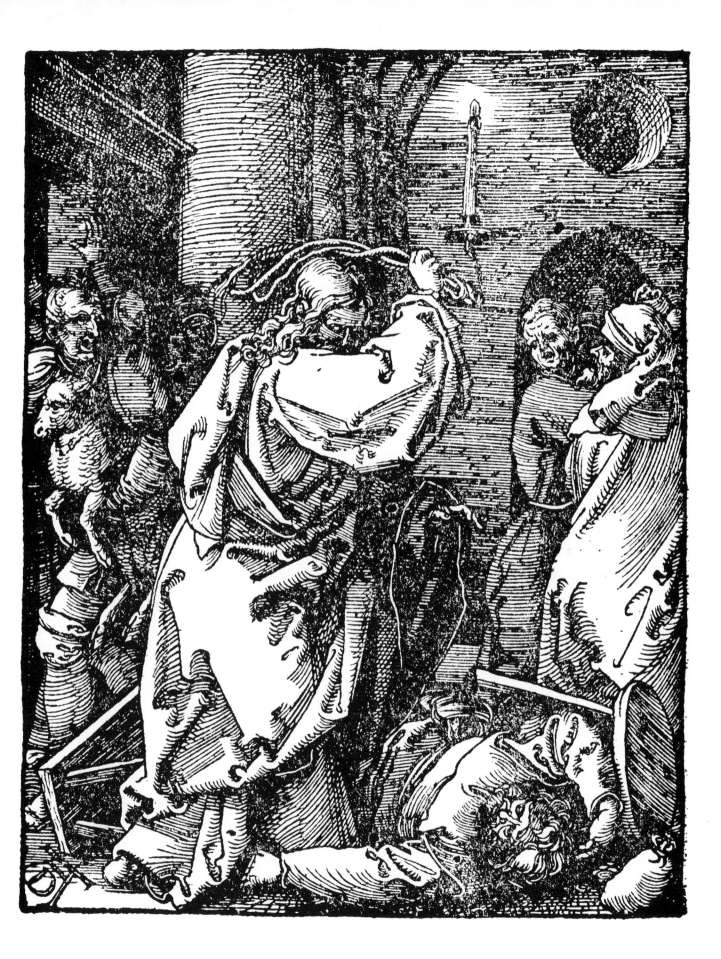

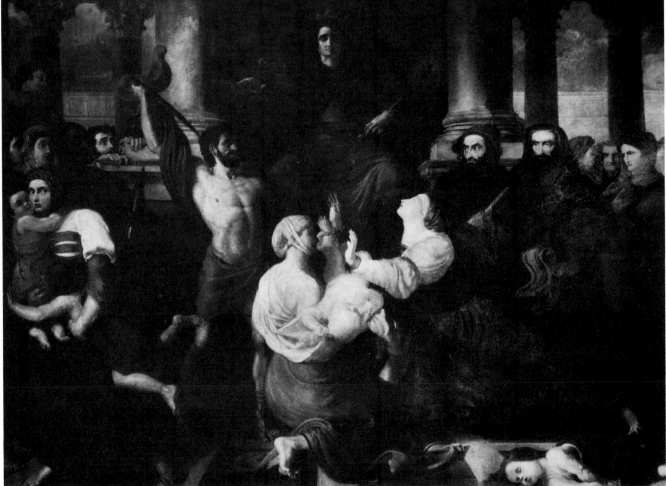

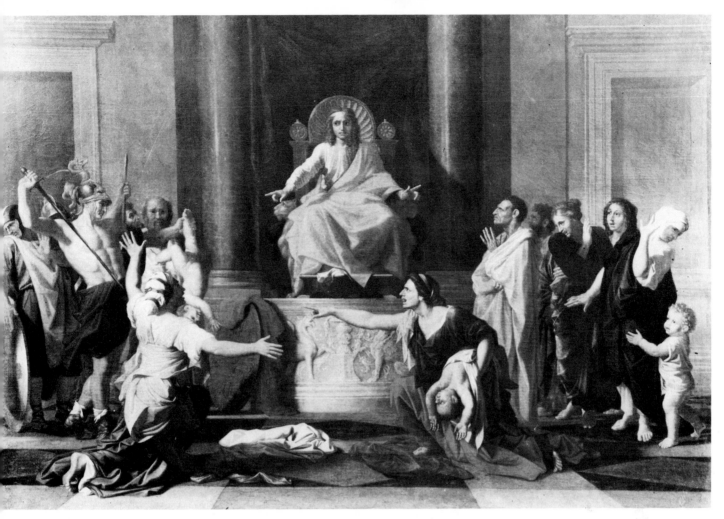

Figure 22. (Above left) Benjamin Robert Haydon: The Judgment of Solomon. Pen and ink drawing. Collection of Willard B. Pope, Burlington, Vermont. Preliminary sketch of the subject. See Figure 23 for the completed painting.

Figure 23. (Left) Benjamin Robert Haydon: The Judgment of Solomon. Oil on canvas, 10' x 12' (3,048 x 3,657.6 mm). Collection of J.B. Gold, Richmond, Surrey, England. Note the preliminary sketch (Figure 22) above. Haydon borrowed the general composition—not any one figure—from Poussin's painting of the same title (Figure 24).

Figure 24. (Above) Nicolas Poussin: The Judgment of Solomon. Oil on canvas, 100 x 150 cm. Louvre, Paris. This painting was used by the English painter Haydon as a starting point for his own conception of the same subject (Figures 22–23).

Figure 25. *Edgar Degas (?):* Variation of Velázquez's Las Meniñas. *Oil on canvas, 31 x 25.1 cm. Bayerische, Staatsgemäldesammlungen, Munich, Germany. Note how this painting, attributed to Degas, compares with the original (Figure 26).*

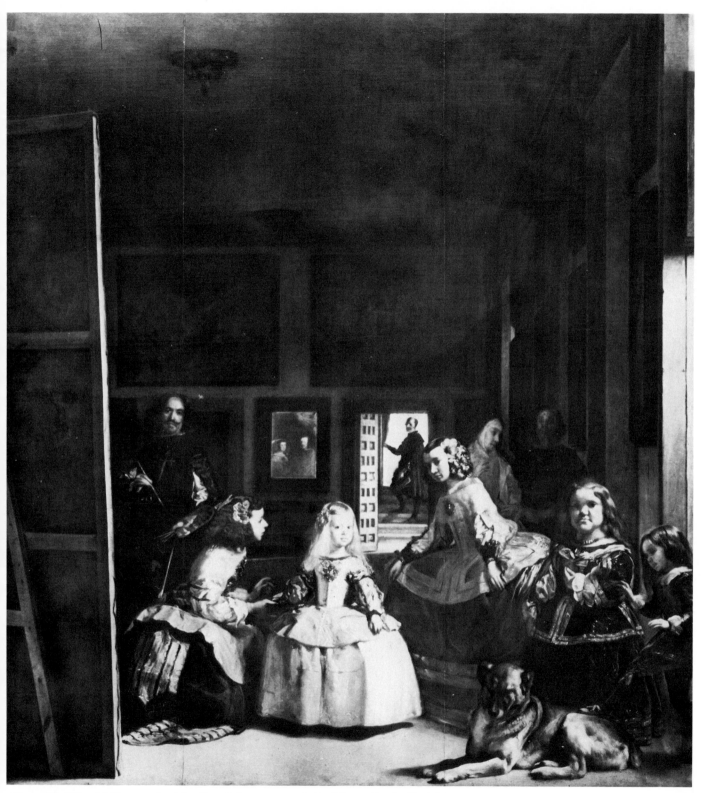

Figure 26. *Diégo Velázquez: Las Meniñas. Oil on canvas, 318 x 276 cm. Prado, Madrid. This painting was used by a number of artists, including Picasso, as a springboard for new ideas in composition. Note Figure 25, attributed to Degas.*

Case History 2: Wyeth, Picasso

To judge by the thousands of people who flock to his exhibitions, Andrew Wyeth is by far the most popular realistic painter of the day. His work is easy to understand and enjoy. Moreover, the public admires Wyeth's superb talent, especially his ability to paint everyday subjects in such detail that his paintings really look like what they're supposed to represent.

But accurate rendering of detail has little, if any, artistic meaning. This can be done by any seasoned illustrator who displays technical skill. The real difference is a simple one: Wyeth's paintings are *alive*. By comparison, the work of most academicians and illustrators is monotonous and static. But if all of them, including Wyeth, have had roughly the same kind of academic training—if they all possess the same sort of craftsmanship—how does Wyeth's approach differ from theirs? What does Wyeth *do* to make his paintings come alive? What's the secret ingredient? Is it something that anyone can apply? If so, why don't the academician and illustrator do it?

Refining a Composition Step-by-Step

One big difference is attitude. Wyeth never hurries, for example. He knows from experience and training that an artist's first requisite is patience. *The Toll Rope* (Figure 30) is a fine example of composition in which infinite patience was taken. When you compare it with his many sketches of the same subject—of which only a few are shown here—you become aware of how much patience and work went into the final painting. Figure 19 is Wyeth's first sketch. After he studied it, I believe he decided to narrow the composition by cropping it along some of the vertical lines. To illustrate this effect, I've reduced the spacing accordingly (Figure 27). Compare this with another of Wyeth's pencil sketches (Figure 28). You'll note that the rectangular shape formed by the outside dimensions becomes still narrower. And when compared with the rectangular shape of Figure 19, the difference in feeling is enormous.

Notice how the subject matter has

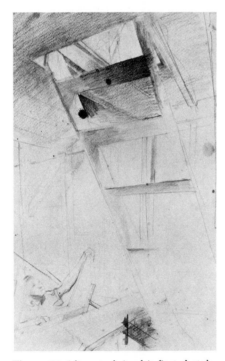

Figure 27. *After studying his first sketch (Figure 19), I believe Wyeth decided to narrow the composition by cropping it along some of the vertical lines. To illustrate this, I've reduced the spacing here accordingly.*

Figure 28. *Andrew Wyeth: Sketch for The Toll Rope. Pencil drawing, 14 1/2″ x 11 1/2″ (368.6 x 317.8 mm). Photo: Coe Kerr Inc., New York. Compare this Wyeth pencil sketch with Figure 27. Note that the rectangular shape formed by the outside dimensions becomes still narrower. Compared with the rectangular shape in Figure 19, the difference in feeling is enormous.*

Figure 29. *Andrew Wyeth: Sketch for The Toll Rope. Pencil drawing, 11 1/4″ x 5″ (285.4 x 127 mm). Photo: Coe Kerr Inc., New York. In this later sketch, Wyeth has compressed the width of the composition still further: the ladder is narrower, and the figure is no longer at the lower left.*

been changed. The ladder is wider at the top and narrows toward the bottom. Such distortion may be introduced purposely in a picture to create more vitality and tension. In the lower-left corner, the figure barely showing at the top of the ladder is still there, but both the figure and the descending ladder have been moved closer to the ladder that reaches to the open trap door above.

Here Wyeth reduced the picture slightly at the top and at the same time cut off a bit of the sky. He also changed the sky area to a much more sensitive shape. Look at the very small, light triangle at the right of the sky area; it's beautifully related to the sky shape. To appreciate the improvement, compare these shapes with the same ones in Figure 27. Part of the improvement is due to the way the trap door opening has been angled more diagonally against the sky.

With the toll rope skillfully introduced in space, we're now ready to discuss the main geometric surface shape motif. Obviously, it's the triangle. You'll notice that the triangular shapes are now more varied in Figure 28 than in Figure 27. Finally, the introduction of light and shade and textural qualities heightens the overall effect.

In Figure 29, a later pencil sketch, Wyeth has compressed the width of the composition still further. The ladder is narrower. The figure is no longer at the lower left. It's not needed, since Wyeth has added diagonal beams, creating more triangular shapes and a better relationship to the shapes at the top of the descending ladder.

Now we come to the painting itself (Figure 30). Wyeth made some final changes in the composition. He eliminated one of the diagonal beams and substituted an almost horizontal one across the picture. This change accomplishes two things. First, it emphasizes the rectangle as a geometric submotif in contrast with the main triangular motif. Second, the change simplifies the area and opens up more space. Then, for variety, Wyeth introduced more diagonals above the hori-

Figure 30. *Andrew Wyeth:* The Toll Rope. *Tempera, 28 3/4" x 11 1/4" (729.2 x 285.4 mm). Photo: Coe Kerr Inc., New York. When you compare this with the many trial sketches Wyeth made in developing the composition, you become aware of how much patience and work go into a final painting.*

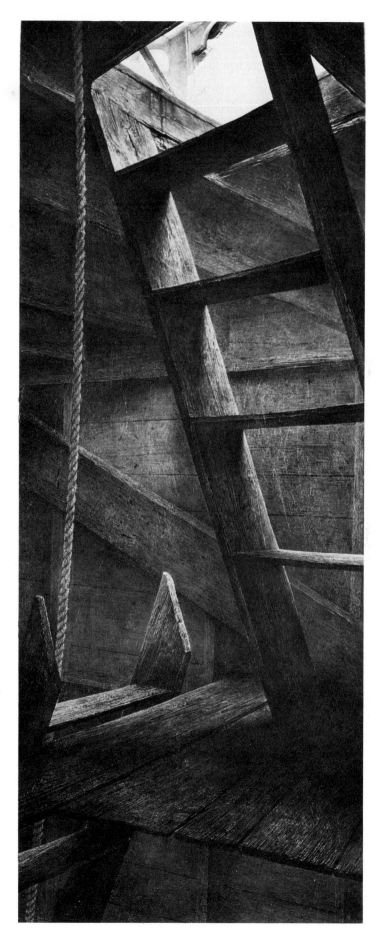

zontal, right up to the trap door. There he cut off a little more of the sky area.

There's only a tiny bit of distortion now in the width of the ladder—so little you can hardly notice it. The right edge of the painting meets the third rung of the ladder, instead of the fourth, as in Figures 28 and 29. This establishes more space between the left side of the ladder and the other, lower one. Wyeth has also moved the lower ladder more to the left, creating a more satisfactory spatial relationship between the ladders.

Finally, he has *lengthened* the painting, which once again changes the proportions of the rectangle. He shows more of the descending ladder and, for the first time, shows space under the platform. The significance of this last change in overall spatial feeling is tremendous. You'll experience this when you compare the outside dimensions of the elongated painting with each of the sketches.

Now we can judge how much time Wyeth spends developing a composition. Academicians and illustrators spend much less time as a rule. They may make a quick sketch or two and then proceed almost immediately to paint the subject before them. They do this with assurance, dispatch, first-rate craftsmanship, and cameralike fidelity. Yet, something is lacking.

Observation and Feeling

If Wyeth obtains better results, it's not merely because he spends more time, but because he uses his time to observe subject matter in a more meaningful way than the usual academic painter.

It's true that Wyeth, like all academicians and illustrators, acquired a broad range of skills and craftsmanship. In such traditional training, everything existing in nature is fragmented into subjects and taught in isolated detail. During the process, attention is focused on the practical operation of transferring what one sees in the three-dimensional world to the two-dimensional surface of paper or canvas. Keen observation is required to reproduce subject matter in proper perspective; in anatomical, textural, and color accuracy; as well as in tonal value and harmony. The acquisition of such technical skills is no small accomplishment.

Unfortunately, the process of such learning is intellectual. It's done mostly with the help of the conscious, reasoning mind. Dr. Anton Ehrenzweig, psychologist and artist, calls it the *surface* mind, and Dr. Joseph E. Bogen, neuro-

logist and brain surgeon, refers to it as the left cerebral hemisphere. While riveting your attention on details will improve your technical skills, such concentration narrows your vision.

As the concentration on details increases, the desire or urge to change direction is lost. The temptation is always to go on doing what you're used to. It's easier. And if changes are made, they're not really changes, but improvements in technique, carried to a higher degree of skill and craftsmanship.

Although he remains a realistic painter by choice, Wyeth made the effort to break away from the strictly academic approach. This is never easy. And he is the first to admit that he has failed at times.

To be creative requires the determination to call upon intuitive faculties that we have within us but rarely use: we must learn to use the *depth* mind, as Dr. Ehrenzweig calls it, or the *right side of the brain*, as claimed by Dr. Bogen; learn to release unconscious, imaginative perception; learn to express inner feelings spontaneously; learn to organize these feelings in a composition, intuitively, on the two-dimensional level; learn to release individual uniqueness. They're all within you. Only when these faculties function, does a painting come alive.

Academic skill is important, but it must not be overemphasized. Academicians and illustrators give very little attention to creative composition, whereas Wyeth is totally immersed in it. He has studied how to integrate subtle relationships in a composition as the old masters understood them.

After he studies his first sketch for spatial improvement, Wyeth relaxes to recall his exciting first view of the subject and the pleasure he received in observing it meticulously. While doing so, his feelings begin to well up from within, as evidenced in Figures 28 and 29. He doesn't cut them short. He allows them to gather momentum as he proceeds from sketch to sketch. Ultimately, he permits his feelings to flood his vision, so that they contribute to his full appreciation and enjoyment. He may even revisit the scene for this purpose.

What did Wyeth sense when he considered the sketches and painting of *The Toll Rope*? What observations contributed to his feelings? The smell of old, dry wood. The texture of the weatherbeaten supporting beams at the trap door as the light shone directly on them. Nuances of color, light, and shade, as the reflected light

changed the subtle tones of the rough-hewn, warped slats, boards, and beams inside the bell tower. The dryness and texture of the toll rope.

These are felt reactions, not intellectual observations. I would describe it as *letting go*—floating instead of tightening up and trying to capture fixed details—like the feelings that emerge when you sit back and permit music to enter your soul. The unconscious mind is a receptacle for these vague, fuzzy, dream-felt experiences so necessary to artistic expression.

Wyeth continues with sketches until these rich feelings rise to the surface and envelop him completely. Only then is the overpowering surface mind, with its drive toward technical skill, bypassed and swept into a secondary position. Only then does Wyeth begin the final painting (Figure 30).

The expressive feelings show up as tiny, sensitive, free strokes, charged with the stamp of Wyeth's unique personality. These strokes are almost invisible, but their vibrating force is permanently implanted in the painting. The sensitive onlooker feels this force and, although unable to explain it, becomes aware that the painting is alive.

Developing a Series of Sketches

Creative artists obtain their best results in spatial relationships by working in stages. It's possible to do so while working on one canvas. Picasso, for example, frequently made twenty or more major changes on one canvas within twenty-four hours. But the felt experiences of spacing are easier for a beginner to control in a series of sketches.

From now on, I suggest that you do as Wyeth did: don't go too far into detail in your first sketch. Stop as soon as the subject shows up and you feel that you've spaced it more or less over the entire area.

The next step is to study it. Find the main geometric surface motif. Remember, this is revealed *after* you've done the sketch.

But sometimes no one geometric shape motif dominates the sketch. In that event, let your intuition decide which motif should be strengthened in the next sketch.

This is exactly what Wyeth had to do when he studied his first sketch (Figure 19). Notice that the triangle motif is present, but it isn't dominant. It's offset by rectangles. Both motifs, which are so dynamic in the final painting, are structurally weak in this

Figure 31. *Pablo Picasso:* Mother with Dead Child on Ladder *from* Guernica Studies and Postscripts. *Pencil and color crayon on white paper, 17 7/8" x 9 1/2" (453 x 241 mm). On extended loan to The Museum of Modern Art, New York. Distortion plays its role in composition—from subtle to dynamic—and Picasso was a master of dynamic distortion. The tension here is felt particularly in the distortion of the mother and dead child.*

TWO-DIMENSIONAL SHAPE RELATIONSHIPS 35

quick preliminary sketch. (It takes an exceptional artist, like Wyeth, to permit the public to see the weakness of a preliminary drawing. But what a boon to students of composition!)

If Wyeth had expressed all his inner feelings in this sketch, and had drawn in all the textural details and light and dark values as he did in the final painting, the end result would have been static. At this early stage there are no rhythmic relationships of two-dimensional surface shapes, no dominant geometric motif, varied and repeated subtly in other parts of the sketch.

Another thing is to check the outside dimensions of your sketch to discover the weak spots.

After you've arrived at a newly adjusted composition—and you've confirmed your main geometric shape motif and possibly your submotif—repeat the sketch from memory. Repeat the process a number of times until you do a final drawing, giving your all.

The Importance of Experimentation

Testing the outside dimensions of a picture is an important step in arriving at the most satisfying spatial relationships of a composition. Wyeth offers the following new lessons.

By *narrowing* the width of a vertical composition, you can arrive at a more dynamic composition. You can even create a more vital composition at times by *lengthening* the vertical dimensions, in addition to narrowing the width.

Note that Wyeth did *not* arbitrarily choose a very narrow paper at the start and then fill in a vertical composition. To do so as a shortcut is to miss the whole point: you'd be overlooking the necessary *experience* of testing and adjusting spatial relationships by drawing upon your inner artistic resources, and the sensitive spatial relationships could easily fail.

In addition to testing the *outside* dimensions spatially, the subject matter and background—*within* the newly narrowed dimensions of each sketch—usually need to be moved or changed after the outside dimensions are narrowed.

You'll sense the importance of spatial relationships not only by shifting shapes, but by *blocking out* certain areas. Wyeth discovered that, by blocking out, he could eliminate the head and arm shown in Figure 28 and thus simplify his composition.

As an experiment, try to do the same thing by blocking out or covering up the monkey in Figure 12. With the monkey eliminated, how do you feel about the space between the lady and the left edge of the picture? In this case, you'll intuitively come to the conclusion that the monkey fills a needed spatial area.

Contrary to popular belief, a good drawing or painting, sound in organi-zation and alive with feeling, cannot be achieved merely by technical skill and craftsmanship, no matter how superb. You should worry less about skill and keep improving the organization of your composition by concentrating on sensitive two-dimensional surface shape relationships. This is our main concern at this point. Nurture any feelings that may arise during this period. Begin to express them more emphatically as you advance in each sketch.

Finally, keep in mind that distortion plays its role in composition. There are subtle departures from realistic likeness in the work of *all* old masters. Ching Hao, a 10th-century Chinese master wrote, "Unless this point is understood, one will draw a mere likeness of external appearance, but not capture the real essence."

There are, of course, degrees of distortion. Picasso was a master of *dynamic* distortion.

Compare the subtle distortion of Wyeth's drawings of the ladder with the dynamic distortion of the ladder in Figure 31. This is one of Picasso's many trial sketches for his famous *Guernica* mural. Tension is felt particularly in the distortion of the mother and the dead child. The total effect is heightened by the intensified integration of all the compositional elements, including two-dimensional spatial relationships.

Project 3: The Figure in Composition

You'll achieve greater satisfaction as you learn to develop skill in controlling more difficult divergent actions at the same time. That is why continued practice in integrative process discipline is so essential.

One of the quickest ways to become accomplished is to form the habit of reacting spontaneously to the most economical and efficient order in which split-second actions take place.

Through this project you should develop discipline in following the sequence of operation and in scanning the whole for a sensitive awareness of shape relationships.

For this purpose, I've chosen a number of stimulating assignments involving the figure in composition. Be alert, nimble, and flexible in order not to be diverted from the main topic of this chapter: two-dimensional shape relationships.

If you're experienced in portrait painting, you've probably studied anatomy, perspective, and problems of volume. These are all *three*-dimensional factors. Therefore, I suggest that you *not* consciously try for a likeness in figure work—not until you've mastered the integrative process in composition.

The same suggestion holds true, of course, if you're *not* trained in figure work. If you feel handicapped and have the urge to experiment on your own, I suggest that you study at leisure the instructions in *Learning to Draw* by Robert Kaupelis, also published by Watson-Guptill. His subtitle, "A Creative Approach to Expressive Drawing" sums it up admirably. I recommend his book without hesitation.

Do the best you can in this project by letting yourself go. You'll be surprised what can happen when you approach the task in the spirit of adventure—particularly if you don't have preconceived ideas of what the end results should be.

Now let's discuss the specific problems of the assignments. Not only do you have to obtain some kind of visual expression, but the very act requires focusing attention on a specific, limited area of the drawing paper. Yet the shape or shapes you make of the head, for example, must feel right in relation to the *remaining unworked space.* Further, as you concentrate on improving your ideas, you'll keep changing the shapes. Therefore, to arrive at

Figure 32. *A student's first attempt to draw a figure from imagination. Working with enthusiasm and feeling, she was so carried away with the excitement of detailing the figure that she forgot to pay attention to spatial relationships. The two-dimensional shapes in the figure bear no relationship to the surrounding space.*

the best possible composition requires constant scanning of the whole surface area, as you keep improving the shapes in the background in relation to the shapes in the figure.

In these assignments you must shift continuously from pinpoint view to whole view spacing. This usually leads to frustration and other psychological problems unless you form the habit of finding the simplest and most direct way to do it. Even then, for various reasons that will be discussed, you'll find that you may not always follow through and do things the easiest way—with disastrous results.

You may be interested to learn that even when the masters were beginners, they experienced similar difficulties in adjusting to the compositional process. As Brancusi, the sculptor, once said, "It is not difficult to make things, what is difficult is to put ourselves in the proper condition to make them."

Test Yourself

Before you try sketching the figure, your first assignment is a self-examination to test your progress after Projects 1 and 2:

1. Study Figure 32.

2. What is good about the drawing?

3. What is flagrantly weak in the composition?

4. What procedure could have avoided the weakness?

5. What happened? Can you think of two possibilities why such procedure wasn't applied?

6. What, if anything, can be done now to bring the composition into balance?

7. *Stop at this point and do the first assignment. Do not read further.* When you've completed the assignment, compare your answers with the following.

Figure 32 is the work of a student who tackled her first attempt at drawing a figure with enthusiasm and feeling. She was obviously carried away with the excitement of detailing the figure and forgot to pay attention to spatial relationships. The shapes of the figure bear no relationship to the surrounding space.

Wouldn't it be safer to make a quick, rough sketch and stop as soon as the image emerges? Wouldn't it be better not to get involved emotionally in improving the details of the figure and instead focus immediately on the whole design?

Unless you approach the first step of integrating the image *deliberately, in slow motion,* you may become fascinated suddenly with some detail that attracts your attention. Then, in a flash, you may be off on a course far removed from harmonizing two-dimensional shapes. In that case, the final composition will betray the lack of balance and unity.

There's another, even more serious psychological reason why you may not have applied yourself to clinching the first integrating step. You may be unwilling to accept any new discipline the first or even the second time it's suggested. Sometimes we find it very difficult to accept wholeheartedly a procedure that's new to us. We often have to test it negatively first, to determine whether we can possibly puncture and deflate it. If we find we can't, then we're more inclined to accept it.

At this stage, the composition of Figure 32 may be brought into harmony by cropping in from the left, masking the drawing until a balance is found. But suppose the painting were done on a solid gesso composition board? Or on a canvas? The job of sawing the board down or making stretchers for an odd-size canvas is not only time-consuming but tedious. How much better to avoid it in the first place by meeting the compositional challenge in the most efficient way!

Sketch Someone You Know

Your second assignment is to make a sketch using a friend or relative as a model:

1. Use a 5B or 6B black pencil.

2. Take as much time as you like to study the person, but when you start to sketch, *do it from memory.*

3. Don't fret if the likeness is poor. The idea is to get started. Remember, this is merely a preliminary sketch. Keep it simple, without details.

4. However, don't overlook the vital spatial relationships. The idea is to arrive at the best possible relationships intuitively.

5. What dominant geometric shape motif does the figure as sketched suggest? Does the motif, by chance, relate to other shapes in the background? What about contrasting motifs for variety?

6. Render the sketch with an indefinite background—that is, without any indication of whether the figure is indoors or out.

7. Don't take more than ten minutes to do it.

The Figure Outdoors

Your third assignment is to try another sketch with the figure *outdoors,* just as Seurat did in Figure 12:

1. Before you start, study the result of your first sketch to see if it lends itself to the outdoors.

2. Again, take time to study the model, but do the sketch from memory, using your imagination to embellish the subject.

The Figure Indoors

In your fourth assignment, try a sketch with the figure *indoors:*

1. Note how the French artist, Berthe Morisot, placed the figure indoors (Figure 33).

2. In both Seurat's and Morisot's paintings note that the spatial relationships are based on the rectangle as the dominant geometric motif. Yours, however, may turn out as a triangle, oval, diagonal, or other motif. Don't be tempted to start with a preconceived motif; that would be cerebral instead of intuitive.

Careful Study of the Model

Your fifth assignment is to make a more careful study of the model:

1. This time work slowly; try for an expression of character and vitality.

2. Blend and vary the shading with a #1 soft charcoal stick.

3. Apply all you've learned in integrating two-dimensional shape relationships as rhythmically and sensitively as you can.

4. Pour all your feelings into it.

Keep a Notebook

Your sixth assignment is a continuing one. Keep a small notebook handy for quick sketches of people at rest and in action.

Figure 33. *Berthe Morisot:* In the Dining Room. *Oil on canvas, 24 1/4" x 19 3/4" (616 x 501.6 mm). Chester Dale Collection, National Gallery of Art, Washington, D.C. The spatial relationships here are based on the rectangle as the dominant geometric motif. In other cases, the main motif may be a triangle, oval, or some other geometric shape.*

Case History 3: Toulouse-Lautrec, Fouquet, Rembrandt

Maurice Joyant, the subject of Figure 38, was a good friend and biographer of the French painter Toulouse-Lautrec. In his biography, Joyant wrote, "Before a picture was begun, it went through a long period of incubation."

This quote confirms that patience is needed to allow the composition to unfold creatively. In this case, Lautrec studied and scrutinized Joyant during their long weekends on Joyant's boat. Finally, the moment of decision arrived. He would paint him as a hunter on a boat at the estuary of the Somme.

During the two years of observation and the many discussions about the portrait, Lautrec did not even draw a preliminary sketch. Lautrec sensed the need, first, to be *steeped in his feelings* about Joyant's essential character. Otherwise, he would be merely portraying the surface appearance.

Sketches were finally made and, lucky for us, kept. Studying them offers you the unusual opportunity to strengthen your own approach to creative pictorial composition.

Composition Comes Before Likeness

Most artists will tell you confidentially that they must constantly guard against emphasizing surface appearance, so important in academic painting. Even a skilled artist like Lautrec was no stranger to this common psychological difficulty. In his first, quick pencil sketch (Figure 34), in which he roughed in the figure, he made a start on his composition. He drew a few lines at the top of the sheet, carrying them down to the top of the hat. This was his first step in establishing two-dimensional shape relationships.

But instead of continuing, he was sidetracked. The impulse to obtain a likeness of Joyant overpowered him. As a result, he returned to the face and emphasized the features of Joyant in more detail. We can see this in the heavier lines around the face. However, we can assume that he recognized the academic trap, for he continued no further with that sketch.

Development of a Portrait

He made another pencil sketch instead. Figure 35 shows that he concentrated on the whole area of the paper, dividing the space intuitively. How can we assume that it was intuitive? *It was done very quickly*, allowing no time for the conscious, surface mind to intervene.

His next sketch (Figure 36), done this time in ink, shows slightly more detail. Essentially, however, Figure 35 is the compositional basis for the sketch in oil (Figure 37) and for the ultimate painting (Figure 38).

Having determined his two-dimensional spatial relationships, he turned his attention—in the oil sketch (Figure 37)—to rendering the inner character

Figure 34. *Henri de Toulouse-Lautrec: First Quick Sketch for Portrait of Maurice Joyant. Pencil, 6 7/8" x 4 3/8" (174.8 x 112.6 mm). Collection of Mme. M.G. Dortu, Paris. Having roughed in the figure, Lautrec started to establish two-dimensional shape relationships by drawing a few lines at the top. But instead of completing the composition, he detailed the features. However, realizing that composition comes before likeness, he continued no further.*

Figure 35. *Henri de Toulouse-Lautrec: Sketch for Portrait of Maurice Joyant. Pencil, 8 3/8" x 5 1/8" (214.2 x 130.2 mm). Collection of Mme M.G. Dortu, Paris. Instead of continuing Figure 34, Lautrec made this pencil sketch. This time he concentrated on the whole area of the paper, dividing the space quickly and intuitively.*

Figure 36. *Henri de Toulouse-Lautrec: Sketch for Portrait of Maurice Joyant. Ink on paper, 4" x 2 3/8" (101.6 x 61.8 mm). Collection of Mme M.G. Dortu, Paris. This sketch shows slightly more detail. However, Figure 35 is essentially the compositional basis for the detailed sketch in oil (Figure 37) and for the ultimate painting (Figure 38).*

Figure 37. *Henri de Toulouse-Lautrec: Detailed Sketch for Portrait of Maurice Joyant, Oil on cardboard, 37 1/2″ x 26 1/4″ (952.8 x 666.9 mm). Collection of Mme M.G. Dortu, Paris. Having determined his two-dimensional spatial relationships (Figure 35), Lautrec turned his attention to rendering the inner character and mood of the portrait. Note how he used distortion of the coat and particularly the sleeve to vitalize the picture.*

Figure 38. *Henri de Toulouse-Lautrec: Maurice Joyant Hunting in a Bay of the Somme. Oil on wood panel, 46″ x 32″ (1,168.4 x 812.8 mm). Albi Museum, Albi, France. Lautrec further strengthened the body here by making the head and hat smaller and narrowing the body to create another kind of distortion.*

and mood of the portrait. These show up not only in the modeling of the facial features, but in the strength and power felt in the body. Observe the exaggerated enlargement of the oilskin coat and particularly the bulky sleeve—proof of how distortion vitalizes a picture.

In the final painting (Figure 38), we can see that the main geometric motif is the triangle, with the arc motif a strong second. The horizontal line creates still another contrasting submotif. There's no false note anywhere. The shape relationships feel very well spaced.

Compare the spatial relationships in the oil sketch (Figure 37) with those in the final painting (Figure 38). Without losing any of the vitality shown in Figure 37, Lautrec further strengthened the body in Figure 38 by making the head and hat smaller and narrowing the body. This *elongated* the body, creating another kind of distortion used by many of the old masters.

Develop the Right Work Sequence

Our conscious, reasoning left-brain hemisphere is not the area that produces the esthetic qualities so essential in a work of art. The splitting up and merging of ideas into new combinations, and our aroused sensitive feelings about them—which give a drawing or painting its personal uniqueness—cannot be expressed unless they are freed from conscious thinking and awareness.

Since artistic qualities are produced as a subconscious activity, we must train ourselves to relax and not draw or apply the brush until we are in the proper mental state. The danger, particularly during the early stages of training, is that we can easily slip back into a conscious state without being aware of it. Check often to be sure that you are in a relaxed state of detachment.

Therefore, to make rapid progress and avoid frustration, develop a healthy mental attitude and the proper work sequence from the start. Integrate a drawing or painting *as you go along*. It takes discipline, but it's the surest road to creative and artistic composition.

If you wish to experiment with different techniques because you want to know how to obtain various effects, do this later on, *after* you've mastered the integrating steps of the creative process.

Don't be tempted to modify these directions. It's easy to rationalize by saying, "Perhaps the directions don't

Figure 39. *Jean Fouquet: Portrait of an Ecclesiastic. Silverpoint and a little black chalk on white prepared paper, 7 11/16" x 5 5/16" (188.8 x 134 mm). The Metropolitan Museum of Art, New York. This is an example of a finished drawing made without the benefit of preliminary sketches. Having mastered creative composition, Fouquet was able to space the drawing intuitively and sensitively from the start.*

Figure 40. *Attributed to Rembrandt van Ryn: Banquet of Esther. Pen and brown ink, brown wash, 7 9/16″ x 10″ (191.8 x 254 mm). The Pierpont Morgan Library, New York. As soon as the subject emerged in his sketch, Rembrandt worked on two-dimensional surface shape relationships over the entire area.*

mean what they say. There are probably exceptions, especially when you're planning to do a portrait."

Your attitude may deepen as you examine and admire finished drawings done without benefit of preliminary sketches, such as the drawing by the 15th-century French artist Jean Fouquet, *Portrait of an Eccelesiastic*, in Figure 39. (At least there's no record of preliminary sketches of this work.) As you study Figure 39 you may find it difficult to believe that Fouquet considered composition before he concentrated on the details of character and likeness.

But masters can break every rule in the book. That's one reason we call them masters. Having mastered creative composition, they require no organized procedures. They're able to space sensitively and intuitively from the start. But you're not a master yet! You must first learn to resist the immediate overpowering desire to work for a likeness. At your stage, that leads to the academic graveyard. Instead, learn to *integrate all parts* as you proceed.

The *key discipline is*: as soon as the subject emerges in your sketch, switch your attention to the whole composition. Get busy immediately with two-dimensional surface shape relationships over the entire area. This is what Rembrandt did in his etchings, *Banquet of Esther*, in Figure 40. Constantly avoid the magnetic pull to concentrate on refining *details* at the expense of the whole composition.

Continue the sequence, sketch by sketch, improving the spatial relationships in each. You'll reach the grand finale when you can advance no further—even after an interval of time. This represents the ultimate creative expression. It's usually the final drawing or painting, into which you've poured the full flood of your emotions.

Light and Dark Value Relationships

2

You've begun to be aware that the *sensing* of two-dimensional spatial relationships is the foundation of composition. Therefore, it's time to concentrate on light and dark value relationships in more detail. I say in more detail, for you've already been studying the black and white illustrations of paintings and drawings in the projects and case histories. And

you've used black and grays against the white of the paper in your assignments.

Light and Dark Gradations

Light and dark gradations are sometimes called values, tones, shades, or densities. These gradations range from black to white—from deep black through a series of grays to light tints.

By comparing Raphael's painting of *Saint George and the Dragon* (Figure 42) with his drawing (Figure 41), from which it was traced, we become aware of the importance of light and dark values as a separate and distinct compositional element.

Without disturbing the two-dimensional shape relationships stabilized in the drawing, Raphael established light and dark value relationships *within the shape areas*. Thus, by harmonizing light and dark values as a whole and superimposing them on the balanced shape relationships, *two separate compositional elements become completely unified*. For the beginner, this particular approach assures excellent control.

The two-dimensional geometric shape relationships not only strengthen the structure of the picture, but also set the mood and movement of the whole. Working for light and dark relationships offers equal but different excitement. It usually arouses greater visual awareness by providing a stimulus to the retina. Light and dark values, when balanced, *intensify* the mood of a picture. They make your drawing assignments come alive.

Superimposing value relationships within shape areas is not a rigid formula. But you do gain greater control and facility by concentration on one compositional element at a time in the integrative process. Nevertheless, even after shape relationships are balanced as a whole, they may still need modification and improvement.

Improving Shape Relationships While Balancing Values

Study the differences between Figures 41 and 42. Note how Raphael, working to improve light and dark values as a whole, improved shape relationships *at the same time.*

What effect does the addition of a sword at the side of St. George have on the geometric submotif of shape relationships? Why are the boulders on the left so distinctly arc-shaped? Why were the trees in the upper left

Figure 41. *Raphael Sanzio:* Saint George and the Dragon. *Pen drawing, pin pricked for transfer, on white paper. Uffizi Gallery, Florence. Courtesy Alinari-Art Reference Bureau. Study the differences between this drawing and the painting (Figure 42). Note how Raphael, in working to improve tonal values as a whole, improved shape relationships at the same time.*

Figure 42. *(Right) Raphael Sanzio:* Saint George and the Dragon. *Oil on wood, 11 1/8″ x 8 3/8″ (285 x 215 mm). National Gallery of Art, Washington, D.C. If you compare this painting with Raphael's drawing (Figure 41), you'll see that by harmonizing light and dark values as a whole and superimposing them on the balanced shape relationships, two separate compositional elements become completely unified.*

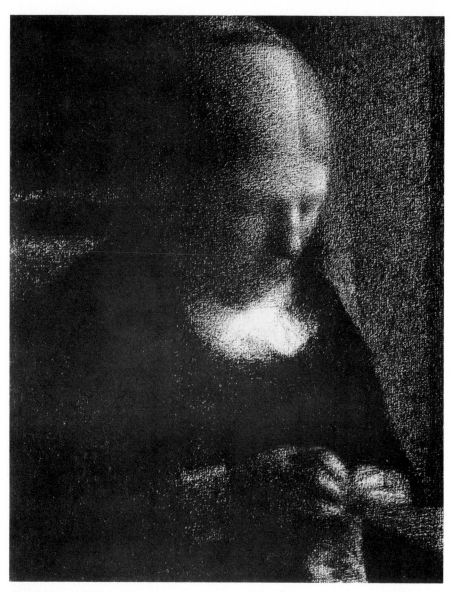

Figure 43. *Georges Seurat: Portrait of the Artist's Mother. Conté crayon, 12 5/8″ 9 7/16″ (318.8 x 240.6 mm). The Metropolitan Museum of Art, New York. Seurat achieved an extraordinary mood in the distribution of light and dark gradations, enhanced by the sensitive spacing of two-dimensional geometric shapes throughout.*

lowered? Why were all the trees, including those in the upper right, given more leaves? In what way do the trees relate to the rest of the painting?

There are many other small, subtle changes in geometric shape relationships. See if you can find them. You'll get a thrilling esthetic response if you do. Also, you'll discover how these changes helped Raphael create a masterpiece.

Two Points to Remember

There are two points to remember. First, balance light and dark relation-ships *intuitively*, the same way you balance shapes—over the surface area as a whole.

Second, test your intuition by blocking out any questionable area and looking at the remaining picture as a whole. Does the picture "feel" better with or without the area blocked out? Disregard logical reasons for making a decision based upon what you've been taught in the past or what you *think* should be done. Make adjustments entirely on your intuitive feeling.

Sometimes the details of the subject matter may be so strongly impressed on your vision that they interfere with your ability to sense that an area needs adjustment. In such cases, try squinting to blur the subject matter out of your consciousness. Squinting lets you concentrate on the variety of light and dark values and helps you see the whole.

One artist I know ordered special eye glasses so he can see his drawing or painting *out of focus* to check values. I suggest that you use a pair of opera glasses for the same purpose, since they can be easily adjusted to blur subject matter.

I discovered another method during an electrical blackout. I placed a candle close to my painting in the pitch-black studio.

Try it sometime. You'll be surprised how details vanish. You can really see value relationships as a whole in the soft light. And you can quickly spot any questionable area.

Use a Soft, #1 Compressed Charcoal Stick

As you study the black and white illustrations in the book, you'll notice that they represent a wide variety of media—pencil, ink wash, etching, oil or acrylic paint, lithography, woodcut, among others. Keep a list of the techniques that attract you. When you feel you've mastered the balancing of shape relationships and the harmonizing of light and dark relationships, try different media.

To develop a high degree of sensitivity and mood in your drawing, use soft, #1 compressed charcoal sticks. Koh-i-noor brand is just right.

The big advantage of these very soft sticks is that harsh lines and consciously drawn details are eliminated. It's easier to release an overall mood and control it.

You should use charcoal paper, but if it's not available, try a drawing paper with a slightly textured surface to give you some of the effect in Seurat's drawing, *Portrait of the Artist's Mother* (Figure 43). That was done with Conté crayon, probably black #3, but you may find charcoal compressed into chalk form easier to control at this stage.

Seurat achieved an extraordinary mood in the distribution of light and dark gradations. Note, especially, how the mood was enhanced by the sensitive spacing of the two-dimensional geometric shapes. Also, note the effect of many more dark than light areas.

Project 4: Relating Light Values to the Geometric Shape Motif

In the three introductory projects, I've emphasized shape relationships and work habits to achieve rapid progress. I indicated that light and dark relationships were closely related, but the suggestions for improving them were rather sketchy.

In the next few projects, the emphasis will be on light and dark relationships *first*. The purpose of these assignments is to help you attain more sensitivity in harmonizing light and dark values.

This project has two specific purposes: first, to test the effect of accented *lights* in different areas of the picture; second, to relate the placement of lights to the dominant geometric shape motif. The idea is to intensify the mood of the picture to the greatest possible degree.

Lights are accented on a sheet of white paper only when areas are surrounded by dark shades. The degree of intensity of lights varies with the shades of dark gradations in surrounding shapes. For example, small areas of intense lights are created by large bordering areas of intense blacks.

Take another glance at Seurat's drawing (Figure 43). This time, note the areas of lights. Study how the mood was created by the subtle intensification of *lights* in relation to the *geometric shape motifs*.

Now, let's see what you can do with Figure 44. It's a sketch for a portrait by a famous English artist of the 18th century. Note that he didn't concentrate on drawing a likeness. On the contrary, using a rough sketchy technique, he was more interested in rendering the feeling of the loose, flapping lapel and the coat of the sitter. Observe the casual way in which the arm on the right appears to hang over a chair as both hands hold an open book.

Vary the Light Values

Your instructions are as follows:

1. Make three tracings or machine copies of Figure 44.

2. Use a soft, #1 compressed charcoal stick. Break it in half and apply it broadside on the paper. Regulate the degree of darks by varying the pressure of the charcoal.

3. In the first tracing, place the light and dark gradations at *random*, intuitively, keeping your eye on the whole for a pleasant overall distribution.

4. Study the result. Then repeat the process in the second tracing, but this time change the areas of lights. Keep turning the paper four ways as you improve the balance of lights and darks over the whole surface.

5. Study the results of both drawings. Before placing the lights in the final drawing, look at Figure 44 once again.

What is the main geometric shape motif? How can the lights be distributed to enhance the movement of the main geometric motif?

6. Simplify the third tracing anyway you like, although I suggest you keep the general outline. You may fill in the background with any subject matter you feel would strengthen the structural shape relationships and unify them with the light and dark relationships as one integrated whole.

Figure 44. *Thomas Gainsborough: Study for Portrait of the Honorable Richard Savage Nassau. Black chalk, 28.2 x 20.8 cm. Staatliche Museen, Berlin-Dahlem, Germany. Note that Gainsborough did not concentrate on drawing a likeness. Using a rough sketchy technique, he was more interested in rendering the lapel and coat.*

The portrait of *The Honorable Richard Savage Nassau* (Figure 45) was painted by the 18th-century English artist Thomas Gainsborough. Essentially, it follows the outline of his preliminary sketch (Figure 44).

Gainsborough was recognized by his contemporaries as one of the two foremost English portrait painters, the other being Sir Joshua Reynolds.

He studied in London with French engraver and book illustrator Hubert Gravelot, and also with a portrait painter named Francis Haymen. From Gravelot, he may have acquired a taste for the elegance and rhythm of rococo art. The word *rococo* comes from the French *rocaille*, meaning shell-shaped, a favorite ornamental motif during the 18th century. The playful vitality and greater freedom of the period was displayed in a wealth of decorative ornamentation. The best expression of rococo is found in the work of the French painters, Watteau, Boucher, and Fragonard.

Gainsborough's feeling for the manipulation of pigment animates his paintings with apparently sketchy, freewheeling brushstrokes. Note them particularly in the upper right-hand corner of the painting.

Accenting Light Values

I chose this composition for two reasons: first, the main geometric *shape motif* is *diagonal*. Gainsborough was well aware of the effect of having his subject lean backward—diagonal is an unstable motif. As the center of gravity presses downward, it requires an opposing force to keep it balanced. For this reason, the diagonal motif is never static. It's a compositional device to arouse in the viewer the same muscular tension that the sitter experiences.

In this painting, if the sitter hadn't supported himself by draping one arm over the chair, he might not appear so much at ease.

How can we confirm that Gainsborough worked for this effect? The loose, wavy manner in which he painted the coat and curling lapel, for one thing, reinforces the feeling of action in the diagonal motif.

It's also confirmed in the light and dark relationships—the second reason why I chose this composition.

Note how Gainsborough accented the *light* values in a *diagonal formation*, stretching from the upper left of the painting to the lower right—from the face and scarf to the calf of the leg. To experience the full impact of this long diagonal stretch, block out the light values of the book and hands. Note how important they are to the total effect.

Here, we have not merely a portrait, but a painting with subtly built-in tension and action. Light and dark values are not only balanced as a whole, but they reinforce the main geometric shape motif—the diagonal.

Note how the landscape painting in the upper-right corner gently stresses a tree as a diagonal, rhythmic in its relationship to the main diagonal. Observe how Gainsborough introduced the square shape of the landscape as a submotif. This is repeated below in the space bounded by the edge of the book, the vertical side of the chair, the dark edge of the table, and the edge of the canvas.

The Lesson to Be Learned

The lesson to be learned is that light and dark value relationships may strengthen the main geometric motif in surface shape relationships. Figure 46 shows another application of this principle. How appropriate that the light values extend from one arm to another, through the light of the dress shirt in a wide arc, in Sickert's painting *Sir Thomas Beecham Conducting*.

Figure 45. *(Left) Thomas Gainsborough: The Honorable Richard Savage Nassau. Oil on canvas, 49″ x 38 3/4″ (1,244.6 x 985 mm). The National Gallery of Scotland, Edinburgh, Scotland. The main geometric shape motif is the diagonal. Gainsborough was well aware of the effect of having his subject lean backward. A diagonal is an unstable motif. As the center of gravity presses downward, it requires an opposing force to keep it in balance. Note how he accented the light values in a diagonal formation, stretching from the upper left of the painting to the lower right. To experience the full impact of this long diagonal stretch, block out the light values of the book and hands for a moment. Note how important they are to the total effect.*

Figure 46. *(Right) Walter Richard Sickert: Sir Thomas Beecham Conducting. Oil on burlap, 38 3/4″ x 41 1/8″ (985.2 x 1,045 mm). The Museum of Modern Art, New York. This is another example of how the distribution of light values strengthens the main geometric motif in surface shape relationships. The light values enhance the main motif of the curve by forcing the eye to move in a wide arc, from one arm to another, through the light of the dress shirt.*

Project 5: Spotlighting Figures

Having experienced the interlocking of value relationships with shape relationships, to the benefit of both, let's take another step forward.

Although the general objective of this project is to continue to test the effect of emphasizing *lights*, the specific aim is quite different from that in the previous project.

Case History 4 showed how lights can be used to reinforce and heighten the action and movement of the main geometric shape motif. The lights were included *within the main shape motif*—the diagonal of the *figure*.

In this assignment, you are asked to spot lights on the figure, or rather figures. Think of characters on a stage, spotted by lights and surrounded by a large mass of *dark* values—the main shape motif.

For this purpose, I've chosen Figure 47, a preliminary drawing by a 19th-century French artist. A young girl stands before a tribunal, alone and fearful about what is going to happen to her, as the judges—official guardians of a minor—consider her case.

Vary the Dark Values

Here are your instructions:

1. Before you start, try to put yourself in the girl's place. How would you feel under the circumstances? Would the judges seem to be ogres, benefactors, or perhaps merely indifferent? Let your mood permeate every part of the four drawings in this assignment.

2. Make four tracings or machine copies of Figure 47.

3. Use a soft, #1 compressed charcoal stick, applying it broadside, *except in the figures.*

4. In the first tracing, try to let down and consciously *forget* the purpose of this project. This should help you loosen up and permit your unconscious feelings to operate. Place light and dark values at random, intuitively, but keep your eye on the total effect. This way your personal reactions to the subject matter will come out as you unify lights and darks harmoniously.

5. Study the result. In the second tracing, don't hesitate to carry over any special effect from the first that appeals to you. This time, keep in mind the purpose of the project. Accent the strongest light on the judge bending forward and a partial light on the young girl. Balance the remaining light and dark values as a whole, letting the dark values form the largest geometric shape as dominant motif.

6. Study the result. In the third tracing, place the light on the judge sitting in the chair to the right. Follow all other instructions in step 5, but not rigidly.

7. Study the result. In the fourth tracing, place the light on the girl. Follow all other instructions in steps 5 and 6.

8. Note how the two lines at the top suggest the division of space and the possible source of a main geometric shape motif. You may modify the two-dimensional shape relationships in any way your intuition leads you, so long as the figures are retained to carry out the theme of the project.

Figure 47. *Honoré Daumier: Déposition de Mineure. Pen and ink, 22 x 33.6 cm. Museum Boymans, Rotterdam, Holland. A young girl stands before a tribunal, as the judges consider the record of her case.*

Case History 5: Daumier, Rembrandt

Figure 48 is a watercolor in gouache, Chinese ink, and pen, by the 19th-century French artist Honoré Daumier. Gouache is an ancient way of painting in watercolor. The pigments are mixed with white and used opaquely.

Daumier loved to draw, and he was trained as a lithographic draftsman. During his career, he drew thousands of lithographs, mainly for a satirical weekly magazine, attacking hypocrisy in all forms. He was a revolutionary— a political satirist, who exposed the foibles, pretentiousness, and conceit of those in authority and power, including the overbearing snobbery of the middle class. He was deeply aware of the social problems of his times, particularly the exploitation of the common man and woman.

His great desire was to paint in oil, as well as to create sculpture, but neither his paintings nor sculpture caught on during his lifetime. He died in extreme poverty. We'll see more of his work and learn more about him later on.

The Effect of Light and Dark Relationships

I chose this composition as a dramatic example of the impact of light and dark relationships. The importance of tonal values as an esthetic, compositional element can be better appreciated by comparing Figure 48 with Daumier's drawing of the same subject (Figure 47), on which Project 5 was based.

Fortunately, we can see an earlier drawing, the very first one in the series (Figure 49). It shows Daumier's freely expressed changes as he developed the many figures in his subject. Compare the drawing with the later one (Figure 47). Excellent draftsman as he was, he didn't narrow his vision by concentrating on improving details. Note how tentatively the figures were drawn in the first, in comparison with those in the second drawing. Again, we find that repeating a sketch in stages brings its rewards of simplification and clarity of image.

Note the improvement of scale be-tween the figure of the girl and the group of small figures at the left. Returning to Figure 48, we find still another adjustment in scale. The figure of the girl appears *smaller* in relation to the judges, especially the one to the extreme right. This was attained, first, by reducing the outside dimensions of the paper, particularly at the top, and, second, by compressing the space between the girl and the small figures at the left. Note also how free and sketchy these figures remain.

The most important change in the spatial feeling of the difference in scale between the girl and the judges was achieved by the sharp diagonal above. Actually, the diagonal line in the drawing (Figure 47) is still included at the same angle in the watercolor (Figure 48), although positioned somewhat lower. The sharp diagonal is the key to both the feeling and the structure of the watercolor. It's the key to both shape and value relationships. It separates the picture into dramatic light and dark areas, in which a

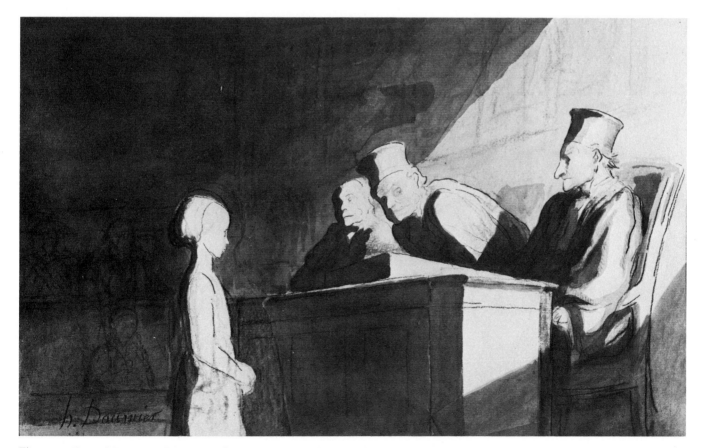

Figure 48. *Honoré Daumier: Déposition de Mineure. Pen, Chinese ink, and gouache, 22 x 33.6 cm. Statens Museum for Kunst, Copenhagen, Denmark. This is a dramatic example of the impact of light and dark relationships. Compare with Figure 47.*

large dark mass dominates two-thirds of the surface area.

The light streams in from the right as if the scene of the girl standing before the guardian judges was staged as a play—the judges and bench in partial shadow, while the full focus of the spotlight shows the girl in complete light.

Here, again, the geometric shape motif of the bold diagonal adds to the dynamic quality of tension, action, and movement in the scene. Note how the line at the left side of the left-hand judge is continued at the same angle upward, as the light and dark diagonal edge extends to the top of the picture. Did Daumier knowingly do this? I think so, because the line in the dark shadow appears to be the edge originally planned. And notice how the diagonal motif is repeated rhythmically in the angled shadow edges of the bench. Even the nose of the judge at the right, together with the dark shadow in his hat, seem to continue at the same angle into his shadowed left side.

The geometric shape submotif of the rectangle shows up clearly in the shadow of the upper left of the picture and is echoed in the rectangular shapes in the lower left and in the bench.

The Lesson to Be Learned

The lesson to be learned is that *lights* can be focused for dramatic appeal on the center of interest. Yet the massing of the *darks*, covering about two-thirds of the total surface area, keeps the tonal relationships in balance.

Rembrandt's etching *The Flight into Egypt* (Figure 50) is another example of the light values focused on the figures. In this etching, the large mass of dark in the background suggests a dominant geometric curve, repeated in the outline of the extended arm and face of Joseph and continued in the shadow above. The submotif, in this instance, is the diagonal, again adding tension and movement. They are strongly visible in the figure of Mary. Both the left and right sides are diagonals, interlocked in a triangular pattern with the donkey. Other diagonals are repeated in the angled leg of the donkey and in the shadows at the lower left and bottom of the etching.

Once again, we can appreciate the strength and vitality of light and dark relationships when we compare Figure 50 with Rembrandt's sketch of the same title (Figure 51).

Figure 49. *(Below) Honoré Daumier: Déposition de Mineure. Pen and ink, 22 x 33.6 cm. Private collection, Paris. This is the first sketch in the series. It shows Daumier's freely expressed changes as he developed the many figures of his subject. Compare it with Figures 47 and 48.*

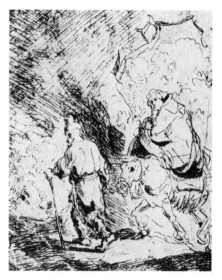

Figure 50. *Rembrandt van Ryn: The Flight into Egypt. Etching, 12.7 x 11 cm. Photo: Prints Division, The New York Public Library, New York. This is another example of light values focused for dramatic appeal on the figures that are the center of interest. Note that the massing of the darks, covering about two-thirds of the total surface area, keeps the tonal relationships in balance.*

Figure 51. *Rembrandt van Ryn: The Flight into Egypt: A Sketch. Etching, touched with pen and brown ink, 14.6 x 12.2 cm. Photo: Prints Division, The New York Public Library, New York. Compare this sketch with Figure 50 to appreciate the strength and vitality of light and dark relationships.*

Project 6: Turning Day into Night

The purpose of this assignment is to experience the mood and feeling of your image breaking through and taking form as you draw in light and dark.

The approach is to turn day into *night*—for the night is known for its moods ("The night has a thousand eyes and the day but one," writes Francis W. Bourdillon). The odds are that in thinking of night you'll turn on your imagination much faster than you might otherwise. Use the following suggestions to trigger your imagination:

Think of *sounds* in the night. The roar of the sea, as giant waves dash against the rock-bound shore, especially in a storm. The terrifying noise level of the hurricane. The weird, mysterious noises that arouse fear of the unknown as you walk through the woods. The baying of dogs in the distance. The "pitiful sound" of the wind through the trees. The foreboding, haunting fear of shocking violence to come. The shivering chill of the cold night. The suffocating gasps as you quicken your steps. Death.

And in strong contrasting moods,

the romantic moon. Love. The peace and stillness of the night. The soft tones of a flute floating over the hills. A Gregorian chant emanating from a monastery. The hustle and bustle of Broadway and city lights.

Figure 52 is an etching of a quiet scene in England. It's meticulously drawn with the fine point of a needle. However, our objective here is not to work with fine line. Just the opposite. We want the mood of the night, or after sundown, when, according to Walt Whitman, the time "for many strange effects in light and shade . . . give effects more peculiar, more and more superb, unearthly, rich and dazzling."

Create a Mood

Your instructions are:

1. Make a tracing of Figure 52 with an inkless ballpoint pen. Don't try to trace the fine details, only the larger shapes. Be sure to include the outline of the locks, however, since Egham Lock is the focal point of the picture.

2. Before you start to draw, sit down quietly and let your feelings about the night rise to the surface. Your specific task is to turn Egham Lock into a night scene of your own choice and mood. Don't try to reason it out. Wait until the mood develops within you.

3. If the mood doesn't come easily after a reasonable amount of time, there's no harm in starting to balance the light and dark relationships. In this way, you'll capture a mood while working. Very often the many gradations of light and dark, especially if massed, will inspire a mood as the drawing evolves.

4. Use a soft, #1 compressed charcoal stick, applying it broadside—except maybe in the framework of the lock or any other area that you wish to point up.

5. As you apply the charcoal broadside—adjusting harmonious value relationships as a whole—keep in mind the importance of constructing a strong, dominant geometric shape motif and contrasting submotifs.

6. If you're not happy with the result, or if you've an urge to improve the drawing, by all means do as many tracings as you like.

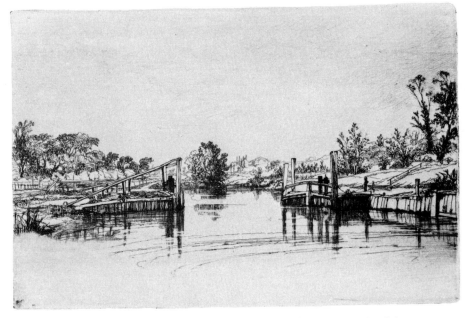

Figure 52. *Sir Francis Seymour Haden: Egham Lock. Etching, 5 15/16″ x 9″ (150 x 228.6 mm). The Metropolitan Museum of Art, New York. One way to inject mood and feeling into your compositions of landscapes is to turn day into night. This serves several purposes for beginners. It postpones working with line, which requires special training to attain sensitivity. Instead, you can transform large areas of the surface into massive shapes while striving simultaneously to balance light and dark relationships. To appreciate the mood captured by Sir Francis during such a procedure, compare Figure 52 with Figure 53.*

Case History 6: Haden

Egham Lock (Figure 53) is a mezzotint by Sir Francis Seymour Haden. Sir Francis was an English surgeon who took up etching at the age of forty for relaxation. Later he tried his hand at mezzotint.

Both etching and mezzotint are engraving processes. In the etching method, an etching needle is used to scrape out a design on a metal plate which has been coated with an acid-resisting ground. The plate is then immersed in acid, which eats into the metal where the ground has been removed, incising the image on the plate.

In the mezzotint method of engraving, a thin ridge is first made on a copper plate by roughening the whole surface. If printed at this point, it would be solid black. The image is then made by scraping away the burr with a many-toothed tool called a "rocker," to produce lighter tones. A pure white results wherever the original smooth surface of the plate is un-covered. The mezzotint produces a velvety, soft-toned effect.

I mention these processes to distinguish the composition of the etching of Egham Lock (Figure 52), which you traced in your assignment in Project 6, and the mezzotint of the same subject (Figure 53), both by Sir Francis. It's interesting to know that he reworked the etched copper plate of Figure 52 many years later to do the mezzotint

The Mood of the Night

Note how Sir Francis responded to the harmonious vibrations of light and dark shades as he turned day into night. Usually the warm passions and soul-stirring sensations from the recesses of the heart gush forth—provided we don't withhold or interrupt the flow and begin to think rationally during the creative period.

In the mezzotint (Figure 53), Sir Francis worked for shape relationships while striving to balance value relationships. Note the dominant geometric curve motif that extends the entire length of the scene, from left to right (or right to left). It stabilizes the whole picture. I suggest you turn the picture upside down; you'll see it more prominently that way. The curve motif is repeated very subtly in some of the tree tops. Contrasting sub-motifs of horizontals and verticals unify the whole.

The Lesson to Be Learned

The lesson here is that light and dark relationships represent one of the most artistic, compositional elements. Values, when harmonized as a whole, definitely intensify the mood and feeling of a drawing or painting.

Light and dark gradations are not restricted to night scenes. Although large masses of darks evoke expressive feelings as moods of the night, they function equally well for subjects in the daytime.

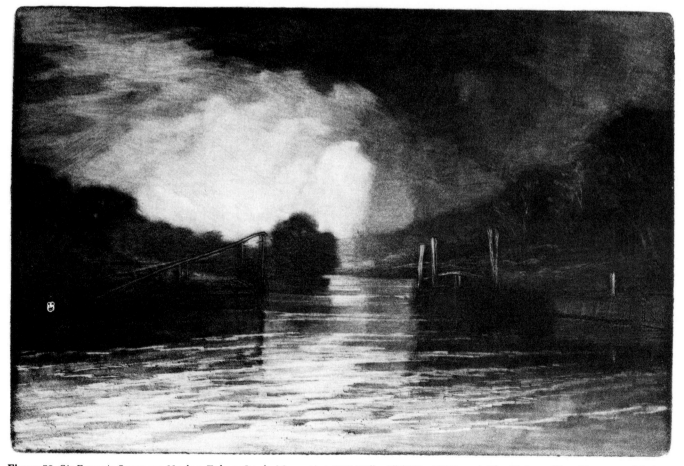

Figure 53. *Sir Francis Seymour Haden: Egham Lock. Mezzotint, 5 15/16″ x 9″ (150 x 228.6 mm). The Metropolitan Museum of Art, New York. Note how Sir Francis responded to the harmonious vibrations of light and dark gradations as he turned day (Figure 52) into night.*

Project 7: Developing Your Compositional Approach

This project has three objectives: the first is to spur you to express yourself with complete freedom as you develop your composition. I can't repeat the need for that too often. Aliveness of feeling and individual uniqueness will show up in your work only when you learn to express inner feelings spontaneously.

The second objective is to encourage you to discover *your* best method, or combination of methods, of approaching the composition of a drawing or painting. Since there's *no one* best method of approaching composition, you must find the one best suited to your own temperament. This will not be easy. It'll take time and require much experimentation.

The third objective is to apply all you've learned about establishing rhythmic relationships of two-dimensional shapes and light and dark values. Good composition requires that you check these relationships in every drawing or painting until they're integrated to the greatest degree possible.

The following assignment consists of three varied compositions.

Express Yourself

Here are your instructions:

1. Use a #1 soft charcoal stick on 18″ x 24″ (457.2 x 609.6 mm) charcoal paper as follows:

Set up your own still life. Keep the objects simple. As an example, study Figure 54. It's *Still Life with Bottles* by the Italian painter Giorgio Morandi. He spent many years of his life painting variations of bottles and the like—but with what care and appreciation for spatial and tonal relationships!

Don't copy or trace Figure 54. Set up a combination of objects that appeals to *you*. Take plenty of time as you draw. Try to be as sensitive as you possibly can. Pour your emotions over the entire surface, not merely over the subject matter. Avoid getting bogged down in meticulous details. Keep the total effect in view at all times.

2. *Do a landscape or seascape from imagination or memory.* Study Figures 55 and 56, two versions of *Toilers of the Sea* by the American artist Albert P. Ryder. They're unusual examples of mood and feeling, plus an artistic structure of shapes and tonal values. Note especially how simple the shapes of the boats and clouds are, yet how dynamic the overall effect is.

3. *Start without a preconceived idea of what the subject will be.* Use the flat, broadside of a #1 compressed charcoal stick, and make large, massed shapes at random. Keep harmonizing the light and dark shapes over the entire surface as you work. Vary the size of the shapes. Use a soft cloth to spread lighter areas of various degrees of gray around and between the large dark shapes. Do this by rubbing in gently, while scanning the whole at every step. Let down as much as you can during the process to permit your intuition to function freely.

Figure 54. *(Left) Giorgio Morandi: Still Life with Bottles. Oil on canvas, 11 3/4″ x 11 3/4″ (298 x 298 mm). Gallery of Modern Art, Edinburgh, Scotland. Note Morandi's expressive power and his care and appreciation of spatial and tonal relationships.*

Figure 55. *(Above right) Albert P. Ryder: Toilers of the Sea. Oil on wood, 11 1/2″ x 12″ (292 x 304.8 mm). The Metropolitan Museum of Art, New York. This and Figure 56 illustrate two versions of the same title by Ryder.*

Figure 56. *(Right) Albert P. Ryder: Toilers of the Sea. Oil on canvas, remounted on board, 10″ x 12″ (254 x 304.8 mm). Addison Gallery of American Art, Phillips Academy, Andover, Massachusetts. This is another version of Figure 55. Observe how the night scene diminishes the need for detail.*

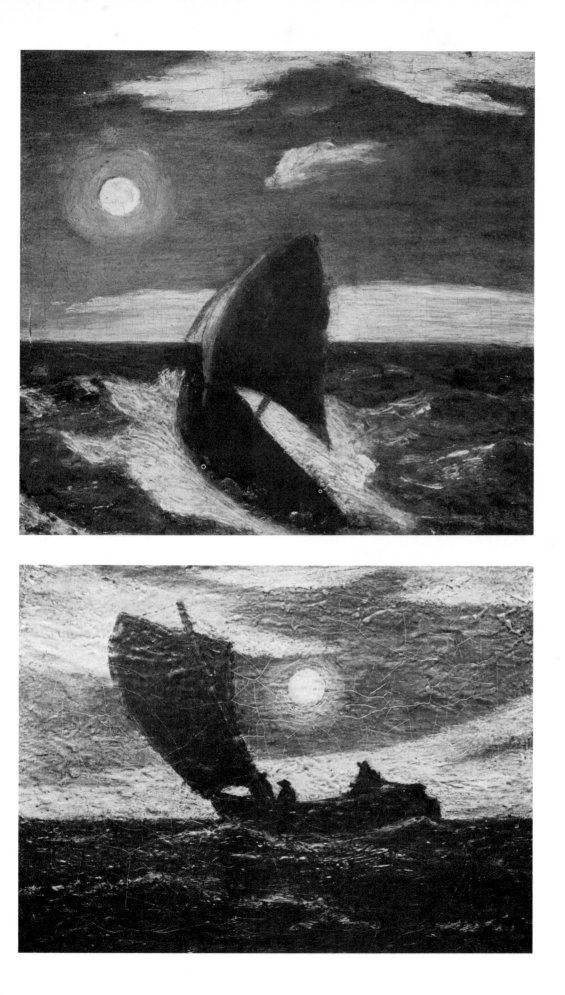

Figure 57. *Ilva Youle: Two Kings. Casein on composition board, 18″ x 24″ (457.2 x 609.6 mm). Collection of the artist. By working intuitively, as Youle did here, you'll find that some unexpected exciting subject will emerge. Youle's subject is a mystery here. Is it a single or double image of an old king?*

When your picture is in balance, for both shape and light and dark value relationships, view the picture from all sides to see what subject it suggests, a subject that requires very little correction. If a subject doesn't appear, continue to add more shapes or even erase certain shapes. Then follow through the whole procedure again. If nothing interesting evolves, make a completely fresh start. By working intuitively, you'll find that some unexpected, exciting subject will emerge.

This is how American artist Ilva Youle works. Her subject in Figure 57 is a mystery. Is it a single or double image of an old king? When I asked her, she said, "To tell the truth, I don't know. Sometimes I see it as one king. At other times, *Two Kings,* the title I finally gave it. But what's in a name?"

The method used by Ilva Youle is not unusual. Many artists follow it with variations. Depending upon your courage, it may frighten you or free you. You may consider such a method too bold and too modern. Yet the idea is an ancient one. Even Leonardo da Vinci in the 15th–16th centuries used the shapes of clouds and the stains on old walls to spur his imagination.

Kenzo Okada, a Japanese artist now living in New York, says, "Start painting with nothing and let it grow." Note how in his *Plum Tree* (Figure 58), the artist's subconscious has become deeply involved with the symbols of nature—the mist, trees, and landscape of his native country.

Figure 58. *Kenzo Okada: Plum Tree. Oil on canvas, 81 1/4″ x 70″ (2,062 x 1,778 mm). Collection of Mr. Jack J. Dreyfus, Jr., New York. Okada says, "Start painting with nothing and let it grow." As in this painting, note how his subconscious becomes deeply involved with the symbols of nature—the mist, trees, and landscape of his native country.*

Case History 7: Corot, De Martini, Feininger, Turner

Although you don't need a particular approach to begin composing pictures, some methods may be more productive for you than others. The basic question is how to start. Do you need to be in *front* of a still life, landscape, or seascape, as most amateurs do?

To make *esthetic* and *creative* drawings or paintings from real life objects or scenes is very difficult for beginners, who are constantly worried about their lack of technical skill. As they try to compensate for this lack, sensitivity goes down the drain,

producing results that are usually labored and rigid.

Assuming this is not your problem, there can still be plenty of others. In one form or another, they are related to the lack of ability or the omission of some vital factor in the integrative process.

Looking directly at three-dimensional subject matter simply places an extra burden on beginners. It is difficult enough to be expressive while simultaneously organizing structural relationships rhythmically on a two-dimensional surface. Unlike profes-

sionals who've learned how to use models as a springboard to personal achievement, amateurs seem to overlook one basic ingredient during the process: *imagination*. By that, I mean images characterized by exaltation of mood.

Why not place an *emphasis* on developing your imagination? Yes, even if it means that the subject matter may lack accuracy if you don't look at it directly.

That's why, in the second part of Project 7, you were asked to choose a subject directly from your imagination or memory. And in the third part, that's why you were asked to let the subject unfold in the course of working the shapes and values, without preconceived ideas of subject matter.

Be Ready to Accept a Change of Mood

As you develop your imagination, your unconscious, with its tremendous memory bank of accumulated experiences, may release a mood that you do not expect. It may be contrary to the specific mood and meaning you wish to convey. This is just another complexity that every professional faces in composition.

You may be disturbed, for example, because you start with the mood you want and suddenly discover it has vanished. Is this due to lack of ability? Not necessarily. Even the great Picasso, wishing to express his horror at the bombing of the helpless inhabitants of Guernica during the Spanish Civil War, couldn't do so without making a long series of sketches. Not only were there changes in spatial and light and dark relationships, but in realigning and changing the symbolic characters. The meaning and feeling of the whole kept changing—until finally, in the mural, every compositional problem was resolved.

Sharpening Your Visual Power to See

No matter which pathway to composition you choose, your results in

Figure 59. *Jean-Baptiste-Camille Corot: The Forest of Coubron. Charcoal on white paper, 17" x 11 3/4" (431.8 x 299 mm). Fogg Art Museum, Harvard University, Cambridge, Massachusetts. The light and dark values here are beautifully harmonized throughout. Compare this drawing with Figure 60.*

drawing or painting will probably show up in one of three forms: an easily recognizable subject, a vague suggestion of subject matter, or nonobjective composition—that is, a picture without naturalistic or recognizable forms.

I've chosen illustrations of the first two categories (the last will be discussed and illustrated at a later stage). They show the results of various artists who used the approaches you experimented with in Project 7. Study their work. It should be helpful in a number of ways: to confirm the best approach to composition for you and to break down conventional thinking and open up new areas of thought about the treatment of subject matter in your own work.

More specifically, since the development of imagination is so important, keep improving your visual perception. Don't hurry or press yourself mentally while studying the illustrations. Let your subconscious have its way. Let it mobilize and line up your inner powers to bring out deeper visual insight. As you know, imagination and memory evoke feelings and sensations. These are enhanced in composition by working for shape and value relationships. Improvement in these areas takes place as you sharpen your visual power to see.

Let's begin with an unusual opportunity to see how shape and value relationships are improved. Compare the drawing with the painting of *The Forest of Coubron* (Figures. 59 and 60), by the 19th-century French artist Jean-Baptiste-Camille Corot. The drawing, I believe, was made on the spot—the painting, in his studio.

Following the 18th-century classical landscape, the drawing (Figure 59) is both delicate and lyrical. The light and dark values are beautifully harmonized throughout. Despite concentration on a shimmering, misty quality in his technique, Corot hasn't sacrificed the composition. The schematic diagram (Figure 61) shows how carefully he structured two-dimensional space with geometric motifs of triangles, verticals, and arcs in sensitive relation to the whole. Altogether, the drawing is a delight to the eye.

Yet it's only when we study the painting (Figure 60) in relation to the drawing that we realize the great improvement in light and dark relationships. He anchored his strongest darks first. Then he carefully established about twenty gradations as he worked from dark to the brightest light, keeping his eye on the entire canvas at every step.

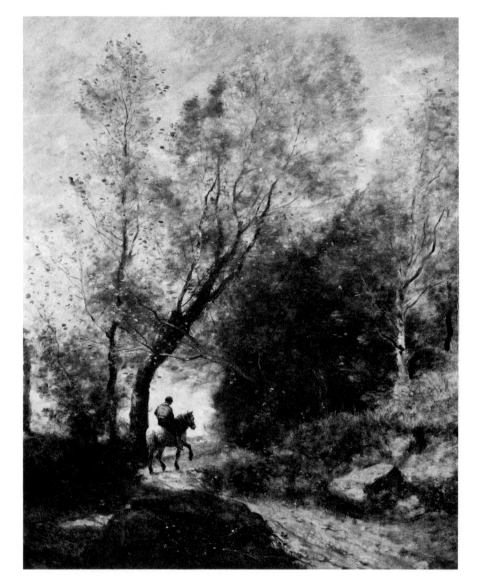

Figure 60. *(Above) Jean-Baptiste-Camille Corot: The Forest of Coubron. Oil on canvas, 37 3/4" x 30" (959.3 x 762 mm). National Gallery of Art, Washington, D.C. When we study the painting in relation to the drawing (Figure 59), we realize the great improvement in light and dark relationships. Now study them both upside down to see the improved shape relationships.*

Figure 61. *(Left) Schematic diagram showing how carefully Corot structured two-dimensional space with geometric motifs of triangles, verticals, and arcs in sensitive relationship to the whole.*

Note how he reduced the light to a minimum. With the sky and the roadway darkened, the horse and rider now stand out in sharper contrast to the focus of light behind them.

Compare the painting and drawing upside down. Surprised? The shapes that seem so satisfactory in the drawing now appear weak. The shapes in the painting are much more clearly defined and strongly felt. The shape motifs have changed somewhat during the process, as certain areas receive more decided darks. However, the shapes are now more subtly related and the underlying geometric structure more solid than in the drawing. This proves, once more, that improvement in light and dark tonal values should and can be coordinated with improvement of shape relationships.

The next example is by American artist Joseph De Martini. He, too, started his preliminary sketch directly from nature. I was with him at one of the numerous quarries in Cape Ann, Massachusetts, where rock formations gripped his attention. He wasn't using the physical eye to depict the external appearance of the rocks. Rather, he felt emotionally, the textural quality, strength, and solidity of the large boulders.

In his painting, *Quarry* (Figure 62), he captured the essence of these qualities. How? By rearranging and simplifying the shapes while simultaneously working for harmonious tonal relationships.

It's interesting to note that the result is *almost* completely abstract. This kind of painting is often called "near-abstract."

Lyonel Feininger is another Ameri-can artist who started his preliminary sketches from nature. In his *Dunes with Ray of Light II* (Figure 63), the painting as a whole is almost completely abstract, except for two tiny figures at the bottom. Do you feel the emotional force in the large sensitive shape relationships? Do you feel the mood created by the subtle light and dark relationships?

You may think that near-abstract painting is a product of 20th-century modern art. If so, consider the secret work of the 19th-century English artist J. M. W. Turner. Working from his imagination and memory, he concealed most of his work painted during the last twenty years of his life. He was only too aware that it was far beyond the comprehension of his contemporaries. Here are two examples. *Snow Storm: Steamship off a Harbor's Mouth* (Figure 64), painted in 1842, is as forceful and fanciful as many a modern painting today. It's practically all feeling and structure. His painting, *Margate from the Sea* (Figure 65), painted between 1835 and 1840, appears to me even more audacious. In both paintings, study the shape and tonal value relationships, for without them the paintings would fall apart in chaos.

Reminders

Here are some reminders:

In developing your composition, don't get deeply involved in improving the details of any subject matter. It's easy to become trapped in that, especially when the subject excites you.

Work with fervor, even when you don't begin with a specific sense of procedure. Emotion must be present in your work at all times.

In freewheeling, remember that you *do* have a means of controlling your composition. No matter how you start to work, shape and value relationships must be stabilized.

Improvement in composition will take place only as you sharpen your visual power to see. Get into the habit of analyzing all paintings.

Finally, one of the most important principles to be aware of is described by the English sculptor, Reg Butler: "Above all, while you work, do not allow yourself to visualize your final result, for to do so will inhibit your powers of discovery."

Figure 62. *(Above right) Joseph De Martini: Quarry. Gouache, 18" x 27 1/2" (457.2 x 698.8 mm). Addison Gallery of American Art, Phillips Academy, Andover, Massachusetts. De Martini captured the essence of the textural quality, strength, and solidity of the large boulders here. He experimented by rearranging and simplifying the shapes while simultaneously working for harmonious tonal relationships. The result is called near-abstract.*

Figure 63. *(Right) Lyonel Feininger: Dunes with Ray of Light II. Oil on canvas, 20" x 35" (508 x 889 mm). Albright-Knox Art Gallery, Buffalo, New York. This painting is almost completely abstract, except for two tiny figures at the bottom. Do you feel the emotional force in the large sensitive shape relationships? Do you feel the mood created by the subtle light and dark relationships?*

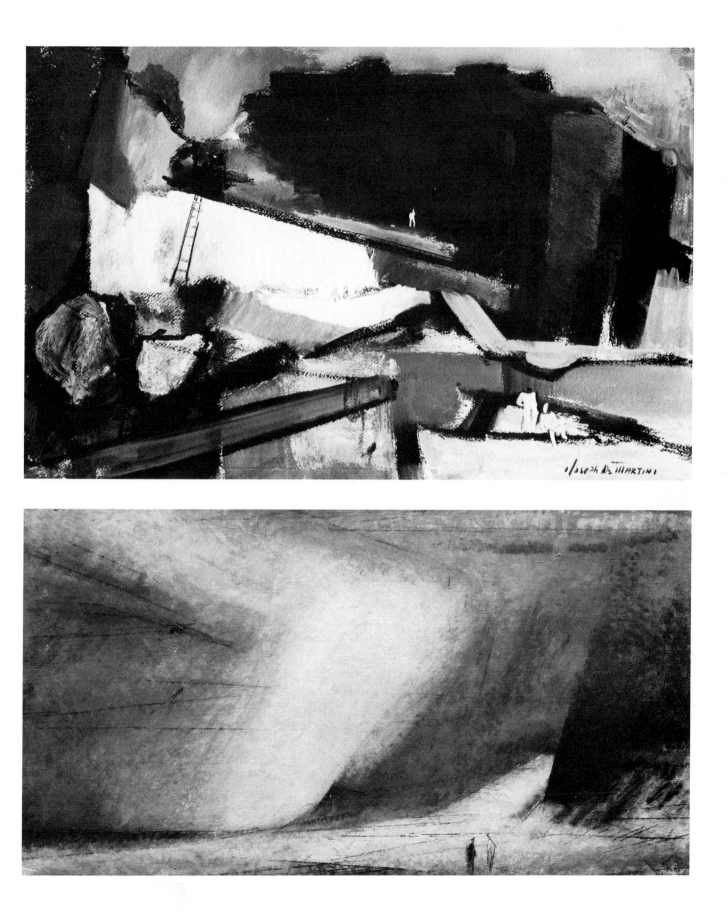

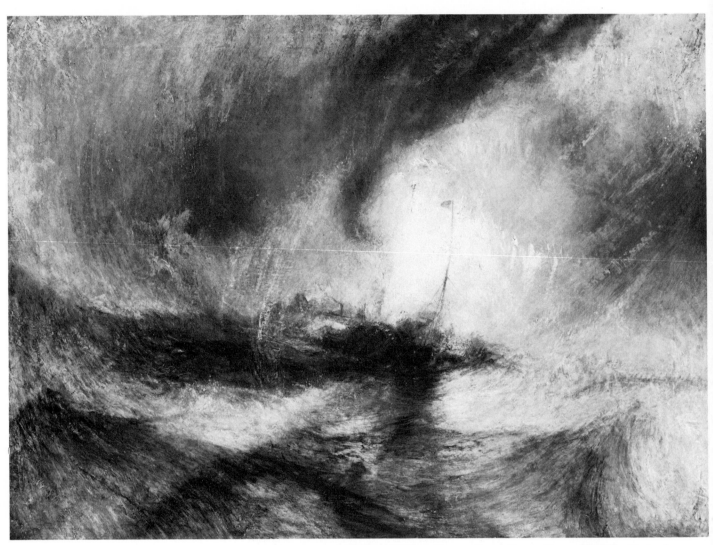

Figure 64. *Joseph Mallord William Turner: Snow Storm: Steamship Off a Harbor's Mouth. Oil on canvas, 36" x 48" (914.4 x 1,219.2 mm). National Gallery of Art, London. Working from his imagination and memory, this 19th-century artist actually concealed most of his work painted during the last twenty years of his life. He was only too aware that it was far beyond the comprehension of his contemporaries.*

Figure 65. *Joseph Mallord William Turner: Margate from the Sea. Oil on canvas, 36″ x 48″ (914.4 x 1,219.2 mm). National Gallery of Art, London. Both this painting and Figure 64 are as forceful and fanciful as many a modern painting today. They're practically all feeling and structure. This one, painted earlier than Figure 64, appears even more audacious. In both cases, study the shape and tonal value relationships, for without the artist's attention to them the paintings would fall apart.*

Negative Space

3

From my experience in analyzing thousands of drawings and paintings by novices, I'm certain that most compositional problems stem from not using negative space.

The term *negative space* means background space. It's called negative to distinguish it from the *positive* subject matter that occupies the center of interest.

Another way of identifying the various shapes of subject matter is to refer to each of them as a *figure*, surrounded by an unoccupied area that is called the *ground*. As an example, the *negative space* or *ground* in Figure 66 is the unoccupied portion of the picture.

Space, whether in *figure-ground* or *positive-negative* areas, is defined here as two-dimensional. *Shape*, which encloses space within designated edges or lines, is also two-dimensional.

The Term "Negative" May Be Misleading

The term *negative* may confuse some readers because it *implies a lack* of importance, perhaps. Yet shapes in the negative area have distinctive characteristics of their own, equal in importance to shapes in other areas.

It's not difficult to identify negative areas. The real problem is to grasp their significance and to give them attention in practice. From force of habit, you'll pay more attention to the shapes of the subject matter than to shapes in the negative area. It takes a great deal of determination and a relaxed frame of mind to focus on negative shapes as well as subject matter.

To give them equal emphasis, you'll need to *appreciate* negative shapes. Otherwise, you may relate them to all other shapes in a perfunctory manner.

How do you go about heightening your appreciation? Perhaps a statement by the late philosopher Alan Watts may help you realize the importance of negative shapes. He once said to me, pointing to a cup of coffee, "You can never have the use of the *inside* of a cup, without the *outside*. The inside and the outside go together. They're one."

An obvious truth, you say. So what? Stop a moment and think about it. While we're drinking the contents, the outside of the cup doesn't exist in our consciousness. It's "negative" in relation to the "positive" use of the cup's inside. But that's just the point: it isn't negative. The outside is a *vital, integral* part of the whole cup, which can't really be divided into positive and negative parts.

The same holds true for the negative background, the open space in Figure 66. It's not *really* negative. The picture couldn't exist within its rectangular frame without it; it is an integral part of a unified whole. Negative space requires the *same* degree of attention and concentration that's given to positive subject matter. No more, but emphatically no less.

The Nature of Open Negative Space

The nature of open negative space poses a special problem: the ever-present danger that large open areas will give the feeling of being "empty." Yet there's something very attractive about keeping negative space uncluttered—even though it may be extremely difficult to bring it into balance with the rest of the painting.

Figure 67, an ink painting by the Japanese artist of the 16th–17th centuries, Miyamoto Musashi, called *Hotei Watching a Cockfight*, is an excellent example of sensitive balancing of open negative space on all four sides.

The masters of Oriental art are world famous for their special genius in the sheer manipulation and balancing of open negative space.

The secret of their unerring placement of positive shapes in completely open negative space lies in the tranquil attitude of the artist and in his training to absorb the whole surface area of the paper at a glance. Oriental artists are known not only for their intuitive placement but also for their skill in controlling line and texture with dispatch. (The latter will be discussed in Chapter 8.) Novices should

Figure 66. *Seido Iwata:* Flower Arrangement—Irises. *The negative space or ground is the unoccupied portion of the picture. Photo: Paul Juley, New York.*

Figure 67. Miyamoto Musashi: Hotei
Watching a Cockfight. Kakemono, ink
on paper, 28 1/8" x 12 1/2" (460.5 x 317.8
mm). Collection of Mr. Yasuzaemon
Matsunaga, Kanagawa, Japan. This is
an excellent example of an ink painting
showing sensitive balancing of open
negative space on all four sides. The
masters of Oriental art are world fa-
mous for their special genius in the sheer
manipulation and balancing of open
negative space.

This work was included in the out-
standing Art Treasures from Japan Exhi-
bition shown during 1965–1966 in the
United States at the Los Angeles County
Museum of Art, Detroit Art Institute,
and Philadelphia Museum of Art, and in
Canada at the Royal Ontario Museum
in Toronto.

The catalog describes the painting
and artist as follows:

"Miyamoto Musashi, also known as
Niten, was a samurai whose prowess as
a swordsman was legendary. He was
also known for his artistic talent. His
ink paintings are marked by a very per-
sonal style, noteworthy for strong
brushstrokes. His manner is somewhat
akin to that of the Chinese artist, Liang-
K'ai in the dynamic use of few, expres-
sive lines.

"Hotei, popularly considered one of
the Seven Gods of Good Fortune, is
shown here as a zen priest, attaining en-
lightenment while watching a cock-
fight."

Figure 68. *Vincent van Gogh: Irises. Oil on canvas, 36 1/4″ x 29″ (920.9 x 736.6 mm). Bemeente Musea, Amsterdam, Holland. Van Gogh controlled the open negative space by making it an integral part of the larger geometric motif—the dynamic diagonal.*

avoid compositions like Figure 67 that require balancing large, open negative space. But do study and appreciate paintings like it. If you insist on trying your hand, I have one suggestion: balance the open space by *cropping*, as described in Chapter 1.

Turning Open Negative Space into Closed Geometric Shapes

Most open negative space compositions don't lend themselves to the solution in Figure 67. Instead, the negative space needs to be broken up into two-dimensional geometric shapes and integrated with the balance of the picture—usually with geometric shapes of the subject matter. This way, open negative space is turned into *closed shapes* and structured as part of the dominant or contrasting geometric shape motifs.

Look at Figure 66 again. It's a photograph of a beautiful Japanese flower arrangement of irises by Seido Iwata. However, the sensitivity of this arrangement is lost the moment it's reproduced as a painting. Why? Unlike Figure 67, the open negative space surrounding the flowers and vase on four sides is unrelated to the whole two-dimensional surface of the photograph. The flower arrangement was designed for three-dimensional enjoyment in three-dimensional space.

Compare it with van Gogh's painting *Irises* (Figure 68). We see that van Gogh closed off the open negative space by extending the stems and flowers to the edges of the painting. In doing so, he controlled the open negative space by making it an integral part of a larger geometric motif—the dynamic diagonal. It's repeated again and again. One diagonal sweeps from the upper left-hand corner down to the right-hand corner of the painting. Another diagonal extends from the vase to the upper right. Additional small diagonals make the flowers appear as a diamond shape.

Some of the stems in Iwata's arrangement extend, but they don't form any dominant geometric motif. This leaves the negative space unstructured. In contrast, van Gogh's painting has completely structured two-dimensional shape relationships. The diagonal stems are so forceful that they carry the eye beyond the edges of the painting to form a large inverted triangle. The diamond shape of the flowers creates smaller triangles *within the negative space*. These are shown in the schematic diagram (Figure 69). Also illustrated in the diagram are repetitions of the rectangular sub-

Figure 69. *Van Gogh's painting (Figure 68) is completely structured in two-dimensional shape relationships. The diagonal stems are so forceful, they carry the eye beyond the edges of the painting to form a large inverted triangle. The diamond shape of the flowers creates smaller triangles within the negative space. Observe them in this schematic diagram as well as repetitions of the rectangular submotif, and examples of the curve submotif.*

motif as well as examples of the curve submotif.

Closure

Previously, I said that van Gogh closed off the negative space in *Irises* by extending the stems to the edges. Actually, if you look closely at the upper left-hand corner of Figure 68, you'll find that the stem does *not* touch the edge. Instead it tapers off in another direction. Nevertheless, the diagonal is so strong that it *feels* as if it not only touches the edge but continues outside the painting to form part of the triangular pattern.

Even though a portion of the pattern is missing, the phenomenon of "closure" take place in visual perception. At what point in negative space does closure take place? How closely must the line or edge bordering a two-dimensional shape come to give the effect of closure? There are no rules; it

must be felt. And it can be tested. Observe Iwata's photograph (Figure 66). The stems that shoot upward and to the right, for example, are definitely not long enough to form closure, whereas the stem that extends toward the lower left-hand *almost* makes it. It probably requires an extra quarter inch. Test it yourself by extending the stem until you reach the point of closure.

Finding the point of closure, in this instance, isn't enough. It doesn't completely solve the larger problem of turning the open negative space into closed geometric shapes and rhythmically relating them to the whole.

Closure can be effected, not only through the extension of line, but through color, texture, and light and dark values. As one example, note how Cézanne, in his painting *Vase of Tulips* (Figure 70), slightly *darkened* the upper left-hand corner to effect closure.

Figure 70. *Paul Cézanne:* Vase of Tulips. *Oil on canvas, 23 1/2″ x 16 5/8″ (597.2 x 420 mm). The Art Institute of Chicago, Chicago. Note how Cézanne slightly darkened the upper-left corner here to effect closure.*

Another Example of Closed Negative Shapes

To broaden your understanding of closed negative shapes and how they are integrated, let's look at another painting by van Gogh, *The Chair and the Pipe* (Figure 71).

Like Figure 67, the subject matter is surrounded on all four sides by negative space. Unlike Figure 67, however, the negative space has *not* been left open. Nor did van Gogh, as in Figure 68, extend positive shapes of the subject matter to the edges of the painting to effect closure and thus structure the negative space. Instead, the positive shape of the chair is surrounded on all four sides by *many* closed geometric negative shapes—the door, wall, box on the left, and the floor tiles. Don't overlook the small closed negative shapes between the rungs of the chair, above and below.

Note how the painting is dominated by the geometric vertical motif in the supports of the chair. The vertical is repeated in the three areas to the right of the chair—one vertical between the chair and the door, two vertical shapes within the door. Equally important, they vary in width and in light and dark relationship. Note, too, how the vertical shape of the hinge on the door is echoed in the small, narrow area between the chair and the box on the left. Both are about the same size, one light and the other dark.

The diagonal submotif contrasts strongly with the upright, stable motif of the vertical. The diagonals in the chair—due to its angled placement—make this an extraordinarily vital composition.

In passing, note the distortion in Figure 71. Observe the two front legs of the chair. One leg has been brought forward dramatically. Van Gogh did this by making it much longer than the other. This is an exaggeration of perspective. Normally, the right leg would be shorter because it's farther back. In this instance, however, the difference in size is exaggerated purposely.

Figure 71. *(Right) Vincent van Gogh:* The Chair and the Pipe. *Oil on canvas, 36 1/8″ x 28 3/4″ (917.6 x 730.7 mm). The Tate Gallery, London. The "positive" shape of the chair is surrounded on all four sides by many closed geometric negative shapes—the door, wall, box on the left, and floor tiles. Closed geometric negative shapes play an important part in the integration of all two-dimensional surface shapes.*

Another distortion in perspective is in the floor tiles. Follow the perspective of the large tile in the lower right as it proceeds under the chair to the left. The tile at the extreme left is much too small, in normal perspective, in relation to the large tile. Nevertheless, all such distortions add another dimension of tension and dynamic vitality to a painting.

To summarize, then, closed geometric negative shapes play an important part in the integration of all two-dimensional surface shapes. They have the following characteristics in common: they're varied—no two are alike in size or shape; and they're related to one another and to the whole. These characteristics apply to the very small closed negative shapes as well—as, for example, between the rungs of the chair, above and below, in Figure 71.

These relationships can always be tested. If in doubt, block out any questionable shape and look at the remaining painting as a whole. Then unblock it and see whether you feel better with the shape in the painting. If not, change the shape according to your feelings.

Figure and Ground

Earlier, I suggested that negative or ground space is extremely difficult to relate esthetically to the rest of the painting if it is left open. With few exceptions, it may give the feeling of being empty.

Certainly, one does *not* get that feeling in Figure 67. Nor do the *figures* in Figure 67 appear to jump out and create unrelated holes in the picture. In this case, the figure-ground relationship is superb. It's delicately balanced in relation to the four edges of the rectangular-shaped paper.

In many cases the figure-ground relationship cannot be avoided. Fortunately, it takes place within only *part* of a picture—often within comparatively small shapes—thus making the open space within these small shapes easier to balance.

In Figure 67, the action takes place within the geometric shape of the rectangle. However, the figure-ground relationship may take place within a *variety* of geometric shapes—for example, within an oval, circle, or triangle. Regardless of which *kind*, the geometric shape may be located *anywhere* in a picture—in the negative area, as well as the positive. No matter where it's located, a *figure* placed within the open space—the *ground*—of any two-dimensional geometric shape must be related sensitively to that shape and all shapes in the picture.

This is illustrated in van Gogh's painting (Figure 71). His placement of the pipe and crumpled paper containing the tobacco within the caned triangular-shaped part of the seat forms the figure-ground relationship. The pipe and crumpled paper are each *figures*. The area within the caned seat is the *ground*. Because the open space is small in both these figure-ground relationships, the harmonizing of the *ground* surrounding the two-dimensional shapes of the figures presents no real problem.

Another example that illustrates more difficult figure-ground problems is Rembrandt's *The Artist in His Studio* (Figure 72). Here both the artist and the easel occupy the center of interest, with the latter dominant.

When I first saw this small painting, I remember being disturbed by the size of the easel. It appeared to overwhelm the composition. Years later, I learned that some of Rembrandt's paintings, including this one, had been cut down by others long after they were painted.

Luckily, a photograph shows the painting before it was cut at the top and bottom in 1925 (Figure 73). What a difference the extra spatial dimensions make! And how the additional closed rectangular shapes in the upper background help the triangular motif of the easel! Squint your eyes as you compare the pictures to see how much better the light and dark relationships are in the uncut painting.

Note the placement of the painter's palette on the wall. The palette is *figure*, surrounded completely by the wall as *ground*. Note the placement of the easel and the artist in their figure-ground relationship to the open wall area. Unlike the palette, both easel and artist are surrounded on only three sides by ground space. The same applies to the jugs on the left. You'll find that most *figures* are surrounded on one or more sides by open *ground*.

Until you learn to paint like the Oriental artists, make trial cutouts of the positive *figure* shapes and move them around within the area of *ground* space, until you find the most satisfying relationship.

A final word on negative space: if possible, use closed geometric shapes structured to the rest of the painting.

Figure 72. *Rembrandt van Ryn:* The Artist in His Studio. *Oil on panel, 10" x 12 1/2" (254 x 317.8 mm). Museum of Fine Arts, Boston. Note the placement of the painter's palette on the wall. The palette is* figure, *surrounded completely by the wall as* ground. *The wall, in this instance, is open space. Note also the placement of the easel and the artist in their figure-ground relationship to the open wall area. Unlike the palette, both easel and artist are surrounded on only three sides by ground space.*

Figure 73. *Rembrandt van Ryn: The Artist in His Studio. Oil on panel. Museum of Fine Arts, Boston. Photo: Frick Art Reference Library, New York. The photograph shows the painting before it was cut down at the top and bottom in 1925 (Figure 72). What a difference the extra spatial dimensions make! And how the added rectangular closed shapes in the upper background now help to accept the triangular motif of the easel. Finally, how much better the light and dark relationships are as a whole.*

Project 8: Redesigning Unstructured Negative Space

Figure 74 is a photograph of painting called *The Coming Away of the Gale* by the American artist Winslow Homer. This version of the painting doesn't exist any longer, having been almost completely repainted and improved by Homer years after it was originally painted.

Your general objective in this project is to redesign the composition and make it a more powerful and better balanced picture.

Although Figure 74 was painted by a famous artist, I'm sure you'll see that the main problem is to integrate the unrelated open areas with the rest of the painting. Your specific assignment is to solve this problem by turning the open *unstructured space* into *structured geometric shapes*.

Structure Shapes

Here is your assignment:

1. In redesigning the composition, retain the mother and child exactly as they are. Consider them the dominant interest.

2. Start by tracing the photograph, outlining the shapes. Indicate the outside dimensions by outlining the four edges.

3. Study the photograph carefully. Test the outside dimensions by narrowing them on four sides, until you arrive at the best possible overall spatial relationships.

4. Check for the dominant geometric shape motif. If it's weak, strengthen it by rearranging, eliminating, or changing shapes (except those of the central figures).

5. Introduce one or more contrasting motifs to give the composition more variety.

6. Use a 5B or 6B black pencil, or a very soft, #1 charcoal stick, and work at the same time for balanced light and dark relationships. Don't think about it; just work intuitively.

7. If you're not certain of your next step, or if you lose interest, stop and rest a while. Then once again study your drawing for shape relationships and light and dark balance.

8. Don't hesitate to do the drawing over again on another sheet, especially if you like certain parts that you might spoil if you continue.

9. Put all your feelings into it. Go as far as you can to make it a vital, sensitively spaced, unified picture.

Figure 74. *Winslow Homer:* The Coming Away of the Gale. *Oil on canvas. Photo: The Winslow Homer Collection, Bowdoin College Museum of Art, Brunswick, Maine. This version of the painting doesn't exist any longer, having been almost completely repainted and improved ten years later.*

Case History 8: Homer

The Gale (Figure 75) was painted by the American artist Winslow Homer ten years after his *The Coming Away of the Gale* (Figure 74). Since Homer painted *The Gale* over the old canvas, we can only see the latter in a photograph. But what a wealth of visual information the photograph contains!

By comparing the photograph with Figure 75, we can appreciate the great progress Homer made in composition during the ten-year interval. Of those compositional elements we've discussed, we can deduce that he had learned the following: the control of open ground space, the establishment of a major two-dimensional geometric shape motif and contrasting submotifs, the balancing of light and dark, and the importance of strongly felt inner expression.

Notice that in Figure 75 he kept the general shape of the foreground, but he substituted rocks for the boat. However, the center of interest remains the same: the mother and infant are exactly as in the original pose. But the mood of the picture has changed. He was thinking of Prout's Neck, Maine, not Tynemouth, England, the scene of the original. Most important, he had learned to integrate all the elements into a unified whole, creating a work of art of elemental force and feeling.

How Homer Improved His Composition

To improve his composition, Homer first tested the outside dimensions, no doubt taking his time in this vital step. Notice, in the overlay (Figure 76), how much of the original canvas he then removed. With the narrowed proportions more attuned to his advanced and experienced sense of space, he cut down all four sides of the new painting.

Next, by introducing the horizon, he established the rectangle as his main geometric motif. He then proceeded to space the new surface area of the canvas intuitively, until he created a variety of rectangles, related to each other and to the whole. Don't underestimate this procedure. It establishes the underlying structure that gives the painting its solidity and strength.

The diagram (Figure 77) outlines the rectangles and shows how Homer used one side of the figure and one side of the spray to establish smaller rectangles as rhythmic relationships.

Note, too, how the spray serves another purpose. Homer turned the

Figure 75. *Winslow Homer: The Gale. Oil on canvas, 30 1/4″ x 48 3/8″ (768.5 x 1,229 mm). Worcester Art Museum, Worcester, Massachusetts. By checking this painting against Figure 74, we can appreciate the great progress Homer made in composition during the ten-year interval.*

Figure 76. *How Homer proceeded to improve his composition is clear from this overlay. With narrowed proportions more to his advanced and experienced sense of space, he cut down all four sides of the painting (Figure 75).*

Figure 77. *By introducing the horizon, Homer established the rectangle as his main geometric motif. The diagram outlines the rectangles and shows how Homer used one side of the figure and one side of the spray to help establish smaller rectangles as rhythmic relationships. The lesson to be learned is to turn large open negative space into structured geometric shapes.*

spray into a large arc as a contrasting submotif. This submotif is repeated in many unexpected places in the painting, which you can find by turning the picture on each of its four sides.

A strong second submotif is the diagonal in the rock ledges. This is repeated in the water at the right. Observe how the latter edge of dark against light serves a double purpose. Not only is the water edge, *as a whole,* a diagonal related to the motif of the rocks, but the scalloped arcs within it are related to the series of small curves at the right of the dress.

While he established shape relationships, Homer worked to improve tonal relationships. Study the difference in light and dark relationships between the old and the new painting. Homer varied his values much more dynamically in the later painting. He used a wide range of tones, from very light to darkest dark.

Note the foreground pier in Figure 75, for example: the contrast of dark in the pier against the light of the water. Note also the number of varied accents of light and dark within the pier area.

Notice how much more imaginative and forceful the broken edge of the pier appears in Figure 75, compared with the pier in Figure 74. The latter, with its uninteresting straight edge, was probably painted exactly like the real pier. On the other hand, the geometric shapes in the broken edge are rhythmic echoes of similar shapes in other parts of the painting.

Study, also, the strong dark in the figure and the extreme dark in the rocks in contrast with the light in the water next to them. Despite the strong contrast, the darks hold their own and don't jump out of the picture.

Why is this? Cover up the sky area and look at the rest of the painting. The latter is now *out* of balance. It needs the *degree* of dark placed in the sky to balance the whole painting—the sky area is almost as dark as the foreground pier.

Now let's look at the negative space in the sky area. Is it empty? Definitely not. Homer's strongly structured geometric shape relationships in Figure 75 *automatically* solve the negative space problem so evident in Figure 74. The very little variation of light and dark needed within the negative space of the sky area proves this. Here, Homer didn't need to use a variety of values to unify the negative space.

The Lesson to Be Learned

The lesson to be learned is to turn large open negative space into structured geometric shapes wherever possible, establishing their relationship to one another and to the whole. Open negative space always poses a difficult problem, so pay strict attention to it. It does take discipline and patience, but you're *capable* of doing it. And you've got light and dark value relationships to stimulate your interest in mood and sustain your efforts during the process.

In Homer's later painting, every part of the *figure* of mother and child locks into the *ground*. The extended elbow is a right angle to the edge of the facial profile, both integral parts of the main geometric rectangular motif. The triangular shape of the shawl is related to the triangle in the upper left-hand corner of the sky area, as well as to the more obvious triangle in the rock ledge below.

If, like Homer, your shape relationships are structured solidly and value relationships harmonized throughout, there can be no empty negative space. The figure-ground relationship will dovetail like the parts of a carpenter's joint.

Project 9: Correcting a Composition

Figure 78 is a tracing of only *part* of a drawing by a contemporary artist: an old-fashioned sink with two faucets, a shelf to the right of the sink, and a suggestion of a wall to the left. From the position of the faucets, it looks like the sink is partially hidden behind the left wall and the depth of the sink doesn't really show.

The faucets are *figures*, well placed within the open *ground* of the sink. Or, stated another way, the faucets are *positive* subject matter within the *negative* space of the nearly rectangular shape of the sink. And the sink itself plus the shelf to the right are both *positive* two-dimensional shapes surrounded by *negative* shapes.

The sink and the shelf are large rectangular shapes, which dominate the surface. Clearly, the main geometric motif is rectangular. Yet, something is wrong and needs correction.

Add Smaller Rectangular Shapes

Your instructions are as follows:

1. Make two tracings of Figure 78, or enlarge it freehand on sheets of charcoal paper, 16″ x 20″ (406.4 x 508 mm).

2. Use a #1, very soft compressed charcoal stick to improve the first tracing. Work from your imagination.

3. Study the shapes above and below the sink. Do they feel empty? Are they too large?

4. If so, what subject matter can be added to make the composition more meaningful?

5. Experiment by letting yourself go! Do *not* check for shape and tonal relationships until you've exhausted your resources.

6. Study an actual kitchen for the second tracing. What is usually found above a sink that may break up that large space? What is usually *underneath* a sink that would reduce the size of the large shape below it?

7. Except for the sink, change any part of the drawing you wish. Add windows, draperies, doors, for example.

8. In correcting Figure 78, keep in mind the overall purpose of the assignment: to introduce a variety of smaller shapes that not only solidify the main rectangular geometric motif, but harmonize the light and dark tonal relationships.

Figure 78. *This is a tracing of only part of a drawing of an old-fashioned sink. From the position of the faucets, we infer that the sink is partially hidden behind the left wall. The main geometric motif is clearly rectangular. Yet something is wrong and needs correction. Study the shapes above and below the sink. Do they feel "empty"? Are they too large? What subject matter can be added to make the composition more meaningful?*

Case History 9: Diebenkorn

Figure 79. (Above) *Richard Diebenkorn: Sink. Charcoal and gouache, 24 3/4″ x 18 3/4″ (629.1 x 467.7 mm). Baltimore Museum of Art, Baltimore, Maryland. Note how Diebenkorn broke up the large areas above and below the sink. In doing so, he made the main geometric motif of the rectangle even more dominant. His use of dark values below the sink and on the floor stabilizes the whole. There's no feeling, for instance, of emptiness despite the fact that the rectangular shapes above the sink contain no subject matter other than wall space. Photo: Eric Pollitzer.*

Figure 80. (Opposite page) *Richard Diebenkorn: Kitchen Interior with Door & Sink. Pencil and gouache, 24 3/4″ x 19″ (629.1 x 482.6 mm). Collection of Mr. and Mrs. Maurice Vanderwoude, Great Neck, New York. This is another variation of the same theme as Figure 79. Here, too, Diebenkorn worked for closed negative shapes.*

Figure 79 is a drawing of *Sink* by the American artist Richard Diebenkorn. The medium is a combination of charcoal and gouache—a method of watercolor, as I've mentioned earlier, in which the pigment is mixed with white and used opaquely.

Diebenkorn is one of a group of California abstract painters known as the *New Realists*. There's a lonely, introspective mood in Diebenkorn's *Sink*, which adds to its freshness. "A rough-hewn, frontier quality, an authentic American bleakness" is the way his work has been described.

His approach is quite unlike that of Andrew Wyeth, who moves toward a more "finished" realism. But he has an important thing in common with Wyeth: a keen awareness of spatial and other esthetic relationships.

Figure 78 is part of Figure 79. Note how Diebenkorn broke up the large rectangular areas above and below the sink. In so doing, he made the main rectangular geometric motif more dominant. Even the plumbing under the sink forms another rectangle—and is an example of the use of *closure*. The submotif is the triangle. The secret of Diebenkorn's spatial sensitivity is that no two rectangular shapes are alike in size or shape.

But spatial sensitivity can't be separated from that of light and dark value relationships. Diebenkorn's use of dark values below the sink and on the floor stabilizes the whole. The brushing and rubbing of light values at the left of the drawing and over the sink create just the right texture for delapidated walls. Although the rectangular shapes above the sink contain no subject matter other than wall space, there's no feeling of emptiness. Even the tonal values on the face of the sink emphasize the neglected, unclean condition of the room.

This drawing is a very good example of closed geometric negative shapes. Figure 80, *Kitchen Interior with Door and Sink* by Diebenkorn, is another variation on the same theme. Here, too, he worked for closed geometric negative shapes. By introducing the pattern of circles and dots in the curtain, he established another contrasting esthetic relationship: simulated texture, which is discussed in Chapter 8.

Project 10: Structuring Negative Space in a Landscape

Figure 81, like Figure 78 in Project 9, is a tracing of part of a picture—a landscape. In Figure 78, the main geometric shape motif of the rectangle was clearly visible, while in Figure 81, the dominant shape motif has *not* been established, and the negative space is practically all open.

You must use your imagination more extensively to complete the drawing. One of the most trying problems for any artist to solve is to turn open negative space into closed geometric shapes in a landscape with trees. Because the branches are covered with leaves against a background of sky, it is difficult, first, to form closed negative shapes geometrically; second, to interlock all geometric shapes into a dominant shape motif, supported by contrasting submotifs; and, third, most importantly, to balance both shape and tonal value relationships with feeling and sensitivity.

Establish the Dominant Shape Motif

Here are your instructions for this assignment:

1. Make three tracings of Figure 81 on sketch paper, using a ballpoint pen lightly without ink (or some such tool).

2. Be sure to trace the four edges of the drawing.

3. Use both a 5B and a 6B black pencil.

4. With the first tracing in front of you, allow your feelings to roam over the entire surface area as you think about the subject. Where are the trees located? Are they in a thick forest? Do you visualize a path or trail? Perhaps a clearing? What about trees on a river bank?

5. Once you arrive at a decision, do the first drawing quickly. As you work for light and dark relationships, keep in mind the overall geometric shape motifs.

6. After an interval, check the first drawing carefully. Is the dominant motif well established? And the submotifs? Are the value relationships harmonized as a whole? Are all the negative areas closed?

7. Don't make further changes. Instead, do a second drawing, adding any changes in subject matter or rearrangements in shape or tonal relationships.

8. Study the second drawing after a lapse of a day or two. Check it carefully against the first drawing. Note the improvements and where further improvements can be made.

9. Use the third drawing to consolidate all your improvements. Now is the time to concentrate on the most subtle and diverse light and dark relationships. Use a range of gentle pressures on the pencils to vary the degree of tonal values. Use the darkest dark sparingly. Check the final drawing for firmly structured shape motifs. Turn it on four sides to make certain that all negative areas are closed and clearly defined geometrically.

Figure 81. *This is a tracing of part of a picture—a landscape drawing. However, the dominant shape motif has not been established here, and the negative space is practically all open.*

Case History 10: Seurat

Figure 82, *Trees on a River Bank*, is a pencil drawing by the French artist Georges Seurat, upon which Project 10 and Figure 81 are based. Here again we have proof of Seurat's sensitivity and control of spatial and tonal value relationships. He was evidently fascinated with the curves, twists, and indentations of the large tree. We can feel the loving care with which it was rendered. Yet, as we study the drawing, we question Seurat's composition.

Did Seurat pay strict attention to the composition as a whole at each step, while expressing such tenderness? I believe not. Isn't this contrary to the procedure recommended earlier? It is, and the chances of your integrating a composition successfully in this way are slim. I think even Seurat barely avoided failure. When the large tree began to emerge as the focal point, he might have switched immediately to working as a whole, instead of improving the details of the isolated tree. But perhaps he had no intention of completing the picture when he drew the tree. Could it have been an afterthought? If so, it might have been far better to have done it over again.

Let's analyze Figure 82 to determine in what sequence Seurat worked on the drawing. There's no written word, to my knowledge, of what Seurat actually did. However, we can arrive at certain conclusions from clues in the drawing. Can we safely assume that because of the careful delineation of details, the large tree was drawn from nature? I think so, except perhaps for some slight changes. Was the tree located on a river bank? We know that Seurat was interested in river banks, from his masterpiece *La Grande Jatte* (Figure 83). Therefore, the large tree was probably on a river bank.

For that reason, I believe that when he started to draw the large tree, he also introduced the horizontal of the river; the diagonal of the bank of the river, followed by a few lines indicating the trunk of the curved tree at the far left; and perhaps a few curved lines for the smaller tree next to it. He then probably concentrated on the details of the large tree, completing it before the rest of the drawing.

What went wrong? I'll explain after I analyze the many good things in the drawing.

Analysis of Major and Contrasting Submotifs

The geometric shape relationships are excellent. The major geometric motif of the arc, starting with the sinuous curves of the large tree, is repeated in the two curved trees at the left.

In contrast to the arc motif, Seurat added a vertical tree in the center. Note how it brings into equilibrium the unstable movement of the surrounding curved trees. Note, too, how the vertical submotif is echoed several times at the right, and particularly how it's repeated very subtly in the upper part of the tree at the left.

The added submotif of the horizontal—in the river and in the shadow of the tree at the bottom of the picture—further stabilizes the drawing. It divides the surface area into three rectangles. At the same time, the vertical motif further subdivides the surface

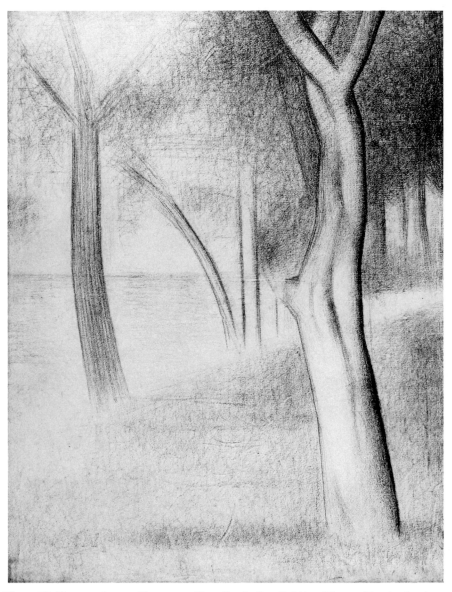

Figure 82. *Georges Seurat:* Trees on a River Bank. *Pencil, 620 x 470 mm. The Art Institute of Chicago, Chicago. This is an excellent example of closed negative shapes in a landscape with trees—one of the most trying tasks to relate rhythmically in two-dimensional geometric motifs. Yet, as we study the drawing, we begin to ask questions.*

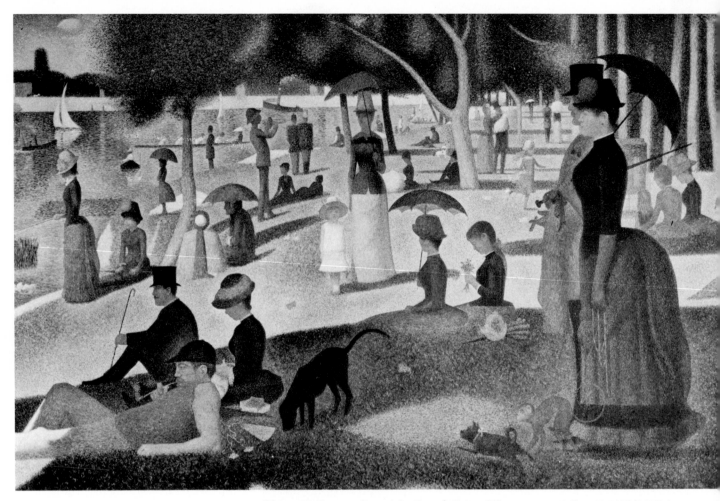

Figure 83. *Georges Seurat: La Grande Jatte. Oil on canvas, 81" x 120 3/8" (2,057.4 x 3,057.7 mm). The Art Institute of Chicago, Chicago. Painting with dots of pure related color, in a style called pointillism, Seurat was a stickler for structural rhythm and tonal harmony. His compositions were finalized in a precise and orderly manner through the slow development of numerous preliminary drawings, small color sketches, and even large preparatory paintings. Figures 12 and possibly 82 were among those Seurat painted in preparation for this masterpiece.*

area into numerous smaller rectangles of varying sizes.

Finally, the river bank creates the triangular submotif, which is repeated in the branches as they meet the top edge of the drawing.

Turn Figure 82 upside down to see how Seurat closed the negative space ever so gently, *suggesting* closure (in what is now the lower right-hand corner).

First, note how he stroked the pencil lightly to suggest leaves on the trees. Second, observe how the small curved tree in the center appears to fade into the branch of the larger tree at the lower right. Although there's no real connection, they appear to interlock. Third, note how closure is suggested by an open space between the edge of the bank and the base of the vertical tree, as well as the adjacent trees.

With Figure 82 still upside down, let's look at the geometric shape motifs to see how they strengthen the composition. The horizontal line of the river creates one huge rectangle in the area above it. Was Seurat aware of this? I believe he was. In contrast with this large rectangle, he introduced a small rectangle below the river line. Follow the vertical tree as it fades into the gray area. Seurat drew some very subtle horizontal lines there suggesting the bottom of the rectangle (bound by the river line at the top and the vertical edges of the trees on the sides). Within this rectangle, note how Seurat placed his figure-ground relationships of the curved tree and surrounding leaves. Note especially how he stroked the pencil very gently into the feathery area of the leaves and

branches, forming a still smaller rectangle within the one just described.

The lesson to be learned here is that open negative space surrounding trees in a landscape can be turned into both closed negative shapes and rhythmically related two-dimensional geometric motif patterns. The idea is to subordinate subject matter and use tonal values with sensitivity while working for shape relationships. That's what Seurat did. Except for the large tree, he didn't render the actual species of trees, nor the grouping of identifiable branches and leaves.

Seurat Barely Avoided Failure

Seurat integrated the drawing in every compositional respect except one: he failed to maintain pictorial *logic*. Judge for yourself. Place a sheet of paper vertically over Figure 82, covering everything left of the large tree. You'll find a magnificent drawing in fine detail, balanced logically.

Now, place the same sheet of paper vertically, covering the large tree and trees to the right of it. You'll find a sensitive drawing of trees, but if you look closer, you'll see that they're not realistic—only *symbols* of trees. Nevertheless, we accept them because they've the same symbolic logic throughout. However, we really have two different drawings with two different approaches in one picture.

Why did Seurat develop a second structure? Why, for example, didn't he continue to use the right-hand structure on the left? This is extremely difficult to do, even for a master, though you may not believe this statement. The fact is, when you work

as a whole without conscious effort, your intuitive feeling unifies pictorial logic throughout. Not so when you've worked in detail, establishing a fixed style in one part of the picture. It then requires that the rest of the picture be the same style as the completed part. This the subconscious finds almost impossible to do esthetically. When the conscious mind takes over and applies technical skill to duplicate the already established style, it usually produces a mere illustration without unified feeling or artistic quality.

Seurat probably had no intention of completing the left-hand side of the drawing originally. Perhaps, without thinking, he became absorbed in balancing shapes and tonal values. When he became aware that the style at the left differed from the right, he accepted the challenge and rose to the occasion.

Did Seurat fail, or didn't he? I think he barely avoided failure. He overcame an almost impossible task because he was able to transcend and transform both styles as one. This is the mystique of irrational art—the magical glue of inner energy and feeling that defies logical rules. My advice is not to waste time breaking compositional principles, but to work on *all* parts of a drawing, building up the total picture in a series of sketches, as you go along. That's what Seurat and others did before, or even after, they became masters.

In summary, Figure 82 offers an excellent example of closed negative shapes in a landscape with trees—one of the most trying tasks to relate rhythmically in two-dimensional geometric motifs.

Project 11: Working with Closed Negative Shapes

This project has several aspects to it: First, it includes a practical, but not foolproof, drawing technique for those who, despite my admonitions, may have fallen into the trap outlined in Case History 10. Second, the assignment tests your freewheeling imagination in design. Third, it's concerned with the composition of clouds in the sky as closed negative shapes. Fourth, light and dark relationships play a special part: the *edges* of tonal values should be used to form two-dimensional geometric shape motifs.

Figure 84, *The Holy Family*, is part of a painting by the famous artist El Greco. The setting is out-of-doors, but I've purposely eliminated the sky and clouds. Instead, we see only a blank negative space which, as a shape, is not rhythmically related to the rest of the painting.

The specific objective of the assignment is to break up this area with closed negative shapes as clouds and sky that must be related both in geometric shape and in tonal values to the painting as a whole.

Look in One Direction and Draw in Another

Your instructions are as follows:

1. Use an inkless ballpoint pen and carbon paper to make four tracings of the blank negative space. Enclose all four sides of the negative space; include the outer edges.

2. Carefully cut out each of the four tracings along the *lower, irregular edge only*.

3. Test each tracing to make certain the irregular edge lines up accurately with the figures.

4. Tape the first tracing over Figure 84, using transparent masking tape that's easily removed.

5. Use a #1 compressed charcoal stick to fill in the negative space with various light and dark shapes. Do this quickly without consciously thinking.

6. Here's the technique. *Look at the rest of the painting (Figure 84) and not at the negative space.* This requires practice. To look in one direction and draw in another isn't easy. It requires visual polarization of the whole, while almost automatically filling in the negative space. The idea is to integrate the geometric structure of the painting by removing the subject matter from your consciousness—as much as possible. Turning the picture four ways during the process helps.

The chances of bull's-eye integration are slim, but potential failure shouldn't deter you. Considering the numerous objectives of the assignment, the effort is definitely worthwhile. Besides, it's a technique that you can use any time with assured success as the image first emerges.

7. Study your first try by checking it four ways, but make no further improvements on it.

8. Instead, do it over again on your second tracing.

9. Follow the same procedure with the third tracing, but this time use *specific shapes of clouds*.

10. Study the result carefully. Then use the fourth tracing with complete abandon in a final effort.

Figure 84. El Greco: The Holy Family. Oil on canvas, 51 7/8″ x 39 1/2″ (1,311.6 x 1,003.6 mm). The Cleveland Museum of Art, Cleveland, Ohio. The setting of this painting is out of doors, but the sky and clouds have been purposely eliminated. Instead, we see only a blank negative space that, as a shape, is not rhythmically related to the rest of the painting. Photo specially cropped by Paul Juley.

Case History 11: El Greco, Cézanne, Modigliani

Figure 85, *The Holy Family*, is the work of the Greek painter who spent most of his professional years in Toledo, Spain, where he was called El Greco.

Very little is known of his early life on the island of Crete where he was born in 1541. Although no one knows whether he started to paint there, his work shows traces of Byzantine culture carried over in Crete from medieval days.

Crete was part of the Venetian Empire when El Greco, at age 25, traveled to Venice to study painting with Titian. Later, while still in Venice, he was attracted to the work of Tintoretto, Veronese, and Jacopo da Bassano. At 29, the paintings of Raphael and Michelangelo in Rome affected him greatly. An intense mystic, he finally settled in Toledo, Spain, where he developed his unique style.

I chose this painting, first, because it's a fine example of closed negative shapes; and second, because of the way El Greco used the diagonal motif in the negative space. He interlocked a line in the clouds at the upper left of the negative space with subject matter in the positive area below.

The diagonal shows up mostly as an edge separating the light and dark tonal values. It moves toward the lower right, first, through the dark lines across the bosom of the Madonna. Then it continues through the eyes of the Child. Finally, it flows along the wavy, yet diagonal edges in the folds of the garments.

You recall that a diagonal line is an active line, in contrast with the generally passive horizontal. The diagonal adds dynamic movement. If you study Figure 85 from four sides, you'll find numerous long diagonals throughout the edges of light and shade, especially in the reflections of clothing. Even the wavy, very light value in the cloak at the center right makes a strong diagonal that continues, at intervals, toward the bottom center of the painting.

Look at the pattern formed by the diagonals and the borders of the painting. They break up the entire surface plane of the picture into a pattern of varied triangles. These form the two-dimensional scaffold for the composition, and ovals and arcs support it as submotifs.

The lesson to be learned here is that El Greco subordinated the shapes and tonal values of the clouds in the negative space for the benefit of the overall picture. In the process, he related the closed negative shapes to the rest of the painting.

An important point to remember is that the relationships established are never superficial nor consciously contrived. The diagonal motif in Figure 85, for example, is never one continuous straight line. In some places, there may be intervals in space that the eye connects up. In others, the motif may be *suggested* in a parallel line, or the motif may be irregular and wavy.

Another Example of Closed Negative Shapes

Figure 86, Cézanne's *Portrait of Victor Chocquet*, is another example of how to handle closed negative shapes. Even in his pencil sketch (Figure 87), Cézanne shows his concern for the negative space around the figure.

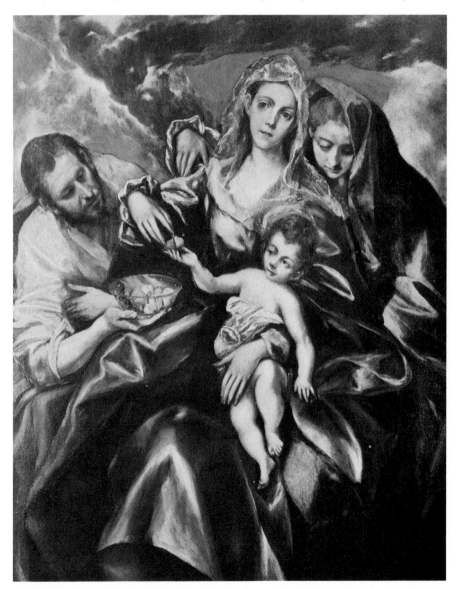

Figure 85. El Greco: The Holy Family. *Oil on canvas, 51 7/8″ x 39 1/2″ (1,311.6 x 1,003.6 mm). The Cleveland Museum of Art, Cleveland, Ohio. This is a fine example of closed negative shapes. El Greco subordinated the shapes and tonal values of the clouds in the negative space for the benefit of the overall picture. He interlocked a line in the clouds, at the upper left of the negative space, with subject matter in the positive area below, thus relating the closed negative shape to the rest of the painting.*

In the painting, he posed Chocquet, who was his first patron, so that the head and torso were parallel to the viewer. Note how the strong light of the shirt calls attention to the portrait of the face directly above it. Together they form a dominant vertical area. This shape motif is repeated in several places: in one of Chocquet's legs, in the vertical leg of the chair next to it, and in the part of the chair leg shown under the seat. But the strongest vertical is in the side of the chair. Note how your eye follows through to the leg below.

The diagonal as a contrasting motif in the clasped hands and in the other leg, together with the extended arm, form a dynamic submotif. Even the arc of the chair repeats the arc of the head in another strong submotif.

But let's concentrate on his composition of the negative space. How awkward a space it is! And how easily a novice might not be able to unify it with the rest of the painting.

You can be sure that Cézanne was well aware of the difficulty. He vitalized the negative space by creating a series of closed negative shapes. Note how the dark horizontal band delineates the floor from the wall, thus dividing the entire surface of the picture into two large rectangular shapes.

Both shapes are broken down into a series of smaller rectangular closed negative shapes, starting with the pictures on the wall at the upper right and continuing down to the floor. Cézanne used the reflected shadow of the chair leg to complete the bottom rectangular shape.

The more or less vertical edge of the chair echoes the dominant vertical area of the shirt and face. Observe how Cézanne called attention to the edge of the chair by emphasizing the vertical edge of the painting above it.

By doing so, he interlocked *all* the closed rectangular negative shapes, from top to bottom. One long vertical is emphasized. This, in turn, is gently repeated in the verticals within the horizontal picture behind the portrait of Chocquet. But this is not the whole story of the dynamic quality of Cézanne's closed negative shapes.

Let's discuss one more geometric submotif—the horizontal. Do you feel the energy and force of the many horizontal areas at the left from the top of the painting to the bottom? This is how Cézanne turned that large open negative area into vitalized closed negative shapes. If you turn the painting upside down, note the variety of additional rectangles throughout. No two are alike in size or shape.

Figure 86. *(Opposite page) Paul Cézanne: Portrait of Victor Chocquet. Oil on canvas, 18″ x 15″ (457.2 x 381 mm). The Columbus Gallery of Fine Arts, Columbus, Ohio. This painting is another example of composition of negative space. See how awkward a space it is and how Cézanne handled it by originating a series of closed negative shapes. Note how the dark horizontal band divides the entire surface of the picture into two large rectangular shapes. In turn, both shapes are broken down into a series of smaller rectangular closed negative shapes.*

Figure 87. *(Above) Paul Cézanne: Portrait of Victor Chocquet. Pencil, 5 1/8″ x 3 5/8″ (130.2 x 92.4 mm). Collection of Ms. Adelyn D. Breeskin, Washington, D.C. Even in his pencil sketch, Cézanne shows his concern for the negative space around the figure.*

Modigliani's Distortion of Closed Negative Shapes

Take a few moments to observe the distortions in Amedeo Modigliani's painting of the art dealer and critic, Paul Guillaume (Figure 88). Both the figure and the negative space are strongly distorted. Note, however, how the dark accent of the tie holds all the turbulent, unstable forces in check and balance.

Note the variety of closed negative shapes that are distorted. Yet something's distinctly different. Modigliani balanced the large areas of compara-

tively light tones in the figure with a massive dark, geometric, closed negative shape behind it. This shows that the subject matter in the negative area can be suggestive rather than clearly defined.

What that dark shape is, I don't really know, but it's a three-dimensional object because of the small, undefined objects above it. What's important is that the negative *shapes* are clearly defined and closed. The same lesson—of treating the negative simply, yet effectively, from the point of view of subject matter—we learned from the Cézanne painting.

Figure 88. (Left) Amedeo Modigliani: Portrait of Paul Guillaume. Oil on board, 29 1/2" x 20 1/2" (749.6 x 521 mm). The Toledo Museum of Art, Toledo, Ohio. Both the figure and the negative space are strongly distorted, but the dark tie holds all the turbulent, unstable forces in check and balance. Modigliani balanced the large areas of comparative light tones in the figure with a massive dark geometric closed negative shape behind it. The special point is that the subject matter in the negative area can be suggestive rather than clearly defined.

Project 12: Improving the Composition

This project is about the kind of compositional problem that looks easy to solve, yet often gives artists great trouble. The subject matter lends itself to a dominant two-dimensional geometric shape motif. Even its repetition presents no difficulty, except for one thing. One large area appears *partly* out of relationship geometrically.

James Abbott McNeill Whistler had this problem with the space representing the river Thames in London in Figure 89. It's the first state of an etching called *Under Old Battersea Bridge*. The pillars of the bridge are emerging with the hint of the surrounding water. A few horizontal lines at the top indicate the height of the bridge. In the distance, we see the beginning of another bridge, with the suggestion of ships under it. To the right, faint outline of buildings and docks.

The negative space in the sky above Battersea is darkened somewhat, suggesting that the area will eventually become a rectangular, two-dimensional negative shape. The sky area under Battersea Bridge, with the distant bridge and buildings acting as a horizontal, is already enclosed by another large rectangular negative shape.

Now here's Whistler's predicament. What to do about the large open area of water in the foreground? The shape surrounding this space is not yet geometrically related to the rest of the picture.

Your assignment is to improve the entire picture, maintaining the feeling of the river and giving special attention to the foreground. The real problem is to turn the large, open negative space into a shape (or shapes) that is definitely and sensitively related to the main rectangular motif.

Turn Negative Space into a Shape Motif

Your instructions are as follows:

1. Make four tracings of Figure 89, including the four edges of the picture.

2. In the first tracing, test the dimensions, particularly the lower part, until you find the proportions that suit you. Then cut the tracing down or add to it, as you like.

3. Using a 5B or 6B black pencil, complete the whole drawing.

4. In the second tracing, keep the dimensions of Figure 89 as ís. (Do so in the third and fourth tracings, too.) Find subject matter that can divide the foreground negative space into smaller *closed* shapes, preferably shapes that relate to the main rectangular motif. Relate the arc in the distant bridge to the subject matter as a contrasting motif.

5. In the third tracing, keep the foreground negative space *open* by adding subject matter *within* the area. This requires delicate spacing of the figure-ground relationship. Here's a hint: study Figures 67 and 72 and reread the chapter before you make a decision. Remember to geometrically adjust the large *shape surrounding the negative space.* For example, how can the bottom of the bridge and shadows be gently adjusted to make the negative shape more rectangular? Whatever you do, keep in mind the purpose of the assignment.

6. In the fourth tracing, adjust the foreground area as one large closed negative shape that relates geometrically to the main shape motif. But don't add any new subject matter within the area. This assignment is the most difficult one to balance. Here's a hint: use your light and dark tonal values in the other areas to bring the whole picture into harmony.

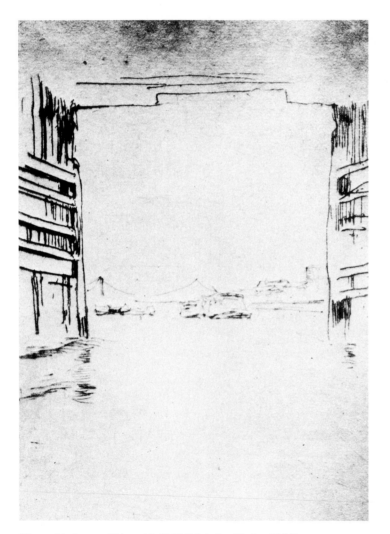

Figure 89. *James Abbott McNeill Whistler:* Under Old Battersea Bridge. *Etching, state I, 8 3/8″ x 5 3/8″ (212.9 x 136.7 mm). Photo: Prints Division, The New York Public Library, New York. In this first state of the etching, Whistler faced a predicament: How to turn the large open negative space in the foreground into a shape that is definitely and sensitively related to the main rectangular motif?*

Case History 12: Whistler

James Abbott McNeill Whistler was a 19th-century American expatriate painter, who acquired a reputation in Europe as a fiercely independent artist. He spent so much of his adult life in England that he's considered there to be an English painter. However, he lived in Paris for two years before settling in London and traveled back and forth on many occasions, also spending some time in Venice. He became an international celebrity in his time.

It was in Paris that Whistler was one of the first Americans to come in contact with Courbet and Manet, two revolutionary French artists. Through them and their paintings, he began to appreciate the works of Velázquez, the 17th-century Spanish master known for his silvery tonality and his geometric spatial organizations.

Courbet had been influenced by Velázquez to paint bold, sometimes harsh, elemental realism. Using a limited palette, he obtained rich effects, very often by applying color with a palette knife. Manet also painted the real everyday world, as well as controversial, carefully composed paintings. He, too, painted with a limited palette, creating moods in gray. Both painters learned much from Velázquez's warm colors against gray, blue-green backgrounds.

Whistler, in turn, personalized all this in his own work. He became known for gray color harmonies and sensitively related compositions applied in a decorative style. His landscapes show a preference for moods in twilight.

This was a period when Japanese woodblock prints were "discovered" in Europe and carefully studied by the early Impressionists, such as Manet and Degas. It was inevitable, therefore, to find the Japanese influence of flat, nonsculptured, decorative harmonies of shapes and color in the Impressionists' paintings and also in Whistler's. Degas and his work also played an important part in Whistler's life.

The etching was another medium in which Whistler's vigorous line and space compositions received well-deserved praise. Figure 90, *Under Old Battersea Bridge*, is a good example. I chose it for two reasons: first, because the Oriental spatial influence is so evident; and second, because three states of the etching are available to illus-

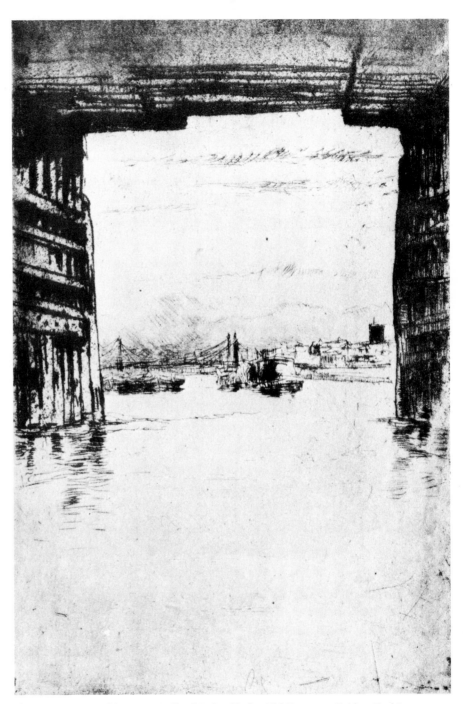

Figure 90. *James Abbott McNeill Whistler: Under Old Battersea Bridge. Etching, state III, 8 3/8" x 5 3/8" (212.9 x 136.7 mm). Photo: Prints Division, The New York Public Library, New York. Both the mood and composition of the etching show Whistler's mastery of Japanese spacing as well as all the other sound influences that helped him develop his own sensitive style.*

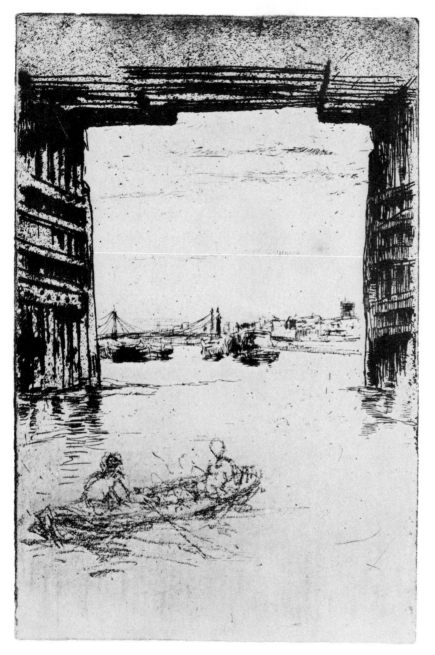

Figure 91. *James Abbott McNeill Whistler:* Under Old Battersea Bridge. *Etching, state II, 8 3/4" x 5 3/8" (222.7 x 136.7 mm). Photo: Prints Division, The New York Public Library, New York.*

a small one next to a large one, the latter contoured by three edges of the picture. Within the large rectangle, he suggests two more rectangles by the dark shadows under the pillars of the bridge.

These changes clearly demonstrate how Whistler parted company with the academicians of his day. "I make use of any incident which shall bring about a symmetrical result," said Whistler.

Are such distortions on the two-dimensional surface plane done mischievously to create a disturbance or to be contrary to the academic way of painting? Not at all. Distortions solidify the overall composition and satisfy our inner desire for spatial order.

Observe how Whistler added a rowboat and two figures rather sketchily. Evidently he wasn't sure about the large space in the river area and decided to break it up.

The unit of two figures and a boat represents *figure* against the *ground* of the river. As such, it must be evaluated as a problem of *positive* subject matter in relation to the surrounding *negative* space. At first glance, the large oval shape of the boat appears to be appropriately suited to the negative space. Yet, if you look at Figure 91 upside down, the oval shape is weak on two counts: in relationship to the space within the rectangular shape surrounding it, and in its angled position in relation to the dominant rectangular motif of the picture.

If the boat were placed horizontally, would it solve the problem? Not completely, but it might help somewhat. The arc in the distant bridge, which is a submotif, might be accented to repeat the lower arc of the boat.

In the final state of the etching (Figure 90), Whistler removed the unit of boat and figures and daringly left the large river area free. I say "daringly," for he was depending upon darkening the tonal values just right. This he did, particularly at the top. Note also how he added more small horizontals as shadows in the water and how the gradations of tones over the entire river area help to unify that space.

Finally, observe how he smudged the distant bridge, eliminating the curve of the cables as a submotif. Instead, he used the diagonals in the pillars of the bridge to counter the main rectangular motif. Both the mood and the composition of the etching show Whistler's mastery of Japanese spacing. They also show all the other sound influences that helped him develop his own sensitive style.

trate how Whistler solved a difficult problem in composition. Let's examine his approach. The second state (Figure 91) tells the story.

We are immediately aware of the dramatic improvement over the first state (Figure 89). There are more dynamic contrasts of light and dark values in the sky. The dark tones in the bridge supports now give it the feeling and strength of a solid bridge. The far distant bridge, buildings, and ships are more detailed.

But the most significant improvement is in the large foreground area that needed to be related geomet-

rically to the main rectangular shape motif.

Note the subtle addition of more horizontals. Then, compare Figures 89 and 91 upside down. Not only has Whistler added horizontals suggesting wisps of clouds, but he has *modified the perspective angle* of the bridge. Contrary to the usual diagonal angle, Whistler made it *horizontal*. He even extended it into the water on both sides just enough to suggest closure.

If we look at Figure 91 from the side, we can see that the river area has been divided into two clear-cut rectangles:

Color

<div style="text-align: right">4</div>

The traditional way of learning to apply color is through exercises that develop the technical skills the commercial artist or illustrator needs. You learn eventually to paint what you see in colors that imitate, as closely as possible, the colors of objects grouped before you.

What we're doing here is something entirely different. We're advancing slowly, but surely, along a carefully developed pathway that will lead you to create compositions with all the qualities of fine art. The objective is to help you function within the same broad framework of advanced concepts that the professional fine artist uses, but on an elementary scale at the beginning.

Color in composition is the core of a work of fine art. Before a professional is able to create a work of art, he or she must learn to *see* color relationships in a select way, unknown to the commercial or traditional illustrator. This you must learn to do, too—and you *can*, although it isn't easy.

The Process of Adjustment

Color, as conceived by fine artists, *broke with conventional thinking and seeing* ages ago. Yet there's nothing mysterious or unique about seeing color relationships the fine art way. It's complex only because there's so much to grasp at once.

How much more natural, easier, and vitally important to train *all* children—when they have less to unlearn—to see color relationships as the fine artist does. And to see and evaluate the structural shape and tonal relationships discussed in earlier chapters. A *continuous, quality* art education and training from primary school onward would not make them professionals, but *amateurs* in the original sense of the word: lovers of art.

Even more important, such basic change in the art education curriculum would help cultivate the fantastic potential of the presently neglected right side of the brain.

It's this process of thinking, seeing, and feeling that we've been slowly de-veloping with the projects in two-dimensional shape and tonal problems. Without such a process, creative artistic compositions are impossible. True, you'll probably produce a modest work of art at the start, but of such quality that it will be recognized and appreciated by professionals immediately.

Color Is the Heart of Art

An important reason why black and white drawings are the first step in the sequence of learning is that they contain the *same* visual elements as colored paintings. By excluding color, you've one less element—and a complex one—to contend with while learning to control all other visual elements. Color is the one visual element that contains *all other elements*. That's why it's essential to learn to unify all the elements in progressive stages.

At this point, you're still in the process of learning to control shapes and tonal values. You've had only minimum experience with textures, through the use of charcoal. (Projects in textures and lines are in Chapter 8.) Although we're talking about color, I must emphasize that continued training in *drawing* can shorten the time it takes you to master the integration of *all* the elements, sensitively and esthetically, including color.

Approaching Color

How should you approach the study of color? Work for *sensitivity* and *feeling first*, limited to *one* medium in color as Matisse, van Gogh, Gauguin, you to cover one color over another with ease. Just as there must be a mood expressed in drawing, there must be feeling in color relationships. Concentrate on this at once.

Start by steeping yourself in the *thinking* of such modern masters of color as Matisse, Van Gogh, Gauguin, Bonnard, Braque, Picasso, and, of course, Cézanne. A simplified, step-by-step system for beginners that takes advantage of their thinking is available in my book, *The Creative* *Way to Paint.* By following it, you can break away from conventional methods and create in color with personal feeling.

Take Picasso's statement, "One never knows what one is going to do. One starts a painting and then it becomes something quite else." Think about Picasso's remark, "The artist is also calculating without knowing." That is exactly what happens when you're finally able to *automatically* balance shapes, tonal values, and other relationships in color as unified wholes.

Paul Klee began a picture by arranging areas of color based solely on his emotional reaction to it. Then he'd impose an outline of a drawing on top and make color adjustments within the shapes.

Other artists, such as Matisse, claimed that they found their colors *intuitively*. Maurice Denis felt that "a picture is first of all a flat surface covered with an arrangement of colors."

All these accounts should give you some idea why I advocate starting with *flat colors*. That's what Gauguin, van Gogh, and others did. But in following this tradition, you must compose your very *own* colors.

Here is one way to determine color sensitivity: in a painting that has satisfactorily integrated color, each color area has a sensitive relationship to neighboring areas.

When you're painting, start by establishing the relationship of one color shape to the one next to it by *isolating* the areas temporarily. This may come as a surprise, because up to now I've stressed integrating everything. However, working for color relationships as an isolated process doesn't prevent you from integrating colors over the entire surface later.

Study two or more adjoining colors in small patches by forming a peephole with your thumb and forefinger. (This is not an infallible test, but it steers you in the right direction.)

In my earlier book, I explain in detail how to adjust color, not only *next* to one another, but color *upon* color. Plate 14 gives you some idea of one simple, but effective method of applying one color over another. Note particularly how the color underneath is allowed to show through.

The important point is that you must *feel* right about any color *next* to another and *over* another. Make a habit of testing the color relationship through the peephole as you go along. If you don't like a relationship, keep on correcting it until you do. Whatever you do, don't *think* about colors but *feel* them. As the nonfigurative

painter, Kandinsky, once said, "Let your eyes be enchanted by the purely physical effect of color, like a gourmet savoring a delicacy."

Integrating a Painting

The sequence for integrating a painting is the same as for a drawing. Stabilize two-dimensional shape relationships first in color. To develop the structure of a painting, look for the largest geometric shape you can find. Make this the main geometric shape motif that dominates the painting.

Note how the *triangular* shape motif dominates and vitalizes the composition in Plate 3. Observe how the geometric *diagonal, horizontal, vertical, oval,* or *rectangle* establishes the main shape motif in Plates 2, 6, 9–11.

There are many things going on in these paintings, but I call your attention to three particular points. First, geometric shape motifs have nothing to do with the choice of figurative or nonfigurative subjects, the techniques used, or style, whether representational or highly abstract. Second, in each painting, there are varied *rhythmic repetitions* of the main shape motif. Third, in each painting, you'll find one or more geometric *submotifs* that add life and movement to the structural compositions.

Since the subject of color in painting is a comprehensive study in itself, I am not including detailed projects in this chapter. Instead, study each of the colored plates very carefully. You'll discover unexpected rhythmic shape relationships when you look at the plates from all four sides.

Negative Space

Pay particular attention to negative space. Plates 1, 4, and 15 give you examples of it: open completely, partially open, and closed. Don't hesitate to reread the chapter on negative space as you begin to see sensitive spatial relationships in the color plates. But don't stop there. Pick up art books in your library at every opportunity to study the illustrations of the masters, old and new.

Light and Dark Value Relationships

As in drawing, harmonizing tonal relationships in painting is closely related to the integration of shape relationships. Note the balanced light and dark relationships in Plate 7.

You may not be able to distinguish this relationship in *color* in your own work at the beginning. If so, take a black and white photograph of your work and compare it with your painting for light and dark values. You may find tonal differences you didn't see clearly before.

Warm and Cool Color Relationships

After harmonizing the tonal relationships in a painting, two other relationships unique to color must be balanced. The first one is the relationship of *warm* colors—the reds, oranges, and yellows—to *cool* colors—the blues and blue-greens. Plate 8 shows this balance.

Intense to Muted Color Relationships

The second relationship is that of intense to muted colors. If any colors in the painting are disturbing, there are probably too many brilliant colors. In such case, use a blocking-out test to decide which *one* color "feels" right. Then proceed to reduce the intensity of the other too-brilliant colors by adding a little of the complementary color to each. Check the painting as a whole once again. If necessary, apply more color over color until there's a balance of brilliant to muted tones. Plates 12 and 13 illustrate this effect.

Texture and Line Relationships

Textural and line relationships are exceedingly important: when balanced properly, they enhance the sensitivity of a painting; conversely, they show up the weakness in a composition at a glance. Both relationships, including projects and case histories, are discussed in Chapter 8. Plates 5, 7, 10, 13, and 16 illustrate some of these relationships in color.

Plate 14 also illustrates one method of *obtaining* a textural effect while simultaneously working to establish a color that will feel right when placed upon another.

Instructions

If you wish to work with color, do so. Start with the best drawings you've done so far. This will save you time in balancing the shape relationships and tonal values. With new paintings, do a number of drawings first. However, schedule time to continue the projects in the following chapters.

Don't worry about three-dimensional space now. You don't need to concern yourself with it, although the illusion of three dimensions will probably be present in your paintings. You can't deal with it until you really open your eyes to *see* and *feel two-dimensional* relationships on the picture or surface plane of paintings.

Plate 1. *Vincent van Gogh:* La Mousmé. *Oil on canvas, 28⅞" x 23¾" (736 x 607 mm). National Gallery of Art, Washington, D.C. Unifying negative space with the rest of the painting always presents a problem, especially in relating positive figure with partially open negative ground. (See Plate 4, Completely Closed, and Plate 15, Completely Open, for other examples of how negative space is used to structure the composition.) Van Gogh solved the problem by subtly texturing the same vibrant color throughout. Five small, completely closed negative shapes are unified with the same color.*

Van Gogh was influenced by the light and color of his contemporary Impressionists and the flat tones and masses of color in Japanese prints. But it was the work of Georges Seurat—the Neo-Impressionist who perfected the method of Pointillism—that especially influenced him. As a result, he pursued his spontaneous expression and vibrant color, enhanced by his use of the loaded brush, palette knife, or color squeezed directly from the tube and always harmonized with sensitive control.

Plate 2. *(Above) Paul Cézanne: Chestnut Trees at Jas de Bouffan. Oil on canvas, 29″ x 37″ (736 x 939.8 mm). The Minneapolis Institute of Arts, Minneapolis, Minnesota. Despite his concern for three-dimensional depth and volume, Cézanne did not overlook two-dimensional spacing on the picture plane. Note how sensitively the trees are spaced across the painting. Yet, while giving the feeling of being vertical, with one exception, they're not actually vertical. Look at the painting upside down. The trees are really arched with many branches repeating the pattern. Note how two branches, in contrast, repeat the lines in the mountain. (See how other geometric shape motifs are used to structure the composition in Plate 3, Triangle; Plate 6, Oval; Plate 9, Horizontal; Plate 10, Diagonal; and Plate 11, Rectangle.)*

Plate 3. *(Right) Max Weber: The Geranium. Oil on canvas, 32¼″ x 39⅞″ (812.8 x 1,016 mm). The Museum of Modern Art, New York. While the attention of the two figures is focused on the geranium plant in this Cubist painting, the cornerstone of the composition is the tree above them. Weber combined the two figures and tree to form the main two-dimensional geometric shape motif of the triangle. It dominates the largest portion of the total surface area of the canvas. The varied repeated patterns of the triangle throughout the sharply angled painting provide the rhythm of the motif.*

Observe the shape and color of the treetop. Without them the composition would collapse. To appreciate their importance, block them out with your thumb and look at the rest of the painting. Then remove your thumb and observe the vital relationship between tree and geranium. Their kinship is strongly felt, not only biologically. There's a tension-pull between the top of the painting and the bottom. The geranium, at the bottom, comes alive only because the tree, at the top, is there!

Plate 4. *Henri Matisse: Piano Lesson. Oil on canvas, 6' 11¾" x 8'½" (2,108 x 2,450 mm). The Museum of Modern Art, New York. Shapes of flat color are rhythmically related to each other and integrated throughout as one unified whole. Note Matisse's textured curvilinear lines as submotif, as well as his delicate variety of lines in the upper right.*

As a young artist, Matisse, among others, continued the revolutionary work of Post-Impressionist masters. He was a leader of a group called Les Fauves (wild beasts) for their vigorous paintings of "outrageous" colors. Matisse was influenced partly by the textural patterns of Persian art. A master of composition, he kept reaching for more exciting combinations of brilliant color relationships throughout his long career. These were always expressed with loving care and tenderness in his search for serenity and simplicity of esthetic unity. Volume, depth, and other illusions of three-dimensional space were kept to a minimum.

(Above) Completely closed geometric negative shapes are emphasized by heavily bordered lines. The dotted lines identify lines of closure. In this instance, they separate positive (P) from negative (N) shapes. Note also how the shape of the boy's head (P) relates as a submotif to the curvilinear shapes at the left and simultaneously serves as part of the negative (N) shape.

Plate 5. Georges Braque: Still Life: The Table. Oil on canvas, 45¼″ x 57¾″ (1,149 x 1,465 mm). National Gallery of Art, Washington, D.C. The textural quality in a painting that evokes its own distinctive feeling is related primarily to the sense of touch. (See Plate 13, Texture in Collage, for another example of how texture is used to structure a composition.) I chose this painting to illustrate two kinds of texture: the first one simulates the nature of surfaces, in this instance wood grain and wallpaper; the second kind simulates the markings that might ordinarily appear in the weave of a fabric. Such markings have been placed arbitrarily in a glass and as dashes in the newspaper Le Jour.

Braque was equally responsible with Picasso for developing Cubism from the very beginning. Because of the imitation of textural surfaces, the form of Cubism shown here was named Synthetic Cubism.

Plate 6. Joan Miro: Red Sun. Oil on canvas, 36" x 28" (914.4 x 711.2 mm). The Phillips Collection, Washington, D.C. Nonrepresentational, abstract, or near-abstract art may be difficult for the traditional painter to accept. Yet the artistic world has long accepted the subconscious symbols of painters such as Miro. They're recognized as poetic eminations of pure lyrical sensation that require no naturalistic interpretation, despite the literary title in this case. While Miro organizes the visual elements of composition automatically, balancing shapes, tones, lines, textures, and colors with uncanny rhythmic precision, he himself doesn't know from what primitive source his paintings derive or what they mean. If we choose, we can read into them the needs that exist within us or our own feelings of his native Spain—memories of the arabesques of Granada or Seville, the drawings in the prehistoric fresco of La Pileta (Malaga), or the Ice Age paintings of Altamira (Santander).

(Above) If you have difficulty distinguishing tonal relationships in color, take a black and white photograph. Since this eliminates the color but retains the light and dark values, a comparison of the photograph with the painting may reveal some surprises in tonal differences not clearly seen before.

Plate 7. Pablo Picasso: Three Musicians. Oil on canvas, 80″ x 74″ (2,032 x 1,879.6 mm). Philadelphia Museum of Art, Philadelphia. Harmonizing light and dark tonal relationships in painting closely follows the integration of shape relationships. Note the balanced light and dark relationships in this Cubist-inspired painting by Picasso. Observe the use of strong flat colors balanced by notes of simulated textural patterns.

Both Picasso and Braque were the masters of Cubism, strongly influenced by the work of Cézanne and possibly African art. "When we created Cubism," said Picasso, "we had no intention of creating Cubism, but simply of expressing what we felt within ourselves." Among other things, what they were trying to do was give the effect of three-dimensional volume on the two-dimensional surface without using perspective, modeling, light and dark gradations, and other traditional means.

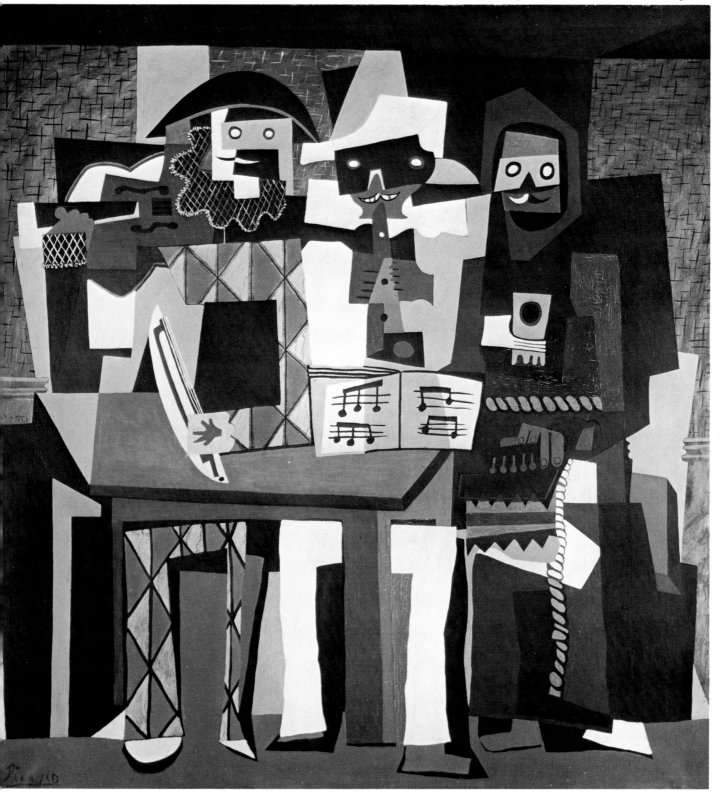

Plate 9. *(Above) Georges Rouault: Afterglow, Galilee. Oil on canvas, 19¾″ x 25½″ (500 x 647 mm). The Phillips Collection, Washington, D.C. Strong religious influences at various times in his career, plus his experience as an apprentice to a stained-glass maker, show up in Rouault's works. The unrestrained color used by his avant-garde contemporaries influenced him against the murky colors taught in school. The combination of these influences resulted in brilliant, intense colors used with a limited palette to produce emotionally charged paintings that vibrate with exalting Byzantine feelings.*

Plate 8. *(Left) Gerrit Hondius: The Lovers. Oil on composition board, 30″ x 24″ (762 x 609.6 mm). Collection of Mr. and Mrs. Milton Stettner, Roslyn Harbor, New York. Note how the warm reds and yellows as well as cool blues are enclosed in distinct shapes, making it easier for us to identify them and weigh their relationships. Observe that while warm colors usually advance and cool colors recede, Hondius has forced the warm colors in the upper left to stay in the background, while the blues in the costume advance. (See Plate 12, Intensity to Muted Color Relationship, for another example of how color is used to structure a composition.)*

 Hondius was considered a painter's painter, functioning on numerous levels simultaneously. The beginner should study how Hondius spaced two-dimensional shapes—positive and negative—with such unerring relationship to each other in the struggle for total integration. Three-dimensional form is enhanced by such treatment and requires none of the modeling in traditional portrait paintings. At the same time, color itself acts as form.

Main Geometric Two-Dimensional Shape Motif: Diagonal

Plate 10. *(Top right)* Tribute to Gerrit Hondius. *Collage, acrylic on burlap on composition board, 24" x 18" (609.6 x 457.2 mm). I started this painting to pay tribute to the memory of a good friend, but as Picasso once remarked, "One never knows what one is going to do. One starts a painting and then it becomes something quite else." At the end, the feeling intended must be completely interlocked with all compositional relationships.*

Plate 11. *(Bottom right)* Above and Below. *Acrylic on composition board, 18" x 24" (457.2 x 609.6 mm). Geometric shape motifs, when rhythmically related, vitalize the composition. Various fundamental motifs are shown in Plates 2, 3, 6, 9-11 so the beginner will become aware of them. Note, however, that they should not be used as a formula.*

All I remember when I started this painting was that I had an urge to express the feeling of water—inlets surrounding a harbor, the sea. (This drive keeps recurring at intervals, perhaps because I've lived most of my life within sight of water. Even in my travels, I settle near water.) While my feeling for the flow of water seemed to permeate the painting, the shapes of colors made a pattern on the picture plane that approached the geometric motif of the rectangle. The point is that I didn't initiate the rectangle. It might just as easily have been the horizontal, diagonal, or vertical, all of which turn up as submotifs. Shape motifs should never be used as a formula.

Main Geometric Two-Dimensional Shape Motif: Rectangle

Plate 12. Menlo No. 2. Acrylic on composition board, 17½″ x 18″ (444 x 457.2 mm). The spiritual significance of the three wise men in a banal creche in a shop window at Christmas partly influenced the harmonizing of relationships and mood in this abstract painting. (The title merely identifies it as the second painting completed in California.) It illustrates another form of color relationship that may be used as an alternate to warm and cool relationships. If any colors in a painting are disturbing, there may be too many brilliant colors. Use the blocking-out test to decide which one color (or even two colors) "feels" right. Then proceed to reduce the intensity of the too-brilliant colors by adding a little of the complementary color to each. Check the painting as a whole again. If necessary, apply more color over color until there's a balance of brilliant to muted tones. Here, red is the intense color that unifies the painting.

Plate 13. East-West. Collage: burlap, canvas, and paper on painted burlap on painted composition board, 19¼″ x 18″ (489 x 457.2 mm). Texture, like color, can affect us strongly. A wide range of textural responses are possible in painting, and collages offer unusual possibilities for significant textural expression.

This collage started originally as an acrylic painting on compositon board, but I was dissatisfied with the quality of Oriental mood I felt but could not evoke. I put it aside until one day I received a package covered with burlap. I placed the latter over the painting and saw certain subtle colors shine through. This started me relating colors on the burlap with colors underneath on the board. From then on, I began the struggle to reconcile contrasting feelings of East and West by adding pieces of canvas, paper, and a variety of burlap strips into a cohesive whole, integrating shapes, colors, tones, lines, and textures as one.

One Method of Applying Color over Color

Negative Space: Completely Open

Plate 14. *(Top left) A painting that is satisfactorily integrated in color shows sensitive relationships of each color area to neighboring areas. Plate 14 is an exercise demonstrating one simple, but effective method of applying one color over another. The important point is you must feel right about any color next to and over another. If you don't like a relationship, keep on changing it until you do.*

How you approach the task makes the difference. Feeling for sensitive color relationships is a challenging game of developing the right hemisphere of the brain. Why is that? We normally use the left side when we're taught to paint. It's connected with the muscles that we develop to achieve skill and technique in painting, as well as to feel the pleasures of such achievement. So, the painting skills you now repeat so easily, coming from the left side of the brain, tend to dominate your consciousness. Free-wheeling, letting go, "playing" with color relationships will allow your personal signature of color sensitivity to appear.

Plate 15. *(Bottom left) Impressions—Nihon. Acrylic on composition board, 24" x 18" (609.6 x 457.2 mm). Most compositional problems stem from neglect of the negative unoccupied space. Negative space is just as important as positive subject matter, and it needs to be interlocked in a sensitive rhythmic relationship with the rest of the picture.*

For beginners, I urge the use of closed negative shapes as in Plate 4. Avoid, for now, the completely open negative space as in Figure 67. The partially open negative space as in Plate 1, while not as difficult to balance as that in Figure 67, should also be avoided for the present.

Here, impressions of Japan—a country whose art and culture has had a tantalizing impact upon me—keep returning in different forms, when I least expect it. This is an example of completely open negative space in which the placement of the abstract sun is crucial in relation to the surrounding open space.

Crowded Space 5

When a painting is cluttered with too many things or people, or both, it's usually called "busy" or "overcrowded." If you're aware of it, you'll probably correct it by eliminating something. This may be the obvious solution, but not necessarily the only correct one.

Then again, a much more serious situation may exist. You may be *unaware* that a drawing or painting is overcrowded. Here, studying masterworks may not really help because problems of overcrowding have already been corrected and you're experiencing the positive qualities of good composition.

A master can be counted on to do a magnificent job of composing a crowd. Yet in viewing the painting, the novice may not see the visual cues and clues, nor feel the tensions, distortions, and rhythmic movements that the artist has introduced to balance the composition as a structural whole.

A beginner may be attracted to the *technical skill* shown in the rendering of a crowd by a painter who himself is unaware that his composition is neither balanced nor supported by expressive feeling. Here the novice may

Plate 16. *Willem De Kooning: Pink Lady. Oil and charcoal on composition board, 48⅜" x 35⅝" (1,229 x 904 mm). Collection of Mr. and Mrs. Stanley K. Sheinbaum, Santa Barbara, California. Textural and line relationships are exceedingly important. When balanced properly, they enhance the painting's sensitivity.*

I chose this painting of De Kooning's early series of Woman because his form of abstract expressionism depends less on color than on his virile line. As the critic Hilton Kramer said, "Painting for De Kooning became more and more a form of drawing." In this painting colors are reduced to large areas of reds, yellows, and greens and the explosive line—with its great variety—dominates the painting. As in Figure 157, the illusion of three-dimensional volume is created mainly by the use of line instead of light and dark shading. Nevertheless, while line dominates, his color simultaneously integrates as form.

simply be reacting to the subject matter without being aware of the compositional lack.

How, then, can you learn when the composition is overcrowded or not balanced? Or if you are sensitive to overcrowding in a picture, how you can solve the problem?

Comparing Various Stages of a Composition

It takes time and constant practice to read a picture for visual clues. The most fruitful way I've found is to study and compare various stages of a composition.

Observe Figure 92, for example. This is by Piranesi, the famous 18th-century Italian etcher. It's a most skillful rendering of *The Harbor and Quay, Called the Ripa Grande*. Piranesi was indeed a master—enjoy his almost endless detail with a magnifying glass.

The triangular geometric motif, formed by perspective lines of the buildings on one side, the cliffs on the other, and the clouds in the sky, is dynamic and dominant. Note how he stabilized the composition by emphasizing the two large vertical masts. They force your eye away from the dead end of perspective to the foreground where the action in this busy port is taking place.

I believe the more Piranesi studied his etching, the more uncomfortable he became. He probably felt he'd been concentrating too much on the loading and unloading of supplies and merchandise. He was definitely aware that unless the composition was unified throughout, the etching couldn't function as a work of art.

Finally he must have concluded that it was overcrowded and "busy." In Figure 93, see how he opened up space by eliminating a ship loaded with cargo. The difference is astounding. When I first saw Figure 92, I felt a constriction around my throat: the congestion of the harbor. Then, seeing Figure 93, I began to breathe freely again. I'm sure Piranesi felt the release of pressure.

How did Piranesi know which part of that closely woven composition to eliminate? By *masking* different areas until he found the right one. Observe in Figure 93 how the additional geometric submotifs are now clear. Note how the arcs in the furled sails and curves of the boats provide additional rhythmic movement to support the total composition.

Figure 94 is a photograph taken at the edge of a lake. Unlike Figure 92, the central theme, figures in a boat, occupies so much of the entire surface space that the problem of crowding is less obvious and may be overlooked. By blocking out each of the three adjacent boats and testing the rest of the picture each time, you'll probably arrive at the composition made by the 19th-century American artist Theodore Robinson in *Two in a Boat* (Figure 95).

How Rembrandt Improved Crowded Space

In Figure 96, a dry point called *Christ Presented to the People*, let's study Rembrandt's way of handling crowds. Note the main motif of the rectangle and the comparatively large open spaces. Yet, in a later stage (Figure 97), Rembrandt didn't hesitate to eliminate many of the carefully drawn figures in the foreground.

In doing so, he worked to gain not only more open space but a more harmonious relationship of light and dark tonal values throughout. Note how the latter also emphasizes the contrasting motif of the arc.

There are quite a number of changes he made throughout. Turn both states of the dry point upside down and compare them carefully. Note how tonal values are interlocked with the accompanying spatial changes.

Correcting Crowding by Changing Tonal Values

The compositional problems of overcrowding are not always solved by reducing the number of elements. Figure 98, for instance, feels somewhat crowded. It's a 16th-century engraving of *Christ and the Woman Taken in Adultery* by Pieter Perret, after the master, Pieter Breughel, the Elder. Although the central figures have sufficient space around them, the rest of the picture seems overcrowded in relation to the total two-dimensional surface area.

One might argue that the artist intended the viewer to feel the uncom-

Figure 92. *Giovanni Battista Piranesi: The Harbor and Quay, Called the Ripa Grande. Etching, state I, 14 7/8″ x 24″ (371.8 x 609.6 mm). The Metropolitan Museum of Art, New York. Piranesi concentrated too much on the life of an active port, and not enough on spatial relationships here. Yet you can enjoy the masterful rendering of almost endless detail in this etching with a magnifying glass.*

Figure 93. *Giovanni Battista Piranesi: The Harbor and Quay, Called the Ripa Grande. Etching, state III, 14 7/8″ x 24″ (378.3 x 609.6 mm). Photo: Prints Division, The New York Public Library, New York. After concluding that Figure 92 was overcrowded and "busy," Piranesi opened up space by eliminating a ship loaded with cargo. How did Piranesi know which part of the closely woven composition to eliminate? By masking different areas until he found the right one.*

Figure 94. *This is a photograph taken at the edge of a lake. The central theme of figures in a boat occupies so much of the entire surface space that the problem of crowding is less obvious than in Figure 92. Photo: Paul Juley.*

Figure 95. *Theodore Robinson: Two in a Boat. Oil on canvas board, 9 3/4″ x 14″ (248.1 x 355.6 mm). The Phillips Collection, Washington, D.C. By blocking out the three adjacent boats one by one and testing the rest of Figure 94 each time, you'll probably arrive at the composition Robinson made here.*

Figure 96. *Rembrandt van Ryn:* Christ Presented to the People. *Drypoint, early state, 358 x 455 mm. Photo: Prints Division, The New York Public Library, New York. Note the main motif of the rectangle and the comparatively large open spaces. Yet, at a later stage (Figure 97), Rembrandt worked not only to gain still more open space—to avoid crowding—but also to attain a more harmonious relationship of light and dark tonal values throughout.*

Figure 97. *Rembrandt van Ryn:* Christ Presented to the People. *Drypoint, state VII, 358 x 455 mm. Photo: Prints Division, The New York Public Library, New York. Turn Figures 96 and 97 upside down and compare every bit of them carefully. Note especially how tonal values have been interlocked with accompanying spatial changes.*

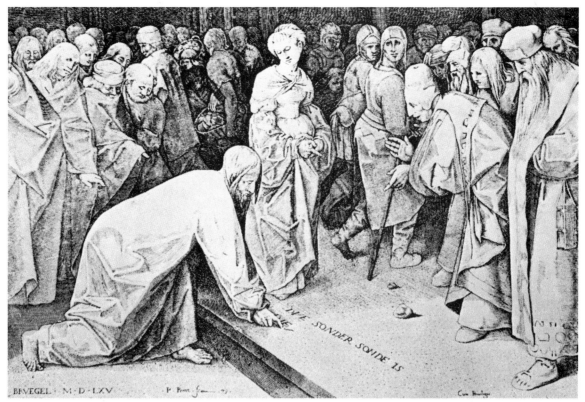

Figure 98. *Pieter Perret: Christ and the Woman Taken in Adultery (after Peter Breughel, the Elder). Engraving. Photo: The New York Public Library, New York. While the central figures appear to have sufficient room, the rest of the picture seems overcrowded when checked in relation to the total two-dimensional surface area. From an esthetic viewpoint, the repetition of so many heads in a line becomes monotonous.*

Figure 99. *Pieter Breughel, the Elder: Christ and the Woman Taken in Adultery. Grisaille on panel, 24.1 x 34.4 cm. Collection of Count Antoine Seilern, London. Photo: The New York Public Library, New York. The compositional problem of overcrowding is not always solved by reducing the number. Observe how Breughel subordinated the crowd, in comparison with Figure 98 by making it less conspicuous. The effect was accomplished by emphasizing the central figures in strong light and dark relationships.*

Figure 100. (Above) Eugenio Zampighi: The Peasant Home. Oil on canvas, 29" x 41 1/4" (736.6 x 1,047.9 mm). E.B. Crocker Art Gallery, Sacramento, California. Here's another kind of space that's called "too busy"—a hodgepodge with neither substance nor inner feeling. It's contrived with devices to create unity in composition, but the concept fails because there are so many individual items of subject matter, all struggling for equal attention. Compare it with Figure 101.

Figure 101. (Right) Diégo Velázquez: The Servant. Oil on canvas, 21 7/8" x 41 1/8" (549.6 x 1,044.6 mm). The Art Institute of Chicago, Chicago. Note the number of vases and other objects spread all about, but what a difference in the quality of mood, spacing, and tonal values when compared with Figure 100. Observe how shape and light in the turban create a spatial tension between it and all other items, thus unifying the entire painting.

fortable pressure of the crowd. However, from an esthetic viewpoint, the repetition of so many heads in a line becomes monotonous. Composition should always be determined in relation to the whole surface. Breughel was aware of this. Observe how he subordinated the crowd in the original painting (Figure 99). He didn't eliminate any of the many heads, but made them *less conspicuous*. The crowd is present, but it doesn't interfere with the theme of the painting. The effect was accomplished by emphasizing the central figures in strong *light and dark relationship*. If you've any doubt about Figure 98 being overcrowded, just compare it with Figure 99.

"Too Busy" Space

There are many variations of "too busy" rather than overcrowded space, but Figure 100 gives you a general idea of it. This 19th-century painting, entitled *The Peasant Home,* shows a high degree of academic, technical skill. But is it art? I'm afraid not—it's only a sentimental pictorial anecdote. Nevertheless, it probably appeals to a vast number of people. That reminds me of George Bernard Shaw's saying, "If more than 10% of the people like a painting, you can be sure it's bad."

To Eugenio Zampighi, like many of the 19th-century artists, the esthetic elements that form the structure of a work of art were either greatly underestimated or unknown.

The painting is a hodgepodge with neither substance nor inner feeling. It's contrived with devices to create a circular movement unifying the composition, but the concept fails.

The eyes of both adults and two children face the infant, directing the viewer toward the apparent center of interest. Then, the focal point shifts to the boy playing with the kitten, onward to the chicks, and back to the central figures.

Note another device: the girl at the left clutches the chair on which her mother sits, who in turn pats the little boy who has wrapped himself around the grandfather who holds the infant. Five figures are interconnected, but the union is not integrated with the rest of the canvas. There aren't the kind of interdependent compositional elements that make for harmony and artistic quality.

If we assume that the geometric rectangle is the dominant two-dimensional shape motif, the only point of real interlocking is the vertical side of the chair at the left with the vertical edge of the fireplace above. There are no underlying rhythmic relation-

ships among the various rectangular shapes, nor have light and dark relationships been balanced as a whole or used with feeling to interlock the rectangular shape relationships.

But the worst offense is that so many individual items of subject matter are included, both on the walls and on the floor. There are no sensitive spatial relationships among them, which are so difficult to create when figures are surrounded by open negative space. Instead of a variety of rhythmic relationships in shape motifs or values, there's a variety of too many objects, all struggling for equal attention and thereby creating the busy character of the painting.

Compare this with the painting of *The Servant,* by the Spanish master Diégo Velázquez (Figure 101). Note the number of vases and other objects, but what a difference in the quality of mood, spacing, and tonal values. This proves that a painting may have many objects in it and not be busy. Note how shape and light in the turban create a spatial tension between it and all other items. Thus, the turban not only harmonizes the light and dark values but unifies the entire painting as one. Verify this with the blocking-out test.

Project 13: Simplifying a Composition

In this project, we have the problem of crowded buildings. Figure 102 is a photograph of an old tenement section of New York City, taken by artist Steve Raffo in preparation for a painting.

Your assignment is to simplify the composition. There are many ways to approach the problem. But if you get into trouble, remember to establish both a dominant and a contrasting geometric shape motif, as well as harmonious light and dark relationships overall. And don't forget to let down and work with feeling.

Make Four Drawings

Your instructions are as follows:

1. Use an 8″ x 10″ (203.2 x 254 mm) sketch pad and a very soft #1 compressed charcoal stick.

2. Do a freehand drawing, adding or eliminating any subject matter you wish. But do it quickly, for this is just to warm up and get you moving.

3. After you've compared it with Figure 102, do a second drawing, using your charcoal *broadside*. Break it in half if it's too big. You'll notice a clarity of composition almost immediately, because working this way usually results in large shapes and in strong black and white relationships. Close all negative shapes, if you can.

4. After you've gone as far as possible in mood and organization, let an interval of time elapse—even a few days.

5. Study both drawings carefully, checking them for possible improvements in shape and tonal relationships. Now do a third drawing. This time, capture the feeling of the place at sunset with strong shadows.

6. In the final drawing, simplify not only the spacing of buildings, but introduce at least two figures. Keep the figures simple, but remember to check out figure-ground relationships carefully.

7. Make separate cutouts of figures and move them around against the shapes of buildings and foreground until you establish the most sensitive relationship—not only to the foreground, but also to the whole composition.

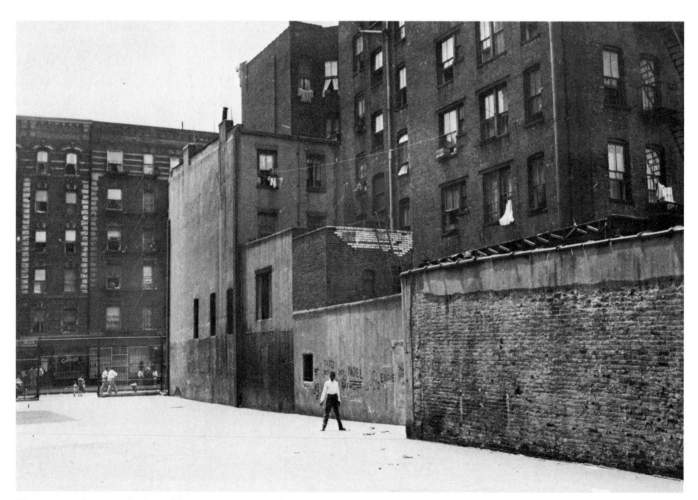

Figure 102. *Photograph of an old tenement section of New York City, taken by artist Steve Raffo.*

Case History 13: Raffo

City Sunset (Figure 103) is a painting by New York artist Steve Raffo, composed from Figure 102. I chose them to help you visualize how a composition can be simplified and crowding eliminated.

Raffo saw that there were just too many windows in the photograph. In addition, the buildings seem to press upon each other, with little breathing space between them.

What attracted him to the scene was the boy, feet spread apart, standing against the background of a low building. He became quite interested in the shape and spacing of the small window next to the boy, and the windows in the adjacent buildings were a real test in balancing *figure* placement in open, negative *ground*. The three

narrow vertical windows needed to be related to other windows in the foreground, as well as to the whole composition.

The problem facing Raffo was how to retain the mood and feeling of the city tenements at sunset, while focusing on the center of his interest. To do this, he had to be highly selective in transforming the subject matter in the photograph. He very subtly simplified and subordinated everything else to the boy and the windows.

How Raffo Developed His Composition

Raffo cut down the outside dimensions first. This brought the negative sky shape into balance with the rest of

the painting.

Next, he introduced large, vertical shapes of varied sizes in the background. The windows in the tenement buildings were purposely eliminated or placed in deep shadow. Thus, they no longer compete with the three narrow windows that captured Raffo's imagination. The buildings, accenting the major geometric shape motif of the vertical, now stand out more prominently than in the photograph, despite their simplification—or, more likely, because of it.

While he worked to vary his vertical shapes and to unify them, Raffo distributed light and dark values in a dynamic relationship, startlingly different from those in the photograph.

The low buildings appearing in the

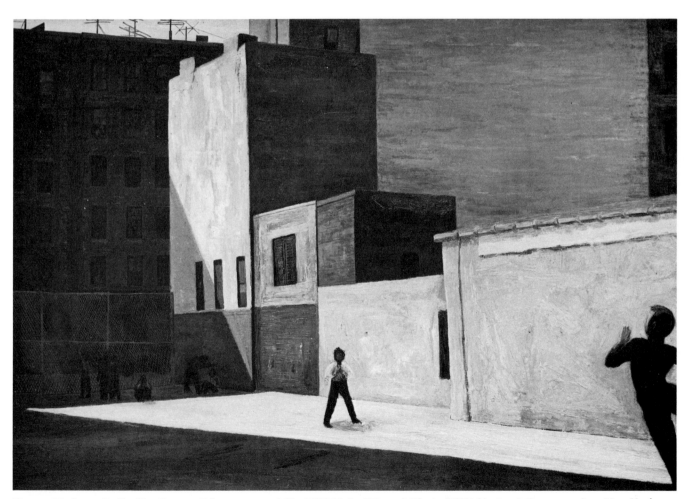

Figure 103. *Steve Raffo: City Sunset. Oil on canvas, 24″ x 20″ (609.6 x 762 mm). Photo: W.W. Norton & Company, Inc., New York. While eliminating overcrowding in Figure 102 was the artist's main concern, the juggling of the figure-ground relationship of the unusual geometric shapes of the boys, in contrast with the stable but sensitively spaced, vertical windows, provided Raffo with plenty of creative interest and movement.*

foreground of the photograph, with their perspective movement to the left, suggest the geometric triangle as a shape motif contrasting with the vertical. Below these buildings, the bright area of playground forms an opposing triangle pointing to the right.

Raffo divided the playground into two shapes, darkening one of them to add another note of variety. The dark area forms a triangle moving to the right. The light area combines with the light of the low buildings to form a big triangle moving left in opposition. He also introduced rhythmic repetitions of the triangle with a large shadow in the light vertical building. The repetitions are within, and alongside, the large triangular shadow. Note how the shape of the central figure also forms another triangular rhythmic relationship.

Raffo flattened out the roofs of the buildings somewhat, in comparison with the sharp perspective angles in the photograph. In this way, he brought the buildings closer, and more parallel, to the viewer. He also brought the action forward by placing the figures at the left *inside* the playground. In addition, he placed the fig-

ures in deep shadow, not only to maintain the light and dark relationship of the whole painting, but to subordinate them to the central interest.

Note how Raffo dramatized the few windows so prominent in the painting. The small window is no longer next to the boy. It has become a very important narrow vertical, echoing the pattern of the three vertical windows at the left that are sharply etched against the broad expanse of wall reaching up to the roof.

Not only did Raffo vary the size and shape of the windows in the foreground, but he was particularly fascinated with their contrasting relationship to the unusual triangular shape of the boy. The latter presented a difficult challenge in figure-ground relationships. The placement against the open negative space behind had to be spaced just right. Changing the shape of the window next to the boy to a vertical and shifting it away from the boy was a happy solution.

Raffo did not overlook the low building at the right in the photograph. The space within felt empty. In some respect, this was his greatest challenge. Unless this area were per-

fectly integrated, his whole composition would fall apart. Here, he introduced a dynamic diagonal figure, full of action, which served several purposes. First, it was a necessary dark tone to balance the light and dark relationship of the composition as a whole. Second, as a diagonal it related to the diagonal of the extended leg of the small boy. And, third, it was a figure-ground placement against the open negative space in the shape behind it.

The Lesson to Be Learned

Eliminating the crowded or busy feeling in a picture is never, in itself, sufficient as a goal. There must always be a positive driving force. Here, the juggling of the figure-ground relationships of the unusual geometric shapes of the boys, in contrast with the stable but sensitively spaced vertical windows, provided Raffo with plenty of creative interest and involvement. In addition, he was inspired by his overall conception—the nuances, feelings, and inner excitement—of a city neighborhood at sunset.

Project 14: Building Up a Composition

In the previous project, you were given an overcrowded situation that you had to reduce in some fashion. Such reduction can be termed the "subtractive method" of balancing a composition.

In this project, you're to do just the opposite—*build up* a composition. Figure 104 is a drawing by the great Spanish painter and etcher Francisco Goya of a group of people dancing before a large crowd. The banner symbolizes the festive occasion they're celebrating.

Remember that a crowd of people in a composition is not necessarily synonomous with an overcrowded composition. The purpose of this assignment is to portray crowds in a composition without overcrowding.

Portray a Crowd without Overcrowding

Your instructions are as follows:

1. Use a 5B or 6B black pencil to cover large areas and a 2B for occasional detail. You'll need an 8″ x 10″ (203.2 x 254 mm) sketch pad and a gum eraser.

2. After studying Figure 104, start doodling your first drawing, without considering what the outcome may be. One proviso: retain the feeling of joy.

3. Be sure *not* to balance tonal values or shape relationships while you work. Have fun, let yourself go, and see what happens.

4. When you've finished, check if it feels overcrowded. If it is, *don't* change it.

5. Instead, check whether you've *unconsciously* balanced tonal values and shape relationships. If you have, it means that you're beginning to develop the habit of integrating your work as a whole. This is a plus. But don't fret if the relationships are not balanced. Merely determine whether the main geometric shape motif needs to be fortified and what improvements should be made to repeat and contrast the dominant motif. But *don't* make the changes. Study the tonal values to see where improvements can be made, but *don't* change them. Put the drawing aside for another time.

6. Spend your energies on a second drawing. This time include a crowd in

fear or panic. If you wish, refer to magazine, newspaper, or other illustrations to refresh your memory of what fear or panic looks like. Carefully check this one for shape and value relationships. Don't forget that the geometric diagonal can help establish dynamic action.

7. In the third drawing, try composing a crowd at a political rally, with some hecklers arguing with the speaker. Finish it very carefully after checking

for relationships. Should the composition be overcrowded or unbalanced, and should you have trouble correcting it, don't hesitate to be ruthless. Turn the composition upside down. Check and *erase* areas, even though you may destroy some finished work. Remember you can make corrections in shape and value relationships by *working* in areas upside down and then completing the composition later right side up.

Figure 104. *Francisco Goya:* The Burial of the Sardine. *Sepia, pen and ink, 220 x 180 mm. Prado, Madrid. Compare this quick sketch with Goya's painting (Figure 105), a dynamic composition of crowds in movement, with no feeling of overcrowding.*

Case History 14: Goya

Figure 105 is a painting entitled *The Burial of the Sardine* by Francisco Goya (1746–1828), the outstanding Spanish painter of his time.

The best way to appreciate the complex temperament of this vital artist is to visit the Prado, the principal Spanish art museum in Madrid, where you can study the vast collection of his works. This painting depicts only one facet of his varied skills in oil paintings, frescoes, ink washes, aquatints, etchings, and drawings.

In his early work, as a painter in the court of King Charles IV, his portraits show a brilliant mastery of varied techniques in rendering the luminous qualities of lavish costumes and precious jewelry. Despite deafness as a result of illness, he enjoyed the contact with high society.

A strongly individualistic and fearless person, his reputation grew rapidly even though his portraits gave no quarter to flattery—not even to royalty. The portraits were subtle, cynical, and penetrating psychological analyses of hollow characters, surrounded by the extravagant trappings and shams of a decadent society.

Goya's work changed radically as he reacted to the tumultuous times. After the abdication of King Charles IV during the Napoleonic invasion, Napoleon's brother, the former ruler of Naples, was placed on the throne. Eventually, the Bourbons were reinstated with Ferdinand VII, when Wellington drove the French out of Spain. The terrifying horrors of the war during the collapse of regimes— the brutality and suffering, the corruption and hypocrisy—expressed by Goya in fantastically imaginative, bitingly satirical, and gruesome ways.

Yet in Figure 105, we see a less-known side of his character—his reaction to the joy and carnival fun of an old Spanish custom. *The Burial of the Sardine* symbolizes the end of Lent and the beginning of flowering Spring.

No Feeling of Overcrowding

I chose this painting to show how Goya developed a dynamic composition of crowds in movement. First, note that there's no feeling of overcrowding.

Second, compare it with his sketch (Figure 104). It makes us immediately aware of the importance of tonal and shape relationships. For example, observe how the vast crowd is enclosed in a large rectangular shape, separating it from the larger rectangle of the sky above it, formed by the three edges of the canvas.

The dominant diagonal motif of the dancers is echoed by the diagonal tree above them and supported by the diagonal banner. Note how subtly Goya interlocked the diagonal line of the narrow pole holding the banner with the diagonal edge of the female figure below it. He created a tension-pull between the tip of the stick above the banner and the diagonal of the foot of the man dancing on the right.

In addition, the pole and tree form a large triangle, repeating the triangular pattern of the dancers. Look for the small, sharply outlined triangular shape between the banner and tree. This is no accident. It complements the triangular motif in a forceful, yet unobtrusive way.

Don't overlook the joyous face in the banner and how the infectious grin sets the carnival mood. The curve of the smile duplicates the arc formed by the outstretched arms of the dancer below it.

Now, turn your attention to the strong balance of light and dark relationships throughout. Without them we wouldn't experience the dynamic action of the painting to the fullest extent. The dark banner against the light sky unifies the tonal harmony. Block it out and test for yourself what happens to the rest of the painting when it's eliminated. I say this to remind you that your awareness and appreciation of artistic relationship grow and develop by testing masterworks, as well as your own work in progress.

There are many more nuances in shape and tonal relationships for you to discover at your leisure, but let me point out one more that may puzzle you. If you look closely, the geometric shape motif of the crowd *is* rectangular. However, it has been purposely angled to relate in a subtle way to all other diagonals. The double use of what appears at first to be a single motif comes up fairly often in works of art. Goya learned this from the paintings of earlier masters and you should keep this in mind in studying masterworks.

The Lesson to Be Learned

Overcrowding in composition can be avoided by paying strict attention to two-dimensional surface shape relationships and light and dark relationships that are stressed throughout this book. Don't worry about the illusion of the third-dimension. It's almost always present in your drawings and paintings, whether you do anything about it consciously or not. In fact, for our purposes it practically takes care of itself during the two-dimensional process.

Build a sound foundation in two-dimensional relationships to gain the coveted core of composition. While you can definitely improve your composition in two dimensions *without* three-dimensional techniques, you *can't* improve the three-dimensional illusion without establishing two-dimensional relationships.

Figure 105. *Francisco Goya:* The Burial of the Sardine. *Oil on wood panel, 83 x 62 cm. Academia de San Fernando, Madrid. By comparing this with the sketch (Figure 104), we see that overcrowding in composition can be avoided by paying strict attention to harmonizing two-dimensional surface shape relationships and light and dark relationships.*

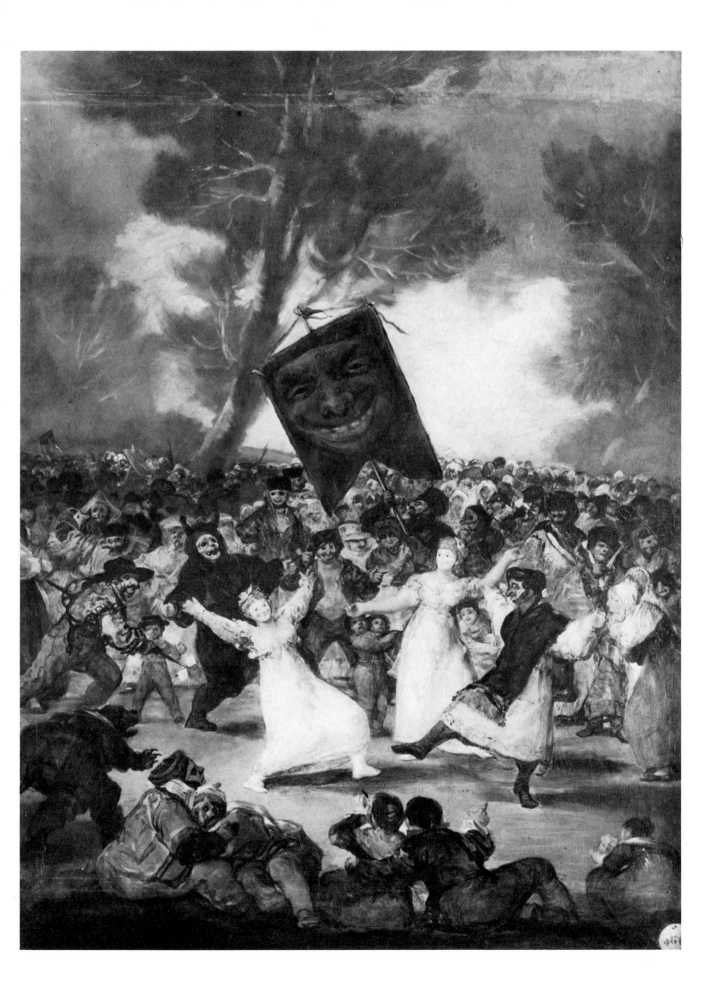

Project 15: Study and Sketch

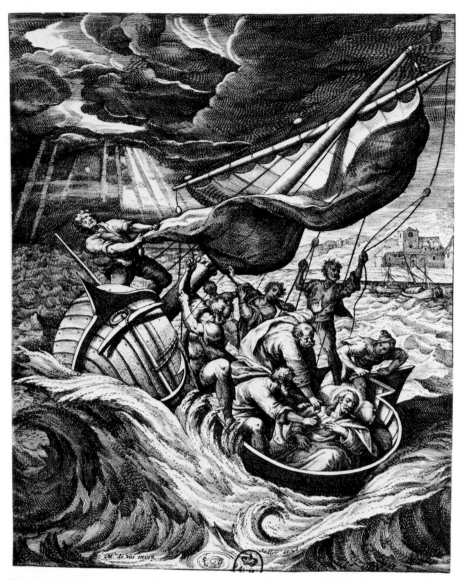

Figure 106. *Marten de Vos: Christ in the Storm on the Lake in Galilee. Engraving. Bibliotheque Nationale, Paris. Study this carefully over a period of time to make a value judgment: Is the composition too busy or too crowded? Did de Vos push the compositional elements too far, possibly negating the total effect?*

In the first part of your assignment, make a value judgment about Figure 106, an engraving by the 16th-century Flemish artist Marten de Vos, called *Christ in the Storm on the Lake in Galilee.*

This isn't going to be easy. We can tell at a glance that the artist's conception of a storm is tremendous and that his skill in rendering his conception is superb.

The question is whether he pushed the compositional elements too far. Did he overdo a good thing? Did he vitiate the power of the total effect? You may or may not decide that the composition is too crowded or too busy, that it needs more space. You may or may not like his style or degree of forcefulness. You may or may not find fault with his composition.

Don't make a snap decision. Study Figure 106 over a period of time. Beside masking or blocking out every area of the picture to test it for spatial and light and dark relationships, look at it in more detail. Use a magnifying glass to study the variety of textural strokes and variety of lines. Note how he distorted the boat. Study the position of each figure. Observe carefully the dynamic major and contrasting geometric shape motifs he utilized to establish violent movement.

The purpose of the first part of the assignment is to heighten your powers of observation and esthetic sensitivity, as well as your appreciation of technical skill. This can't be done all at one time. Come back to study it again and again.

In the second part of the assignment, make a quick sketch of a boat in a storm at sea, using a very soft charcoal stick broadside on an 8″ x 10″ (203.2 x 254 mm) sketch pad. After checking the result carefully and noting where improvements can be made in shape and tonal relationships, do another sketch in more detail on 18″ x 24″ (457.2 x 609.6 mm) charcoal paper. The purpose is to take full advantage of all you've learned in studying and evaluating Figure 106.

Case History 15: Rembrandt

Figure 107 is a painting by Rembrandt, entitled *The Storm on the Sea of Galilee*. Attracted by the theme of de Vos's engraving, he used it as a springboard to develop his own composition.

Rembrandt's painting is presented here, not to prove that he was a better artist, nor to compare the two, but to make some observations. Whereas de Vos's composition might be improved, Rembrandt's organization of his composition is complete. At least, we can't say its too crowded or too busy.

Don't make a judgment of Rembrandt's painting based on feeling alone. You'd probably assume—incorrectly—that de Vos should have handled his composition in somewhat the same manner. Actually, Rembrandt's mood and feeling are *different* because he expressed the compositional elements in a wholly personal way and in the medium of oil that offers a greater opportunity for subtlety.

I believe, despite the limitations of engraving, that de Vos could have accomplished more by testing his tonal values and spatial relationships more carefully.

Analysis of Rembrandt's Painting

One of the first things I noticed in checking Rembrandt's painting (Figure 107) was the sense of no crowding in the boat. When I counted fourteen people aboard—50 percent more than in Figure 106—I immediately double-checked this feeling.

Just as Breughel avoided crowding the figures in Figure 99 by concentrating on light and dark relationships, so Rembrandt did in Figure 107. Two of the figures are almost completely hidden. Some are in dark tones, others in semidark, and still others in full light.

The full dramatic impact of light and dark relationships, however, comes from the emphasis on *light*. The large light spot on the water as it washes over the boat and some of the men is the key to the harmonious distribution of lights throughout the painting. The strong light carries over to a lesser degree into the sails. From there it fades into the vast sky area.

If you squint your eye, you'll find that lights are balanced—tension-pulls are created—by delicate highlighting on the figures of Christ and on those near him. This continues in the isolated spots of light. Test the spac-

Figure 107. *Rembrandt van Ryn: The Storm on the Sea of Galilee. Oil on canvas, 63" x 50" (1,600.2 x 1,270 mm). Isabella Stewart Gardner Museum, Boston.*

ing of these lights in relation to the whole painting. Block each one out in turn. You'll see they're absolutely necessary to the total balance!

The diagonal shape motif in the mast obviously dominates the painting. It is supported by the adjacent diagonal lines of the ropes. It's bold and forceful—a symbol of violent action.

The geometric submotif of the arc, strongly accented along the inner edge of the sail, enhances the vitality and movement of the whole. The dynamic effect of a curve in proximity to a straight line was well-known to Rembrandt as a compositional device.

If you squint at the left side of the painting, you'll discover that the dark

areas surrounding the sail *extend* the total sweep of the arc at both ends. Observe the extension of the arc into the sky area that almost forms an oval. This repeats the large geometric oval made by the combination of the boat and the sweep of surrounding water.

The Lesson to Be Learned

Overcrowding is avoided by large two-dimensional shape motifs, sensitively organized and interlocked with contrasting motifs over the entire surface. Light and dark values, harmoniously related and carefully checked, can help dramatically reduce overcrowding.

Vertical vs. Horizontal Compositions

6

So far, we've only discussed compositions on the most commonly used *rectangular*-shaped canvas or paper. But there are nonrectangular paintings that you may be interested to note in passing for future investigation.

The *irregular*-shaped canvas is quite popular among some contemporary painters. Their concepts are radically different from the early Christian, Byzantine, and Renaissance artists who decorated the inside of churches with frescoes, mosaics, wood panels, and canvas paintings that conformed to the irregular spaces shaped by various architectural frameworks.

Another form of shaped support still used today is the *tondo*, or *circular*, oval, and other shapes in the round. Still others are the *square* canvas or the *diamond*-shaped canvas (the square canvas turned at an angle).

At this stage, however, stick with the standard *rectangular*-shaped canvas. The use of more varied *sizes*, and particularly more varied *dimensions*, can provide greater challenges, if you wish, without going beyond your depth.

A question that has puzzled not only beginners, but advanced students is why do artists who decide to do additional versions of the same theme change the composition from horizontal to vertical, or vice versa? What advantages, if any, are there in making the change?

It's an interesting question, but it might be more fruitful if directed to individual artists who have made such switches. Unfortunately, the only examples that I've found are works by artists of the past. So we must depend mainly upon clues in their compositions and on any written comments.

You should also study books on how the eye organizes visual material according to psychological and physical laws. I recommend *Art and Visual Perception* by Professor Rudolph Arnheim. You won't find a direct answer to the question there, but you will broaden your insight into art.

Some Emotional Implications of Composition Placement

Try a simple experiment. Place a fresh canvas, 18″ x 24″ (457.2 x 609.6mm), on an easel *horizontally*. Then switch it vertically. Try it a few times. How do you react to the position of the bare canvas without *any* composition on it?

You'll notice that a bare canvas placed horizontally, gives you a sense of solidity because of its broad base, compared with the reaction you feel when the canvas is placed vertically. In that position, the narrow base creates a certain feeling of insecurity, of being top heavy against gravity. (It's lessened if the canvas is firmly clamped.)

So, we might say that it's more natural to paint compositions of peaceful tranquility horizontally rather than vertically. And we might reason that paintings registering apprehensive suspense should be in the vertical position. You might conclude that the placement of a composition depends in a sense upon the kind of feelings you want to express about a subject.

For example, let's assume that you want to symbolize the dependability of a lighthouse. You have a vision of its eminent height and lonely, majestic dignity withstanding the elements of a strong sea or sending out its beacon of aid during a treacherous fog.

Try as you will, your painting conveys none of these qualities.

Did you place the composition horizontally? If so, do it over on a vertical canvas. Make sure its base is fairly narrow in relation to its height, automatically increasing the feeling of greater height. The resulting vertical *negative* shapes surrounding the lighthouse, if related sensitively, will add to this feeling. In addition, the vertical motif of the lighthouse will repeat the rhythm of both vertical edges of the canvas, further enhancing the feeling desired. At least, the composition will show more vibrant tension and possibly gain subconscious apprehension.

Clarifying Your Feeling: An Aid to Compositional Placement

This is only the beginning. The question you must ask yourself is are you really *feeling* an image or merely filling a canvas to depict a scene? The more you can center and clarify your feelings, the greater your impact of expression. It's the *degree* of expressive power aroused that helps your unconscious decision of compositional placement.

Before you can paint the strength of the lighthouse walls and the heavy boulders that support them, absorb their strength in your being.

One way is to do an exercise: stand up; close your eyes; stretch your arms as high as you can, imagine yourself the majestic dignity of the lonely lighthouse. Then spend a moment stamping your feet against the solid pavement. Pound the walls of buildings with your fists. Get the feel of rock and the strength of lighthouse walls into your consciousness.

Then, make a complete change. Sit down quietly with your eyes closed. Make no effort to think about the lighthouse, or the boulders that support it. Your subconscious will already have the message. In fact, try to keep your mind a blank. At first, you'll hear the local sounds around you. Try not to identify them. Let them happen as you sit in silence. Gradually, your true feelings about the lighthouse will begin to emerge through *inner* sounds.

Is it the roar of the sea crashing against the rocky supports of the lighthouse? Is it the sound of rattling rocks and pebbles as the waves recede among the rock crevices? The screeching of gulls? Rain squalls? The pitiful sound of the lonely wind? Or the deep, mournful foghorn?

As you sit, you *become* the lighthouse, the boulders beneath it. You glory in the inner sounds that seem to surround you. Sooner or later, *one* sound will predominate. You become one with that sound. It symbolizes the *real* image of your true feelings.

What you're trying to do during this process is separate your mixed feelings and limit your composition, eventually, to *one overriding feeling*.

Is it the lighthouse that grips you? Or is it the force of the storm? If you decide it's the storm, then you may turn the canvas horizontally to emphasize the broad expanse and force of the sea. The lighthouse becomes secondary.

There's much more to the placement of the composition, vertically or

horizontally, than I've described. As you study the masters, you'll find that some have produced works of art by doing just the *opposite* of what I've suggested—the equivalent, let's say, of creating the feeling of majestic dignity and height of a lighthouse in a horizontal composition!

However, you've many things to learn before you can do complex things. One of the first steps is to give up learning to paint academically. At least for the time being. Give up pouring your emotions into the literary representation of subject matter.

As an alternative, approach subject matter through visual symbols. Shape motifs are elementary emotional symbols. Learn to become aware of their impact. They're not just geometric shapes. Experiment with the tension-pulls and thrusts of shape motifs as professionals do. As Dr. Rudolph Arnheim says, "...all visual form is constantly endowed with striving and yielding, contraction and expansion, contrast and adaptation, attack and retreat...."

Positioning the canvas, horizontally or vertically, is just one more element to consider while learning to combine shape motifs as emotional symbols.

Horizontal and Vertical Versions of the Same Composition

Let's look at two paintings of the same subject by the same artist to see what we can learn. Figure 108 is a *horizontal* version painted in 1778, entitled *Watson and the Shark,* by the American artist John Singleton Copley. Figure 109 is the vertical version painted four years later.

Watson, a successful merchant who ultimately became Lord Mayor of London, commissioned the painting to

Figure 108. *(Above right) John Singleton Copley:* Watson and the Shark. *Oil on canvas, 71 3/4" x 90 1/2" (1,821 x 2,297 mm). National Gallery of Art, Washington, D.C. Compare this horizontal version with the vertical version in Figure 109. It's easier to avoid negative space problems in the horizontal version, which may be considered "cropped." Cropping tends to bring the action forward, sharpening the intensity of the picture.*

Figure 109. *(Right) John Singleton Copley:* Watson and the Shark. *Oil on canvas, 36" x 30 1/2" (914.4 x 775 mm). The Detroit Institute of Arts, Detroit, Michigan. What are the advantages of the vertical composition? What are the disadvantages?*

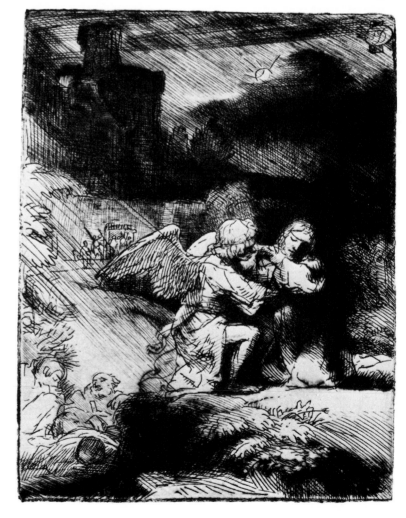

Figure 110. *(Above) Rembrandt van Ryn: The Agony in the Garden. Drawing, 184 x 301 mm. Kunsthalle, Hamburg, Germany. Rembrandt recognized that the vertical unit at the right held the key to his emotional feelings about the composition, so he discarded the horizontal format in the etching (Figure 111).*

Figure 111. *(Right) Rembrandt van Ryn: The Agony in the Garden. Etching, 118 x 83 mm. British Museum, London. In this vertical composition, in contrast with Figure 110, Rembrandt relates the two central figures more directly to the structures and hills beyond. The strong, contrasting tonal values make the dark massive structures and hills appear monumental. Note how subtly Rembrandt placed his center of interest into a rectangular frame that is repeated and varied in the upper-left corner.*

commemorate a tragic event that cost him a leg. An orphan, he was sent to sea on a trading vessel to the West Indies. The disastrous encounter with the shark occurred while he was swimming off Havana.

By checking both versions of the painting, note that very few changes were made in the content of the later version. The anatomical drawing of the shark was improved, after the original was criticized. There's a greater contrast of light and dark tones. Observe how the clothing of two figures has been darkened. A highlight on the shoulder of one figure interconnects with a highlight of the flag on the distant ship. It accentuates his agonized look.

What are the advantages of the *vertical* composition? What do expert historians say about it? I wrote to the Detroit Institute of Arts that has the latter painting and received a copy of the 1968 exhibition catalog in which the painting appeared. In it Frederick Cummings, Director of the Detroit Institute, wrote, "All parts, including the landscape, are welded into a compact psychological and physical harmony. . . . The psychological drama is the true subject of the painting, and it is more unified and more graspable in one moment of time in the vertical composition. . . . Copley selected this moment (after the shark had bitten off Watson's leg) when each person could be studied for his own psychological response."

John W. McCoubrey in his book, *American Traditions in Painting*, points out the following about Figure 109: "The action is set well back into the picture space and, because it is so nicely framed, takes on a more monumental quality" than the horizontal version.

There's little doubt that Copley received the benefit of built-in tension merely from the position of the canvas. In addition, the vertically placed canvas provides much more space at the top and bottom of the picture in which the impact of the towering triangular shape motif can be felt.

The full-length view of the boathook seems to add potentially more power behind the forthcoming thrust. The threatening clouds also add to the horror of the tragic moment. Note how the clouds slant as a group, despite their circular formation. One interlocks with the dynamic diagonal of the figures. Another edge of clouds parallels the same diagonal. You can see them easily by turning Figure 109 upside down or sideways.

On the other hand, what did Copley

lose by switching from a horizontal to a vertical composition? I wrote to William P. Campbell, Curator of American Painting at the National Gallery, who replied, "My feeling is that the horizontal composition is more 'powerful' to use your word, because the viewer is closer to the action, with the players practically in your lap. . . . Much of the horror and urgency of the scene seem to me to be eliminated in the vertical format by pushing the event farther off, enlarging the scene and making the classical triangular composition painfully obvious."

All the historians' opinions are not the whole story by far. The versions have to be weighed much more carefully than we have space for here. But for our purposes, the horizontal version may be considered a "cropped" version. For one thing, it's easier to avoid negative space problems with cropping.

Compare the positioning of the boathooks in the two paintings. In Figure 108, you run the risk of insensitively spacing the upper portion of the boathook in the open ground area of that swirling cloud as well as imbalancing other relationships. You can see there's less chance of losing control of the total effect by cropping. Besides the cropping tends to bring the action forward, sharpening the intensity of a picture.

Perhaps McCoubrey sums it up best in discussing the vertical version: "The intuitive rightness of the earlier version, with its wild and fortuitous projection of sudden shock, is gone."

Rembrandt's Compositions in Horizontal and Vertical

Rembrandt was accustomed to making quick, preliminary sketches, stopping as soon as the idea emerged and the composition took form. As you can see, there's not much detail in his rough drawing of *The Agony in the Garden* (Figure 110). In the upper-left corner, note that he expected to develop a triangular shape motif extending over the figures of the Angel and Christ kneeling on the Mount of Olives. Also, notice that a large, almost oval, open shape was reserved for the Mount of Olives.

But he soon realized that the right side of his drawing, which occupies little more than one-third the total area, was a compact *vertical* unit isolated from the rest of the drawing. Even more important, it contained the key to expressing his emotional feelings about the composition.

Rembrandt discarded the horizontal format in his etching (Figure 111) to accommodate the formerly isolated vertical unit. The latter now dominates the composition, relating the two central figures more directly to the structures and hills beyond. These symbolized Christ's sorrow and sense of doom, as felt and expressed by Rembrandt.

The dark massive structures and hills appear monumental, yet the size of the etching is only 3¾" (95.25 mm) in height! Here, again, is proof of the importance of relating the vertical placement of a canvas or paper to our feelings.

Note how the strong contrast of tonal values is balanced throughout. Also, see how subtly Rembrandt placed his center of interest into a rectangular frame that is repeated and varied in the upper-left corner. Finally, observe how the dark diagonal submotif increases the tension of the scene as it rises from the lower-left-hand corner to the Angel and Christ. Echoes of the diagonal can be seen throughout, especially by viewing the etching upside down and from the side.

Daumier's Compositions in Horizontal and Vertical

Honoré Daumier's horizontal drawing of the French painter Corot in a garden setting, *Corot Sketching at Ville d'Avray* (Figure 112) was probably sketched partly or in whole at the scene. It was done in pen and Chinese ink over a slight preparation in pencil and washed with gray and yellow watercolors.

Close inspection shows that staccato lines and a great variety of light spots that dart over the drawing are responsible for its sensation of movement and feeling of freshness.

Why, then, does Daumier's *vertical* composition (Figure 113), *Man Reading in the Garden*, appear to be superior? Doesn't this contradict our earlier conclusion that quiet, peaceful compositions often benefit from horizontal placement, and may lose by being placed vertically?

The latter conclusion may still hold true, provided everything else is equal. But in comparing Figures 112 and 113, you'll find that everything else is far from equal.

Unlike the two versions of Copley's painting, in which there were practically no changes in the content, there *are* changes here. One of them is crucial and it shows the need for establishing a specific mood.

Figure 112. *Honoré Daumier:* Corot Sketching at Ville d'Avray. *Pen and Chinese ink over slight preparation in pencil, washed with gray and yellow watercolors, 17.2 x 19 cm. Private collection, Paris. Note that staccato lines and a great variety of light spots are responsible for this picture's sensation of movement and feeling of freshness. Why then did Daumier change to a vertical composition (Figure 113)?*

Let's reconstruct the situation from the beginning. The sketch (Figure 112) had served its purpose. Daumier had drawn Corot in the actual setting. It was a record of an event. No thought was given to the structure of the drawing.

Later at his studio, Daumier probably checked the sketch before repeating it more carefully. He appreciated its good points. But he also became aware of its basic structural weakness in shape relationships. It lacked a submotif strong enough to counter the dominant arc motif. Note how the arc motif starts at the base of the tree, to the left of the figure, and moves upward in a wide swing to the right. This is repeated by a smaller arc in the tree at the right. The combined movement needs an effective counterthrust.

I feel sure that solving the problem in the horizontal didn't interest Daumier, although it might have proven our premise once again. He had a very good reason for not repeating the composition on the horizontal. He was more interested in establishing the dignity and form of the trees. The vertical of the trees was what he felt, and that required a vertical placement.

The vertical composition is superior, first, because the structural relationships support two moods: the majesty of stalwart trees, spreading their bountiful leaves, and the restful relief from the blazing sun that their shade provides.

Second, note the stately vertical, motif's recurrence, not only among the trees of varied width but also in the varied vertical negative shapes separating them so harmoniously. The restful and peaceful feeling is aided by the carefully composed horizontals as submotif. Not only are they spread across the bottom of the picture, but they're gently introduced in the *short horizontals* underneath and behind the chair and in the shadows of tree trunks. The rhythm continues in the short horizontal *negative* spaces between them and in a few horizontal branches above. Here there are no weaknesses in two-dimensional shape relationships, as compared with those in Figure 112.

Third, the vertical composition is superior in quality because of the delicateness in the varied pressures of *line*, which will be discussed in Chapter 8. Compare both drawings. Figure 112 shows a line of the same degree of thickness throughout, while in Figure 113, you'll find a variety of lines—thin lines, light lines, numerous other kinds, including the staccato, thick line in Figure 112.

Fourth, and finally, the tonal values affect us more deeply. There are lights spotted throughout the vertical composition, as there are in the horizontal. But there are fewer of them in the vertical composition. Placed more artfully, they give the effect of a deeper shade than that in Figure 112. In this case, more dark than light values over the surface enrich the mood of the picture.

In conclusion, we find that to arrive at the most effective placement of compositions, horizontally or vertically, is not a simple task, but a teasing, tantilizing, esthetic challenge.

Figure 113. *Honoré Daumier: Man Reading in a Garden. Wash drawing on paper, 13 15/16" x 10 5/8" (356 x 270.2 mm). The Metropolitan Museum of Art, New York. While appreciating the good points of Figure 112, Daumier was probably aware of its basic structural weakness in shape relationships. It lacked a submotif strong enough to counter the dominant arc motif that moves upward in a wide swing to the right. Besides, he was more interested in emphasizing the vertical dignity and form of the trees, and that required a vertical placement. Note how more dark than light values over the surface enrich the mood of the picture, and observe the delicateness in the varied pressures of line.*

Project 16: Experimenting with Horizontal Composition

The purpose of this project, as well as of Projects 17 and 18, is to launch you on the decision-making process described in this chapter.

I hope Figure 114 will spark your imagination to create a mood of your own. It's a quick sketch by Daumier in quite a different mood from that in Figures 112 and 113. *Three Gossiping Women* shows his more satirical side.

Start with a Horizontal, Then Do a Vertical

Your instructions are as follows:

1. Use a 5B black pencil or a #1 very soft charcoal stick.

2. Make a quick sketch of two or more figures in a horizontal composition. Do it from your imagination, if you can. Think of *any* human situation. The unifying theme may be comedy or tragedy—dramatic, mysterious, lyrical, gentle, satirical, frightening, symbolic, even political.

3. If you find it difficult, approach the assignment by making a freewheeling drawing of any three figures in a horizontal composition. Then let the result stir your imagination to start developing a mood. As soon as you have the beginning of a mood in any *part* of the drawing, stop and do another sketch. This time try to develop the mood *all over* the drawing.

4. Study the result carefully for possible improvement in shape, value, and other relationships.

5. Can the mood be intensified by changing the composition from horizontal to vertical?

6. As an experiment, try the composition in a vertical placement. Then compare it with your best horizontal composition.

7. Make a final drawing in the placement of your choice. Go as far as you can.

Figure 114. *Honoré Daumier: Three Gossiping Women. Pen and ink over charcoal and brown chalk, 16 x 26 cm. Victoria and Albert Museum, London. This is a quick horizontal sketch in a satirical mood. Why did Daumier switch to a vertical composition? Compare this with Figures 115–117.*

Case History 16: Daumier, Rouault

Why did Daumier switch from a horizontal to a vertical composition? Figure 115, *The Three Gossiping Women,* is a watercolor in a vertical composition, developed from the horizontal drawing of the same subject in Figure 114.

To make it easier to reconstruct how he switched to a vertical composition, I've cropped Figure 115 on four sides (Figure 116), reducing the area to correspond to the drawing in Figure 114.

Figure 116 shows how the finished watercolor might have looked had Daumier decided to keep the composition horizontal. The light and dark relationships certainly intensify the mood. Even the background negative area has been broken up into closed shapes, adding to the tension of the whole. Without question, Figure 116 is a decided improvement over the original drawing. Why, then, didn't Daumier retain the horizontal composition?

To answer the question, let's compare Figure 116 with another painting with similar compositional elements. Figure 117, entitled *The Three Judges,* is a painting by the French artist, Georges Rouault, who not only admired Daumier greatly but was influenced by his work. You'll notice that Rouault used a horizontal composition in content approximately equal to that in Figure 116.

Why, then, is the vertical composition appropriate in Daumier's Figure 115 and not in Rouault's Figure 117?

Rouault's repugnance and outrage at the sordid state of justice are expressed in his painting, which is a zealous indictment of corrupt justice. In Daumier's watercolor we have an example of his keen memory and vivid characterization of the social foibles of common people.

Both artists had something in common. They *felt* the characterizations. Rouault *became* each one of the corrupt judges. He entered inside their minds, particularly that of the central figure. Broad of back, short-necked, ready to stare down anyone who dares to challenge him, he isn't a shrinking vertical, requiring vertical space. On the contrary, with elbows outstretched, permitting no one to cross him, he's a horizontal figure, requiring plenty of horizontal space. That's why a horizontal composition is needed in Figure 117.

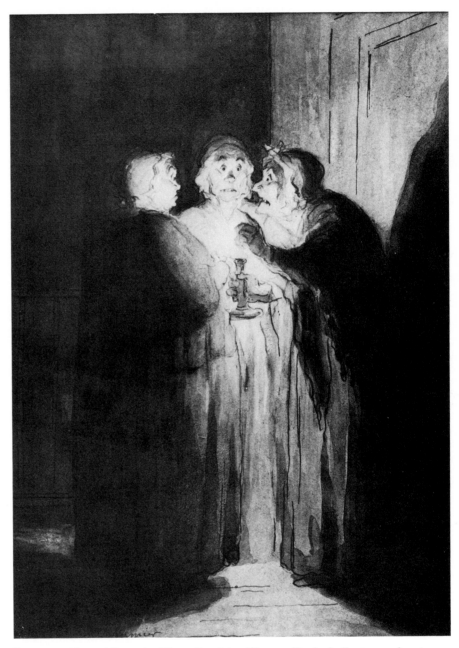

Figure 115. *Honoré Daumier:* Three Gossiping Women. *Black chalk, pen, and watercolor, 10 1/4″ x 7 1/8″ (257.2 x 181 mm). Photo: Wildenstein Gallery, New York. This vertical composition was developed from Figure 114. It provides more space that acts as a counterpull downward, eventually separating at the lower end and continuing to flow upward around the figures, finally returning to the center. Note how the powerful tonal relationships intensify the expression. Observe, too, Daumier's attention to closed negative shapes and how both were very carefully balanced with the main shape motif and contrasting motifs.*

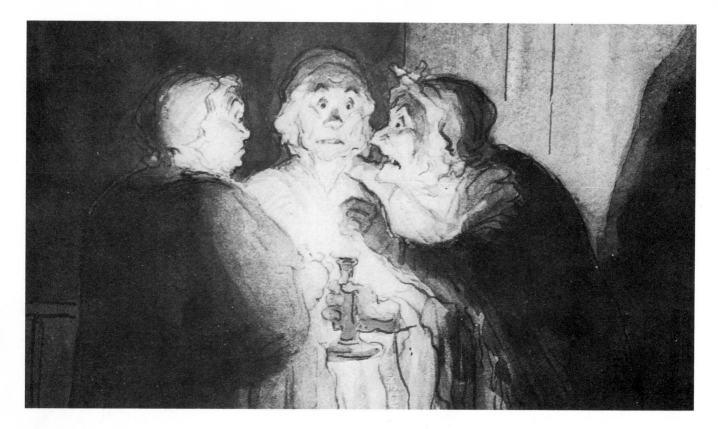

Figure 116. *With the area in Figure 115 cropped to correspond with the drawing in Figure 114, this shows how the finished watercolor might have looked had Daumier decided to retain the horizontal composition. Why didn't he? Rouault didn't hesitate to use a horizontal composition with approximately equal content (Figure 117). Why, then, is the vertical composition called for in Daumier's Figure 115 and not in Rouault's Figure 117?*

Daumier, on the other hand, seems to be an invisible fourth person grouped together with the women in whispered secrecy. In Figures 114 and 116, you can almost hear the horrifying tale being told. The vivid scene seems to move *inward* toward the center. In Figure 116, this movement is accentuated by the crony on the right, who huddles even more closely toward her companions than in Figure 114.

I believe Daumier *felt* the magnetic, inward pull. If left as a horizontal composition, the movement of the forceful scene would come to a halt in dead center. On the other hand, the vertical composition provides more space that acts as a counterpull down the full length of the figures. That forces the central inward movement downward, eventually separating at the lower end and continuing to flow upward around the figures, finally returning to the center.

Don't forget that Daumier was a master at composition. Even Cézanne learned a great deal from him about spatial organization and distortion to create monumental figures and ennoble realism.

Compare Figure 115 with Figure 114 to see the numerous little changes that provide less crowded space for more forceful gesticulation.

Most important to remember is that Daumier never sacrificed his composition for the sake of expression. Note how the powerful light and dark relationships in Figure 115 intensify the expression. These are very carefully balanced with the main shape motif and contrasting submotifs. Observe, too, his attention to closed negative shapes. As an example, note how he avoided leaving the upper-left negative area empty—not just by the placement of the heads as figure in relation to the surrounding negative space, but by the integration of overall light and dark tonal masses with his subject.

Figure 117. *Georges Rouault: The Three Judges. Gouache and oil on cardboard, 29 7/8" x 41 5/8" (759.3 x 1,057.6 mm). The Museum of Modern Art, New York. Rouault's repugnance and outrage at the sordid state of justice show up particularly in the central figure—broad of back, short-necked, ready to stare down anyone who dares challenge him. He's easily conceptualized with elbows outstretched, permitting no one to cross him—a horizontal figure, requiring plenty of horizontal space. By comparison, the vivid scene in Figures 114 and 116 seems to move inward toward the center. If left as a horizontal composition, the movement of the otherwise forceful scene would come to a halt in dead center. The vertical composition (Figure 115) provides more space as a counterpull.*

Project 17: Experimenting with Vertical Composition

Figure 118. *Rembrandt van Ryn: Saskia Lying in Bed. Pen and bistre, 170 x 134 mm. Weimar Museum, Weimar, Germany. Rembrandt stopped sketching here as soon as he recognized that he couldn't complete it to his satisfaction. He was stuck with the lower-right corner—and gave up! Later, he changed to a horizontal composition (Figure 119).*

In this project, you're going to experiment with a *vertical* composition. I've chosen a preliminary drawing (Figure 118) by Rembrandt of his wife, entitled *Saskia Lying in Bed*.

The question is should the composition be switched to a horizontal placement? Your assignment is to arrive at a conclusion based upon your *own* drawings and feelings.

Feel a Vertical or Horizontal Composition

Your instructions are as follows:

1. Use a #5B black pencil or #1 soft charcoal stick.

2. Make a freehand drawing of Figure 118. Note that a rectangular shape motif is established in relation to the dimensions of the paper.

3. Obviously, the compositional weakness lies in the negative space at the lower right. Before you make any changes, be sure to create your own mood. This isn't going to be easy because the scene is a 17th-century bedroom, but you may shift the time to any century. The important thing to remember is the two figures.

4. So, prop yourself up on a sofa or bed, cover up with a blanket or coverlet, lean back and close your eyes, let your mind become a blank. Eventually you'll know who you are and who the seated figure is facing you. Become the figure in the bed, male or female. You're the center of interest. How do you feel? Where are you? What are the circumstances?

5. Don't try to hurry the process. You may need to try the experiment a number of times before you arrive at an answer that's uniquely yours. The next and last step is to feel the mood in vertical or horizontal terms before doing a final drawing.

6. Repeat the entire experiment. Start with another freehand drawing of Figure 118. This time become the seated figure at the lower left. Make that the center of interest. Make the figure in bed or on a couch a child of any color, creed, or country. But don't use this example unless you really feel the mood. It's only to show you how to evoke any mood from the tremendous reservoir of your imagination. Again, arrive at a *feeling* for vertical or horizontal compositional placement before doing a final drawing.

Case History 17: Rembrandt

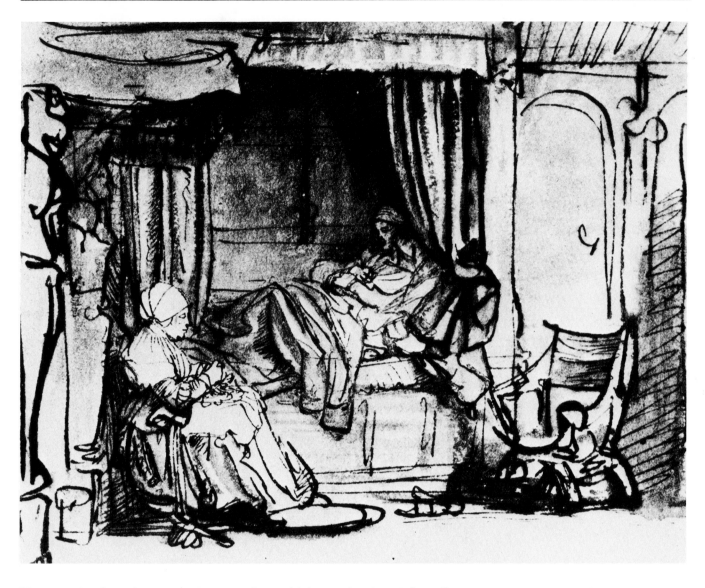

Figure 119 is a later drawing by Rembrandt of *Saskia Lying in Bed*. Although it's still a sketch, Rembrandt's feelings have poured into it, and the difference between it and Figure 118 is immense.

One reason I chose these illustrations, particularly Figure 118, is to squash a fallacy about the study of composition. Some novices feel that if they start a composition, they should be able to finish it *without having to repeat it*. They feel a stigma of failure, they're frustrated, and they think they're incompetent if they don't complete it successfully in one sitting.

Even masters have their compositional problems and failures. But they look at failures as exciting challenges.

Rembrandt stopped sketching Figure 118 as soon as he recognized that

he couldn't complete it satisfactorily. He was stuck with the lower-right corner—and gave up! He, like other masters, took the next step, of resting while analyzing the situation and then approaching it again in a different way.

This happened to Picasso in a unique situation. His execution of a great composition, which took him some time to do, went astray during the filming of a full-length movie. As he began to obliterate the composition, he said, "It's going wrong—all wrong. That's not what I want. I'm not satisfied." Then he decided that his failure should be recorded on film. "It's all right, though; people will see it's not easy. I shall begin again."

I think Rembrandt originally wanted to use the vacant chair that

Figure 119. *Rembrandt van Ryn:* Saskia Lying in Bed. *Pen and bistre, washes in bistre and Indian ink, heightened with white, 143 x 176 mm. The Hague, Holland. In this horizontal composition, the chair placed beyond the bed creates a tug-of-war tension-pull between it and the seated figure. It stretches the composition horizontally, reinforcing the vitality of the drawing.*

appears in Figure 119 to complete the composition in the lower right of Figure 118. He decided against it, probably because it would have cramped the space between it and the seated figure. And, as we've seen in Figures 96 and 97 (page 116), Rembrandt was a stickler for the feeling of spatial relationships.

If you've any question about the negative space in Figure 118, do a quick sketch of the chair, cut it out, and move it around until you find the best position. Now, note the crowded space between the figure and chair. Compare it with the same space in Figure 119.

But there's much more to the horizontal placement of the later drawing. To begin with, there's the advantage of the horizontal figure lying in bed. In addition, the chair placed beyond the bed in Figure 119 creates a tug-of-war tension-pull between it and the seated figure. It stretches the composition horizontally, reinforcing the vitality of the drawing.

One edge of the empty chair anchors the corner of a dynamic triangle, truncated at the left. The line of the chair interlocks with the drapes and reaches eventually to the top of Saskia's head. Follow the triangle downward. Observe the downward slope of Saskia's body and the bed-clothing as it directs your attention to the seated lace-maker moving her many bobbins at a fast clip. Note how the latter's profile and figure clearly repeat the triangular motif, as the base line is common to both triangles.

There are a number of submotifs. Rembrandt divided the drawing into rectangular shapes all across the horizontal composition, emphasizing their verticals in contrast to the main triangular shape. For good measure, he added the submotif of the arc. Note how the arch at the upper right repeats the curves of the lace-maker and particularly the sharp curve at the front of the vacant chair. Observe the other curves with the drawing upside down. Finally, note how Rembrandt

extended the series of horizontals across the top and, gently, repeated them as he moved downward to the bottom of the bed.

The tonal relationships add so much to the horizontals—from the strong light and dark contrasts at the top to the more subdued grays in back of the bed, to the very light one at the bottom. They all help to intensify the feeling of restfulness in the horizontal placement.

Compare Saskia's head in both drawings. Although she's the center of interest, the apex of the triangle, Rembrandt made her head smaller and placed it in semidarkness. By so doing, he increased the distance between her and the seated companion. Even more important, he sensitized the whole drawing by deemphasizing the center of interest—just the opposite of what a novice might do.

Project 18: Testing a Vertical Composition

Flatford Lock, in Dedham, England, is the scene where the famous English artist John Constable made many preliminary drawings and oil sketches for his paintings, two of which are included here.

Figure 120 is a *Study for the Lock*, done with reed pen, sepia wash, pencil, and traces of white heightening. What is particularly interesting is that Constable *added* two strips of paper to the original drawing, extending its width and height in an effort to improve the difficult composition.

It's not easy to compose in a meaningful way such two dissimilar objects as a pair of magnificent trees and Flatford Lock.

Figure 121 shows a boat at the right waiting for the water level to be lowered. This sketch of *The Lock*, shows how Constable investigated the possibilities of rendering light in a new way. He drew it in Indian ink and sepia wash with highlights scraped.

Although landscape and water might very well suggest the horizontal composition, your assignment is to test the possibilities of placement in a vertical composition.

Move around a Drawing in Both Vertical and Horizontal Positions

Your instructions are as follows:

1. Use a 5B black pencil and a #1 soft charcoal stick. You'll also need Elmer's Glue.

2. Do a freehand drawing of the lock without the trees. Note the differences between Figures 120 and 121. Use features of both if you wish.

3. Place the drawing of the lock on a larger sheet of paper and move it around in both vertical and horizontal positions. Do it again on sheets of various dimensions until you arrive at the placement you like best.

4. Whether vertical or horizontal, cement the drawing and complete the enlarged composition.

5. Pay no attention to the location and size of the trees in Figures 120 and 121. Place as many trees as you wish, wherever you please. In any case, work for a mood. Check results carefully for balanced shape and tonal relationships.

6. When completed, check whether the mood is intensified by vertical or horizontal placement.

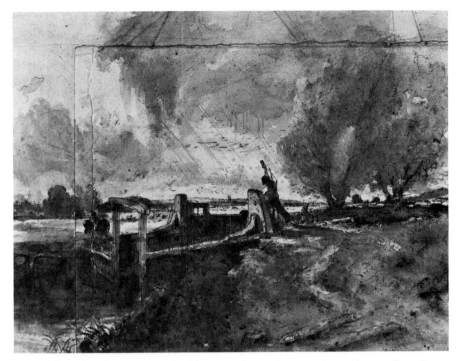

Figure 120. *John Constable: Study for the Lock. Reed pen, sepia wash, pencil, and traces of white heightening, 11 5/16″ x 15 1/2″ overall (287.7 x 368.6 mm). Fitzwilliam Museum, Cambridge, England. Flatford Lock in Dedham was the scene of many preliminary drawings and oil sketches by Constable (Figures 121–126 include most, but not all, of the completed versions). What is particularly interesting here is that Constable added two strips of paper to the original drawing, extending its width and height in an effort to improve a difficult composition. Photo: Stearn & Sons.*

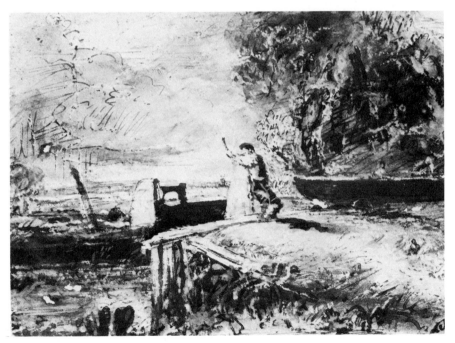

Figure 121. *John Constable: The Lock. Indian ink and sepia wash with highlights scraped, 4 7/16″ x 5 3/4″ (109.1 x 146.5 mm). Fitzwilliam Museum, Cambridge, England. Here Constable was investigating the possibilities of rendering light in a new way by scraping highlights. Photo: Stearn & Sons.*

Case History 18: Constable

Innovators usually find it difficult to be accepted by their immediate peers. The English landscape painter John Constable (1776–1837) was no exception. Both he and his contemporary, J.M.W. Turner, in their own individual way, defied the academic standards of their time.

It was the French painters, Delacroix and Gericault, who first spread the word of Constable's original style. Not long afterward, his paintings exhibited at the Salon in Paris overwhelmed the eager, up-coming French painters who were freeing themselves from the conventional way color was applied: a tint over a drawing on canvas, previously prepared in light and dark tonal values. They recognized both Constable and Turner as true reformers in landscape painting. In fact, Constable's influence was so strong that Delacroix made immediate changes in his own work.

As Delacroix noted, "The failure of the common run of landscape painters to give intensity and life to their greenery results from making it one uniform color." Constable explained that the superiority of his landscape came about because it was composed of a *multitude* of greens. Delacroix

wrote in his journal: "What he says about the green of the fields can be applied to the other tones."

Where did Constable get his ideas? He never studied light scientifically, but he did study light, color, and composition among the old masters—the Dutch, Ruisdael; the French, Poussin and Claude Lorrain; the Italians, Titian and Canaletto; and the Flemish, Rubens.

Constable's fresh outlook and expressive power came from his early days in the country. "The sound of water escaping from mill dams, willows, old rotten planks, slimy posts, and brickwork. I love such things. These scenes made me a painter and I am grateful." At another time, he wrote, "The landscape painter must walk in the fields with a humble mind." Constable *saw* nature.

Independent in character, he refused to conform to the warm yellow tonality, the brown trees, and static compositions in the landscape paintings of his contemporaries. Constable's paintings were full of light—atmospheric light bursting through the countryside as clouds floated by. But even more important were his flicks of white across the canvas as he

built up dots of various colors and juxtaposed clear color harmonies with short thick strokes. Little did he realize that he was anticipating a revolutionary movement that developed decades after his death: French Impressionism, headed by Monet, Pissarro, Renoir, among others.

The Question of Horizontal vs. Vertical Placement

Figure 122, *Flatford Lock*, a pencil drawing, shows how important the large tree was to Constable. Compare his treatment of the smaller tree to the right, which is only suggested here, with the same area in Figures 120 and 121.

Let's look at Constable's large horizontal paintings of Flatford Lock. Compare Figure 123, *Study of a Boat Passing a Lock* with Figure 124, *Boat Passing a Lock*. Both are oil paintings, the latter more finished, though considered highly controversial by his contemporaries. However, the freshness of light and atmosphere and the bold textural strokes in Figure 123 are much more appreciated by modern standards.

Observe how clearly the trees are etched against the sky in Figure 123. The large tree is still predominant, but now there are several smaller trees next to it. Although the trees occupy a small area of the composition, Constable treated them with loving care.

Constable concentrated on the details of the lock and foreground and on the passing boat. But what about the structure of the composition? The two broad rectangular horizontals with their brilliant light and dark relationships establish the peace and tranquility of the countryside. In contrast, the strong diagonal sweep of the clouds adds to the vitality of the action around the lock.

Look at the left side of the painting. The straight edge of the diagonal clouds effects closure with the figure, forming a huge triangle with the horizon line as the base. There are many other triangles repeated in the foreground and in the boat sails. Note the apex of the large puffy clouds in the upper center. This is the beginning of a triangle extending from one side of the painting to the other, with the horizon line as the base. This triangle is easier to trace upside down.

Figures 125 and 126 show that Con-

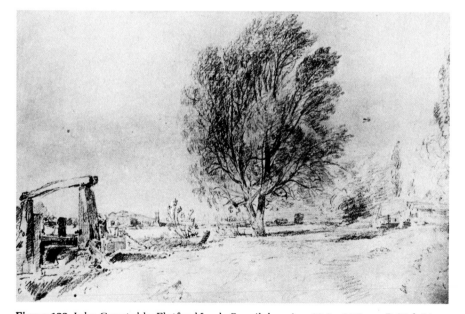

Figure 122. *John Constable: Flatford Lock. Pencil drawing, 22.2 x 32.7 cm. British Museum, London. Constable was in the habit of drawing in pencil when the occasion moved him. This drawing shows how important the large tree was in his mind. Compare his treatment of the smaller tree to the right of it, which is only suggested here, with the same area in Figures 120–121.*

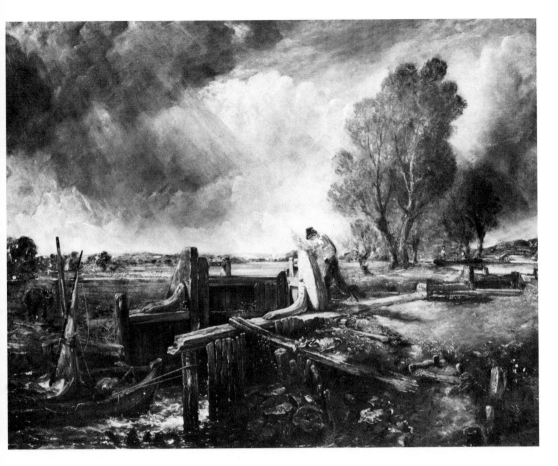

Figure 123. *John Constable: Study of a Boat Passing a Lock. Oil on canvas, 40 1/2" x 51 1/8" (1,029 x 1,298.6 mm). National Gallery of Victoria, Melbourne, Australia. Compare this large horizontal painting of Flatford Lock with Figure 124. Both are oil paintings, the latter more "finished." Even the finished one was considered highly controversial by his contemporaries. However, the freshness of light and atmosphere and the bold textural strokes are much more appreciated in modern times.*

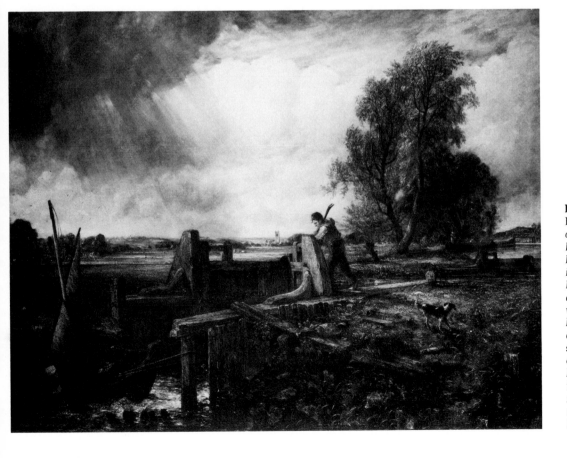

Figure 124. *John Constable: Boat Passing a Lock. Oil on canvas, 102.9 x 127 cm. Royal Academy of Arts, London. This is a more "finished" horizontal version of Figure 123. Most important are Constable's flicks of white across the canvas as he built up dots of various colors and, with short, thick strokes, juxtaposed clear color harmonies. Little did he realize that he was anticipating a revolutionary movement that bloomed decades after his death: French Impressionism.*

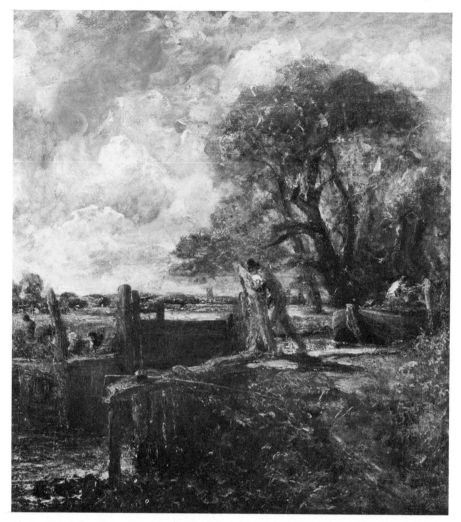

Figure 125. *John Constable: The Lock. Oil on canvas, 55 3/4" x 48 1/4" (1,416.5 x 1,225.7 mm). Philadelphia Museum of Art, Philadelphia. Constable was equally fascinated with a vertical composition of the lock. Once more we see the vibrancy of light and luminosity here in comparison with the finished Figure 126.*

stable was equally fascinated with a vertical composition of the lock. Once more we see the vibrancy of light and luminosity in Figure 125 not shown in the finished work, *The Lock* (Figure 126).

Note how in the latter he relates the sharp diagonal in the clouds to the strong diagonal in the foreground. Look at the painting from the right to feel the unification of this extraordinary large area.

In Figure 125, the same diagonals are there, more or less, but these diagonals are *not* accented in this most vibrant painting. Instead, observe how the diagonals in the tree trunks and the figure dominate the canvas. The rhythm of diagonals continues toward the left, ending with the long angled pile supporting the lock. That the latter is crucial can be tested by blocking it out.

Figure 125 is an excellent example of Constable's use of the palette knife. The painting throbs with vitality throughout. The atmosphere, the light, the feeling of aliveness are deeply felt. Constable's love of nature is expressed with stunning force.

The Lesson to Be Learned

What conclusion can we draw by comparing the horizontal Figure 124 with the vertical Figure 126? Or better still, by comparing Figure 123 with Figure 125?

Here, Constable demonstrates that a master can destroy any fixed ideas concerning horizontal or vertical compositions. He proves there's no sure way of doing anything in art.

Does this make you feel insecure? I know it did me when I first encountered the contradictions. It took me a long while to replace insecurity in art with humbleness.

There are many insights into art for you to learn from the ideas and discussions in this chapter. Try them, make them yours, build on them. The lesson to be learned is not to become set on any ideas about art—for art is open-ended.

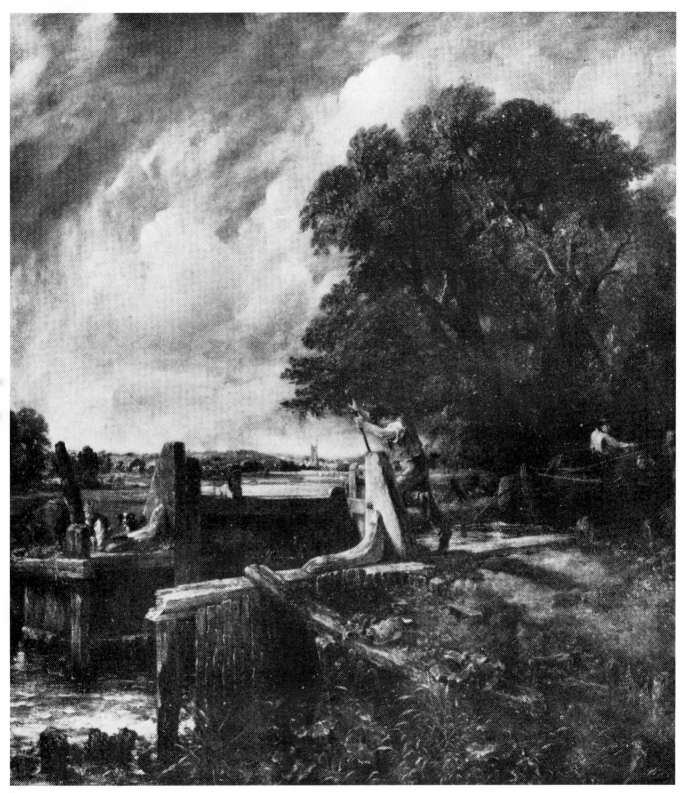

Figure 126. *John Constable: The Lock. Oil on canvas, 146 x 128.3 cm. Collection of Major A.W. Foster, M.C., England. What conclusion can we draw by comparing the horizontal Figure 124 with this vertical? Or better still, by comparing Figure 123 with Figure 125? Constable demonstrates that a master can destroy any fixed ideas concerning horizontal or vertical compositions.*

Empty
Space

7

This chapter is an extension of Chapter 3 on Negative Space, which was an overview of the various factors affecting negative space. In this chapter, I'll concentrate on some of the behavioral patterns that cloud the beginner's vision, thinking, and attitude toward empty space.

Unless you're sensitized to the *feeling* of empty space and do something about it, you'll overlook one of the basic reasons why paintings fail as works of art.

Some problems arise because beginners lack an awareness of empty space. Others crop up because beginners let the *suspicion* of emptiness pass by. Also, many beginners, seeking *ideas* for compositions, consider most space around them to be empty—empty of the visual excitement they need to spark them to act. Let's consider each problem separately.

Overcoming Lack of Awareness of Empty Space

Your perception and awareness of two-dimensional areas of space that feel empty come about in only one way: by scanning the entire surface of a drawing or painting as a unified whole. Depending upon the size of your paper or canvas, you can't do this physically unless you *step back*.

This is so obvious that you may wonder why I mention it. But it's the one habit that most beginners fail to establish. They're usually so absorbed in technically improving some part of the drawing or painting that they don't watch what's happening to the relationship of one part to another and how that may affect the total picture.

I can assure you that the professional steps back after each tiny change or addition to the drawing or painting. One moment, he or she gathers inner forces—without conscious awareness—to express the self. The next moment, after a brushstroke, he or she releases the built-up tension—to let down.

Scanning the whole this way gives the subconscious the opportunity to *sense* when relationships are out of

balance. The feeling of empty space is just a signal from your subconscious that one of the visual elements—two-dimensional shapes, light and dark values, or colors—is out of balance. Later in Chapter 8, the same signal will alert you to any imbalance in texture or line relationships.

Now, let's examine the imbalances in shape and tonal relationships that produce empty space.

Rembrandt Corrects a Student's Drawing

Figure 127 is a drawing by the Dutch artist C. van Renesse of *The Annunciation* that was corrected by his art teacher—none other than Rembrandt!

Here we have proof that a recognized artist had. to go through the process of learning to avoid pitfalls in composition—just as you must!

Study Figure 127 closely. At first glance, it may be a little confusing. You may find it difficult to distinguish the original lines of van Renesse's drawing.

Consider the prie-dieu in the center foreground. The low kneeling chair has been deliberately increased in size. Note how one vertical edge has been emphasized. Together with the sensitive, vertical line above it, they form a dividing line that encloses all the area to the right of the drawing in one huge rectangle.

Rembrandt probably corrected the drawing of the angel first. Obviously, he sensed what van Renesse didn't: the space surrounding the angel was *empty.*

What probably fooled van Renesse was that he thought the diagonal shaft of light above the angel—barely distinguishable now—together with the circular light surrounding the angel, was enough to keep the remaining space to the right from feeling empty.

Instead, Rembrandt *distorted* the scale of the angel. By enlarging the size, he accomplished two things simultaneously: He strengthened the mood of the drawing by vitalizing the role of the angel. And, by increasing both the height of the angel and the width of the wings, he automatically

decreased the area of negative space, reducing any possible emptiness.

In addition, he improved the light and dark relationship. All the bold outlines, accenting various parts of the picture, are Rembrandt's. Note the added verticals and horizontals under the arch and to the left. Your eye is forced to accept them, including the circular knobs, as important geometric shape motifs and rhythmic tonal relationships that unify the entire drawing.

Delacroix Corrects a Subtle Feeling of Empty Space

Figure 128 is a small preliminary study for the large painting *Entrance of the Crusaders into Constantinople* by the 19th-century French artist Eugene Delacroix.

If you study Figure 128 carefully, you'll become aware of a subtle feeling of empty space—but for a different reason than I've mentioned before.

The imbalance is in the upper right of the painting, despite the strong rectangular motif there. Yet you can't say that the negative space in the sky is empty because the rectangular shape of the sky area is nicely related to the large rectangle below it.

The main shape motif of the circle formed by the grouping of horsemen in the foreground is echoed in the high archway and in various arcs throughout the painting. So, the problem of emptiness is not due to an imbalance of shape relationships.

Block out the left third of the picture—the arches and pillars—and note that the rest of the painting is in balance. There's no feeling of emptiness in the upper right now. So, it's the dark values in the pillars and arched building that are too dynamic in tone. The strong darks in the pillars plus the strong darks in the circle of horsemen are altogether *too much*—causing the imbalance in the upper right.

Delacroix recognized this when he composed the large painting of the same subject (Figure 129), which now hangs in the Louvre in Paris.

The light and dark relationships are now more evenly distributed. The figures in the foreground are especially highlighted in value. Note the many more degrees of grays throughout the painting.

The pillars are now partly in light. The values above the pillars are also much lighter than in Figure 128. Two additional vertical columns have been introduced in tones of dark. But they don't offend the eye because they're partially obstructed by figures modu-

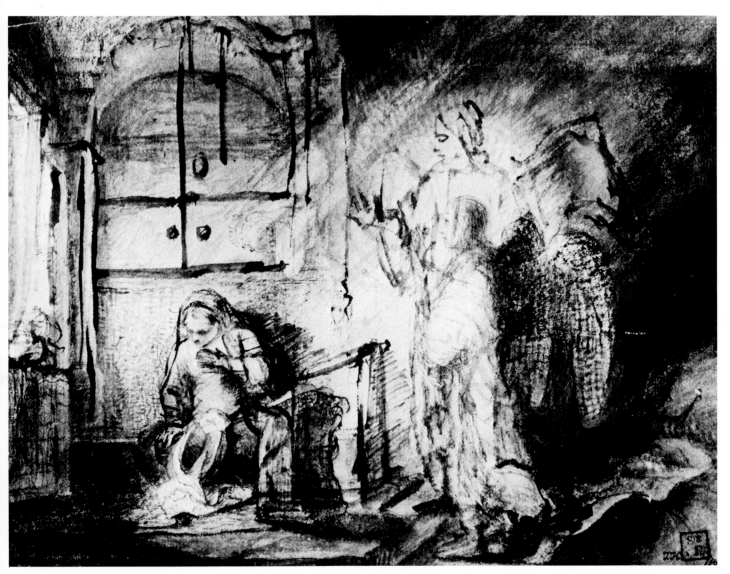

Figure 127. *Rembrandt van Ryn: The Annunciation (Drawing by pupil, C. van Renesse, corrected by Rembrandt). Red chalk, pen and bistre, wash heightened with white, 173 x 231 mm. Staatliche Museen, Berlin-Dahlem, Germany. Here we have proof that a recognized artist had to learn to avoid the pitfalls of composition. Obviously, Rembrandt sensed what van Renesse didn't: the space surrounding the angel was empty.*

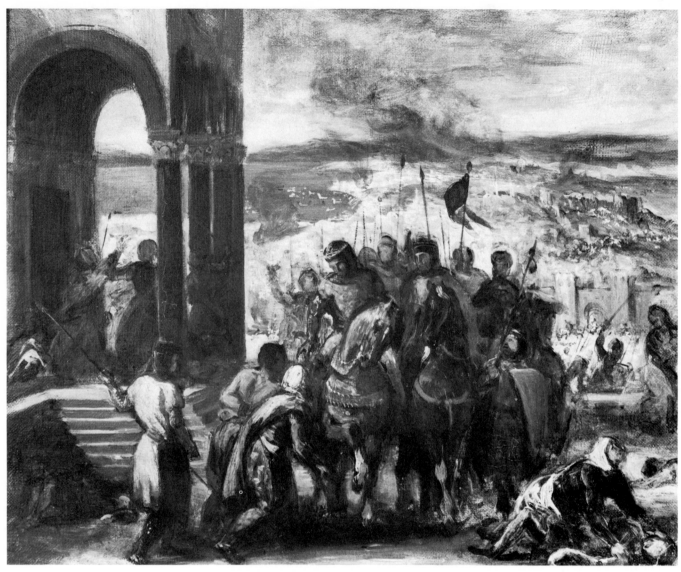

Figure 128. *Eugene Delacroix: Entrance of the Crusaders into Constantinople. Oil on canvas, 33 x 41 cm. Musée Condé, Chantilly, France. This is a small preliminary study for the large painting in the Louvre (Figure 129). If you study it carefully, you'll feel the empty space in the upper right. It's not due to an imbalance of shape relationships but of tonal relationships. The dark values in the pillars, arched building, and circle of horsemen are altogether too much. Test this by blocking out the left third of the picture and the rest of the painting becomes balanced.*

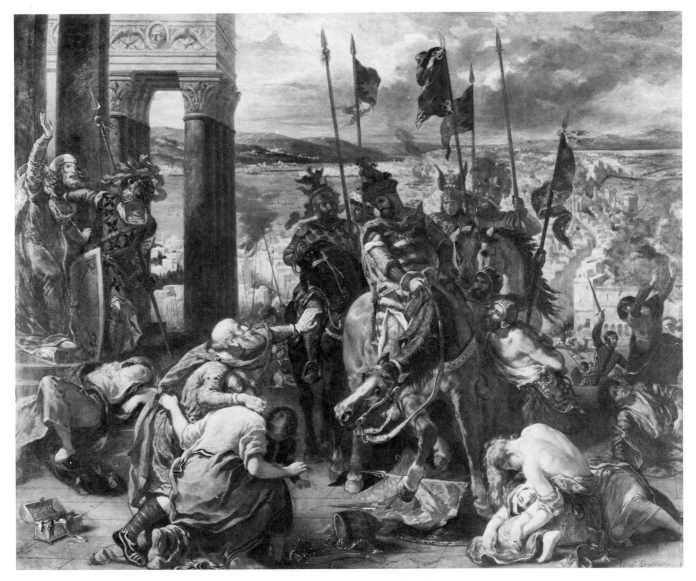

Figure 129. *Eugene Delacroix: Entrance of the Crusaders into Constantinople. Oil on canvas, 410 x 498 cm. Louvre, Paris. Delacroix recognized the problem in Figure 128 when he composed this painting. The light and dark relationships are now more evenly distributed. The figures in the foreground are especially highlighted in value. Note the many more degrees of grays throughout the painting. Even the pillars are now partly in light, with values much lighter than in Figure 128.*

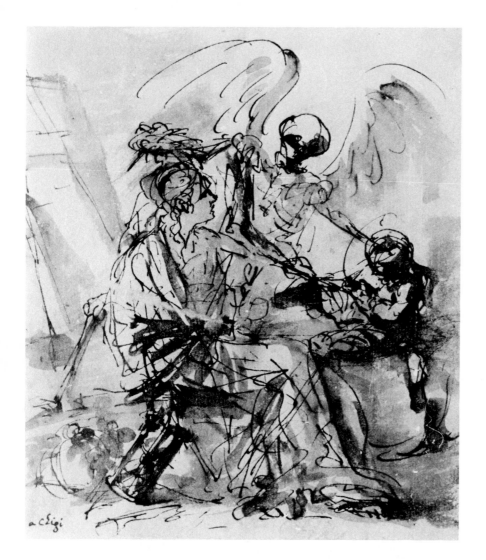

You might add that the tonal values are good enough and require only a touch more light, here and there. But not so the master. For him, it's *never* good enough. He studies the composition by turning it four ways to determine how best to improve it.

Luckily, we can compare the composition of the sketch with the later, more carefully composed painting. Study both illustrations upside down. There are so many rhythmic relationships in Figure 129. Note just one: how the forelegs of the horse are each related geometrically to the shape motifs in the painting. The light edge of one is a diagonal related to the diagonals of the spears. The other continues the large arc of the body and extended arm of the figure at the lower left. The arc of the reins repeats the same arc, curving sensitively in the opposite direction.

This painting can and should be studied again and again. It contains so much for you to discover.

Avoiding Empty Space

To avoid the problem of empty space, *close* negative areas, wherever possible, turning them into closed geometric shapes that are repeated with rhythmic variety.

Don't attempt this when you're in the first stage of expressing an idea, an image, or a feeling. Always approach the sketch with complete freedom and *with no conscious thought of composition.*

Figure 130 is an example of a first stage. This is a pen and bistre wash—light brown in color, made from the soot of charred wood—by the 17th-century Italian painter Salvator Rosa, called *L'Umana Fragilita.* The theme is symbolic and introspective, inspired by the death of his son and brother during a plague.

Only after the sketch was done did Rosa begin to analyze it for possible changes and improvements in composition, in preparation for the painting in oil (Figure 131).

He changed the position of the figures. But more importantly, he was aware of the empty space at the left and top, which was not integrated with the rest of the drawing.

Rosa solved the problem by extending the wings of the symbolic skeleton of Death to the *edges of the canvas.* There's no feeling of emptiness here because he *closed* the open unrelated areas. He made geometric shapes out of these newly closed areas, relating them rhythmically to each other and to all the other shapes in the painting.

Figure 130. *(Above) Salvator Rosa: L'Umana Fragilita. Pen and bistre wash, 200 x 172 mm. Museum der Bildenden Künste, Leipzig, Germany. Only after the sketch was down on paper did Rosa begin to analyze it for possible improvements in composition (Figure 131).*

Figure 131. *(Opposite page) Salvator Rosa: L'Umana Fragilita. Oil on canvas, 78 3/8″ x 52 3/8″ (1,900.9 x 1,330.5 mm). Fitzwilliam Museum, Cambridge, England. Compare this with Figure 130. Rosa was aware of the empty space at the left and top of the sketch that was not integrated with the rest of the drawing. He solved the problem by extending the wings of the symbolic skeleton of death to the edges of the canvas. Thus, Rosa avoided the feeling of emptiness by closing open, unrelated areas and transforming them into geometric shapes. Photo: Stearn & Sons.*

lated in a variety of light and dark tones. In fact, this whole area has become very exciting because of the variety of dark verticals interspaced with light vertical shapes.

The large circular motif of the horsemen as a group in Figure 128 is no longer there—although there are geometric arcs among the foreground figures and in the curves of the horses. You can see the arcs easily when you look at Figure 129 upside down.

The horsemen have been *compressed* as a group, with only one in front. The diagonally spaced spears with flying banners now play a prominent part: first, in balancing the tonal values throughout the painting; second, as a contrasting geometric motif to the verticals on the left; and, third and most importantly, in eliminating the feeling of emptiness in Figure 128.

A beginner might very well be happy with the composition of Figure 128. You might defend it because the shape relationships conform to what has been discussed in earlier chapters.

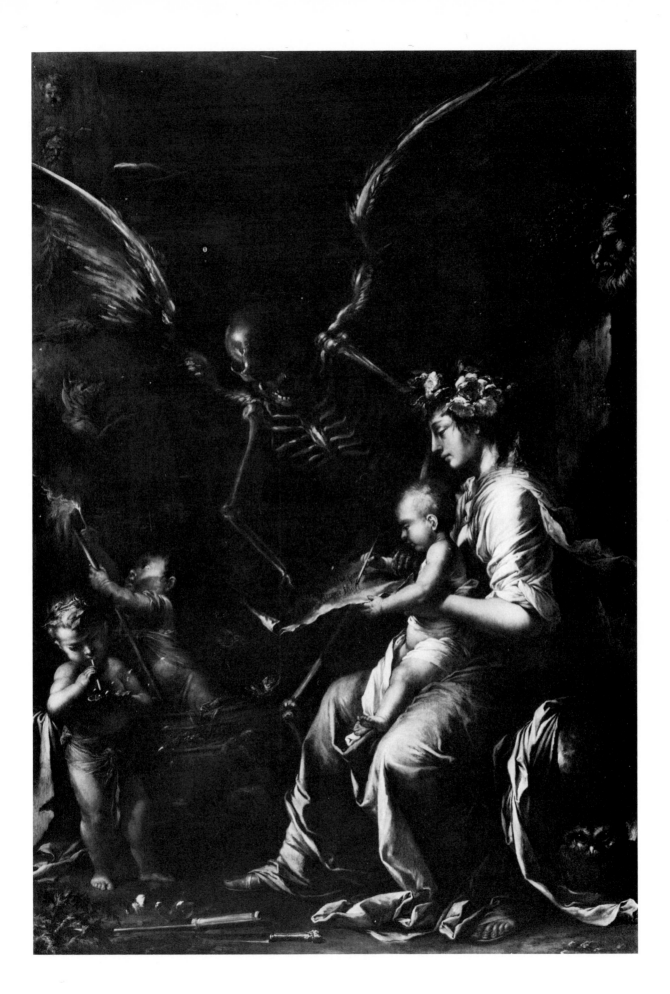

Project 19: Balancing the Entire Surface Area

The purpose of Projects 19–21 in this chapter is to give you another chance to experience and solve some of the problems of negative space, particularly those that give you the feeling of empty space.

I chose Figure 132 because the dark tonal values are so dominant against the practically empty background. It's a drawing combining wash, charcoal, and chalk on paper, called *Les Deux Avocats*.

This is another work of the French artist Daumier, a skilled craftsman who depended for his livelihood on his satirical illustrations. The drawing of two lawyers greeting each other in their court robes must be considered complete, serving the purpose he intended. Note how the angled line suggests the hint of perspective. Also, the light lines at the right suggest some form of building, giving the illusion of volume and depth.

But because of our discussion of empty space, you can sense that the drawing definitely needs improvement. In a small way, it's like Delacroix's sketch (Figure 128). It needs more degrees of light and dark tonal relationships throughout to balance the entire surface area. This, then, is your first consideration, with harmonizing shape relationships a close second.

Adjust Tonal and Shape Relationships

Your instructions are as follows:

1. Make two tracings of Figure 132.

2. Turn the first one upside down. Without thinking about the subject, begin to darken the drawing in various shades of gray, using half of a very soft, #1 charcoal stick broadside.

3. Work at random, inside and outside the traced lines. Don't be concerned if you destroy some of the contoured lines. The idea is to work freely, balancing light and dark values as a whole over the entire surface of the paper.

4. Smudge certain areas lightly to create a variety of tones, allowing the white of the paper to reflect the lightest light. Press hard or very hard in other areas to vary the whole with dark or very dark tonal values.

5. When you feel the drawing is completely balanced in light and dark relationships, turn it right side up. Study it for two-dimensional shape relationships. The large geometric oval shapes of the two figures will probably still be there unless you altered the contoured lines radically. The oval shapes may still remain the dominant motif, but probably not as overwhelmingly as in the figure.

6. Now check the negative space. Does it feel empty? Probably not. However, if any part of it feels empty, make whatever adjustments are required. But do them carefully, making sure not to unbalance the rest of the drawing.

7. Next, check the negative area to find a geometric shape submotif that contrasts with the dominant oval motif. Here's where the main purpose of the assignment begins: if you find a shape submotif that pleases you because of its relationship to the large ovals, see if it is repeated in rhythmic harmony. If not, keep adjusting it carefully, without upsetting all other shape relationships, until every shape is in balance and relates to all others.

8. Finally, if you have trouble and cannot get the negative space in balance, it may be due to the lack of *closed shapes*. Try another tack. Turn the drawing upside down again and boldly make erasures and additions in the negative area that result in closed shapes. Then, continue with step 7.

9. Do your second tracing right side up. Work immediately for a geometric shape submotif that relates to the main motif of the oval figures. A good rule to keep in mind that the masters never forget is: a straight line is sure to contrast nicely with any arc. Try verticals or verticals crossing horizontals to make patterns of varied rectangles. Do they have to represent something naturalistic? Not at all. The only requisites are, first, the negative areas must not feel empty; and second, tonal and shape relationships must be in balance to create a mood throughout the entire composition.

Figure 132. *Honoré Daumier: Les Deux Avocats. Wash, charcoal, and chalk on paper, 9 3/4″ x 8 1/2″ (248.1 x 216.2 mm). Glasgow Art Gallery and Museum, Glasgow, Scotland. I chose this drawing because the dark tonal values are so dominant against the practically empty background. Note how the angled line suggests the hint of perspective. Also, light lines at the right suggest some form of building, thus giving the illusion of volume and depth.*

Figure 133 is Daumier's *Mon Cher Confrere*. The subject is the same as in Figure 132, except that the image of the two lawyers has been reversed. How did this happen? Daumier redrew Figure 132 for one of his innumerable lithographs, which when printed showed the figures in reverse. Evidently, he preferred the reversed print as his model for Figure 133.

Let's concentrate on the improvements in composition that took place between Figures 132 and 133. To make the comparison easier, I've reversed Figure 132 in Figure 134.

Daumier must have had second thoughts about the negative space in Figure 134. I'm not certain whether he actually considered it empty, but I'm sure he realized that it could be *improved*.

The compositional improvements in Figure 133 are dramatic. Does the negative space feel empty? Definitely not. Strong verticals equalize the strong arcs and ovals in the figures. Were the two figures in Figure 134 duplicated exactly? Definitely not. The conception is the same in both, but the facial characteristics are different, particularly in one of them.

Don't be disturbed about your own work when you repeat a subject. Each drawing or painting will show variations if approached freely. In art, we're looking for the total *mood* and not for likeness.

Rhythmic Verticals

Let's turn to shape relationships in Figure 133. Are the verticals rhythmic? Yes, the columns are repeated with sensitive variety. Daumier took great care not to repeat them monotonously.

But when does a rhythm end? Only when you've exhausted every possibility of another echo! Do the rhythms end here with the vertical columns? Not at all. Note how Daumier repeated the vertical rhythms in the robes. Consider the figure holding his hat aloft. The dark edge is vertical. But Daumier didn't stop there. He interlocked it with the vertical column above. Note how he emphasized the column by extending it downward.

The vertical rhythmic relationships continue in the robe of the other figure. The vertical in the lower front edge is more obvious in Figure 134. But observe what Daumier did with it in Figure 133. He carried the vertical upward to meet the vertical lines etched in and against the light area of the starched dickey. Note how he spaced the vertical edge of the build-ing above to interlock gently with the dark edge of the dickey below.

Finally, note how Daumier added an extra rhythmic relationship in the sleeve. Unlike the one in Figure 134, the sleeve drops vertically. Most importantly, it repeats the dark vertical edges in both robes in a crisp emphatic staccato, reinforcing the dominant sharp rhythmic relationships of the vertical columns above.

The large shapes of the two lawyers in their robes have been exaggerated. The geometric ovals and arcs within the large shapes are not only more varied, but the underlying structure of the bodies is more clearly defined and felt. The oval and arc motifs are repeated in the heads, hands, and hats. Don't overlook the large irregular arc shadow in the upper-left background. And note how the small curve at the base of the column at left center repeats the curve of the hat held high.

The dynamic quality of light and dark relationships in Figure 133 is obvious. The improvement in the overall balance of tonal values also helps to destroy every suspicion of empty negative space.

We've much to learn from Daumier, who was a master of composition. Let Figure 133 remind you to routinely pay attention to the possibility of empty negative space. When in doubt, do what Daumier did in Figure 133. Use closed shapes in the negative area by introducing vitalized geometric shape motifs. Relate them rhythmically, checking out every possibility as you turn the picture four ways. Enhance the whole by harmonizing light and dark relationships just as carefully.

Figure 133. *(Opposite page) Honoré Daumier:* Mon Cher Confrere. *Crayon, pen and wash, watercolor and wash, 11 5/16″ x 8 7/8″ (287.4 x 224.2 mm). National Gallery of Victoria, Melbourne, Australia.*

Figure 134. *(Above) I've reversed Figure 132 here to make the comparison easier with Figure 133.*

Project 20: Correcting Imbalances

This assignment is much more difficult than Project 19. Figure 135 is a study of *The Herring Net* by Winslow Homer in black, brown, and white chalk on green paper.

As a preliminary drawing, the composition is so highly developed that you could easily question that it has any empty space. The large cloud shape at the top repeats the pattern of the boat. Additional clouds, lighter in tone, waft across the sky. Homer introduced a bird in the middle of the remaining negative sky area to reduce the possibility of emptiness. Did he succeed? Almost. However slight, the feeling of emptiness still persists in the negative space.

Your assignment is to find ways to correct whatever imbalances exist in the sketch as a whole, so that the slight feeling of emptiness disappears.

Find Ways to Make the Emptiness Disappear

Your instructions are as follows:

1. Use a 5B black pencil and a #1 soft charcoal stick.

2. Make a freehand drawing of Figure 135. Be sure to maintain the same size and proportions of the study.

3. Check the result in terms of the suggestions in the previous chapter

about mood and feeling in the horizontal composition. Although you're not concerned here with the problems of horizontal vs. vertical compositions, it's a matter of using any suggestions that may *improve* the horizontal composition of Figure 135,

4. Also check the dimensions. Try masking and cropping the top and bottom. Try extending the sides by placing your sketch on a larger sheet of paper, as in Constable's sketch (Figure 120). Continue the drawing on one or both sides.

5. Do a final drawing, taking into consideration mood and structural relationships: shapes, tones, and textures.

Figure 135. *Winslow Homer: The Herring Net. Black, brown, and white chalk on green paper, 16 5/8″ x 20 5/8″ (422.6 x 524.2 mm). Cooper-Hewitt Museum, New York. The composition here is so highly developed that one could easily question whether it reflects empty space. Nevertheless, the feeling of emptiness, however slight, does persist in the negative space.*

Case History 20: Homer

The American artist Winslow Homer (1836–1910) was one of the truly great artists of his time. Yet, his mature work was not really appreciated by his contemporaries. Perhaps they classified him as the illustrator who became well-known during the Civil War for his drawings commissioned by *Harper's Weekly*.

Few artists of his period were able, as Homer was, to transcend their academic training to produce outstanding fine art in the realist tradition. The ten-year interval between Figures 74 and 75 tells the story of his progress and arrival. Case History 8 describes how he finally learned to overcome compositional problems of mood and structure.

Firmly settled in isolation on the Maine coast, he painted *The Herring Net* in 1885 (Figure 136) from the study (Figure 135). By this time his perceptive insight into art had shaped his work habits. While every new painting presents a struggle and a challenge, he knew how to make the adjustments necessary to arrive at something whole and harmonious.

As in Figure 75, he first checked the outside dimensions. By comparing Figures 135 and 136, you'll see he cropped a good deal off the top and a little off the bottom of the sketch. Reducing the negative sky area made an enormous difference in decreasing the feeling of empty space there. In addition, by reducing the space at the bottom, he brought the action forward, forcing the viewer to enter into the experience of the fishermen.

That's not all. He shifted the men and dory to the center of the painting. This necessitated moving the buoy, marking the position of the fishing net, nearer the center of the picture. These moves vitalized the composition.

Note how, by placing the fisherman at the left almost outside the dory, he conveys the tension-pull of the herring net against the force of the sea. The dory itself is angled differently. Look at Figures 135 and 136 lengthwise from the left to appreciate how the

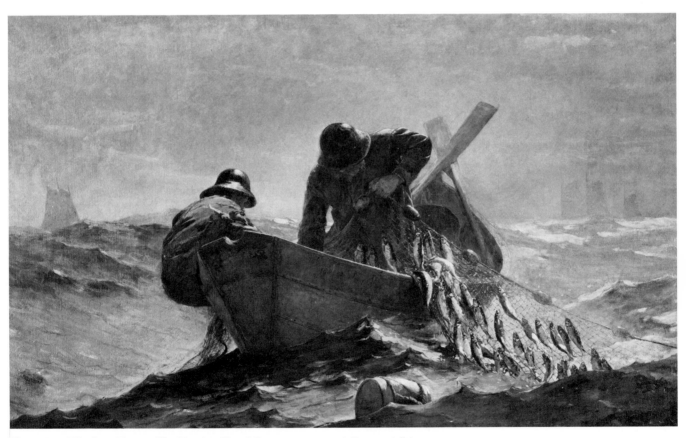

Figure 136. *Winslow Homer: The Herring Net. Oil on canvas, 29 1/2″ x 47 1/2″ (750 x 1,206.8 mm). The Art Institute of Chicago, Chicago. Homer cropped a good deal off the top and a little off the bottom of Figure 135. Reducing the negative sky area made an enormous difference in reducing the feeling of empty space here. By showing more sea at the left and raising the horizon line, he created a feeling of vast space. Compare this area with that in Figure 135.*

curve of the dory has been sharpened and compressed and how the change affects the position of the oars.

We come now to the most dynamic effect of the painting. By showing more sea at the left and raising the horizon line, Homer created a feeling of vast space. Through keen observation, Homer learned how to render the trough between waves for an exciting effect. Compare this area with that in the sketch to see the improvement.

No Feeling of Empty Space

Homer divided the painting into two *equal* rectangles. Normally, such a division would make the composition monotonous—and I recommend that beginners refrain from doing it. Yet, in this case the result is far from monotonous, and there's no feeling of empty space in the negative sky area. Why?

Cropping the sky area eliminated most of the empty feeling, and the textural quality of the clouds helped. Most importantly, the tonal value in the sky is quite dark, blending with the gray of the sea on the right and with the trough of the waves at the left. The extremely dark figure-ground relationship of the fisherman with his back to the sky and one end

of the dory breaking into the negative rectangle further reduces the sky area. The head of the other fisherman and the oars also help—particularly the one oar that extends sharply upward.

Note the diagonal motif of the oars. This powerful motif symbolizes the ever-present danger of the seas. That's also strongly felt in the long dark diagonal shadow extending from the lower-left corner to the center of the painting and repeated again in the lower right. Are these coincidences? Hardly.

Observe the quiet repetition of the diagonal as the cloud in the left center of the sky extends downward toward the dory and interlocks from behind it with a white cap in the sea at the right. All the diagonals make a variety of triangular shapes throughout the painting.

Note how one herring appears to extend the length of the oar. Test the effect it has on the painting by blocking it out. You'll see how important such a small matter as a fish can be in influencing the structure of a composition.

Finally, consider the dominant shape motif—the arc in the bodies of the fishermen—and how it's related to the hats, the curve of the dory, and the

arcs in a variety of objects that you'll discover by studying the painting from all sides.

Once again, light and dark relationships play a vital role. Homer couldn't have succeeded in unifying the great painting without them. The mood is set by his use of the lower range of dark grays, topped by extreme darks. And the value relationships are balanced harmoniously. Highlights are handled with discretion and subtlety.

The Lesson to Be Learned

To overcome empty negative space, first check the dimensions. If cropping eliminates the feeling of emptiness, you may *not need to work for closed negative shapes*. But don't make the decision lightly. If you've any doubt, then establish closed geometric shapes in the negative area.

If you think empty space in the negative area can be transformed into a vital geometric motif—as in Figure 136 where the sky area became a large rectangular motif—then the need for closed shapes within that area is lessened. Even so, you'll probably still need added textural or tonal relationships to reduce the possibility of emptiness.

Project 21: Eliminating Emptiness While Creating a Composition

Figure 137 is a photograph of a coastal scene by the American artist Morris Blackburn. Here again, the negative sky area feels empty. The vast foreground, devoid of trees, buildings or people, may also appear empty to some viewers.

Depending upon your point of view and special interest, *any subject*, no matter how dull at first glance, can be transformed into a vital composition—without the feeling of emptiness.

That's your assignment. Open the inner eye of your imagination. How? Learn to look for something of interest in *any situation*.

Find the Focal Point of Your Composition

Here's how:

1. Look at the photograph as a whole. Then use a magnifying glass to study every part of it. Here are some possibilities to consider.

2. Does the photograph excite you at all? If so, why? Does the large unobstructed view of the sky remind you of some unusual experience? Perhaps an unexpected change in weather? A howling wind and threatening sky signifying an approaching storm? Hurricane? Tornado? Or perhaps just the opposite? A beautiful sunset? The afterglow? If so, keep the large negative sky area as the focal point of your composition and find ways to eliminate the feeling of emptiness. Crop any other part of the picture to strengthen the composition.

3. Does the feeling of a broad expanse of flat land with no trees attract you? Does it remind you of flat lands in other countries? Holland, for example? Perhaps a windmill will complete the scene? Or would you like to see rows of deep furrows in this untilled land? Or possibly a field of bright desert flowers blooming in springtime? Sand dunes? Or is it the mood of quiet solitude to which you're responding? Perhaps the immense forces of the universe stir you. Whatever it is, crop the sky and concentrate on the large expanse of land in the foreground.

4. Do the buildings attract you? Consider enlarging them and diminishing everything else. Study the buildings very carefully. Are they too close to each other? Do you feel like altering the angle of some? Perhaps eliminating some buildings and substituting others? Does the large building interest you? Should it be made wider, narrower, taller, or left as is? Are there too many windows? Accent one feature of the large building that will show its uniqueness.

5. Do the waterways attract you? Do they remind you of inlets, small rivers, or canals? If so, emphasize the waterways. How? Imagine yourself looking at them from the top of a three-story building. That way you'll see them separated. Crop everything else that interferes with your closeup, imaginary view. Keep in mind the time of day. Early morning? Late afternoon, with shadows? Moonlight?

6. If the buildings attract you as much as the waterways, consider combining both. No matter what details of Figure 137 you decide to make your center of interest, include any other item or items that interest you, whether they're in the photograph, your memory, or your imagination. The important point is to discover something of real interest with a magnifying glass.

7. Make as many quick sketches and trial runs as you like, using a #1 soft charcoal stick. When you're ready to make a final drawing, use a #5B or 6B black pencil. Check for shape and tonal relationships. Pay attention to negative areas to make certain there's no feeling of emptiness.

Figure 137. *Photograph of a coastal scene by the American artist Morris Blackburn. Here the negative sky area gives one the feeling of being empty, and the vast foreground, devoid of trees, buildings, or people, may indeed appear empty to some. Yet, even with such circumstances, it's possible to create a good composition.*

Case History 21: Blackburn

I've chosen Morris Blackburn's oil painting, *Red Summer Sunset* (Figure 138), because the composition is so impressive in contrast with the photograph. The problem of the large negative empty sky has vanished. Even the questionable wide-open space in the foreground has been reduced to interesting proportions, complementary to all other spatial relationships.

In developing his composition (Figure 138), Blackburn took full advantage of dramatic light and dark value relationships at sunset. In addition, the dominant geometric shape motif of the rectangle appears to sweep across the painting, horizontally from left to right and vice versa. Look at the numerous irregular horizontal bands from both sides of Figure 138. Note how they vary, not only in width, but also in tonal relationships. There are many degrees of light and dark values, the horizontal river bands reflecting the lightest value. Overall, light and dark relationships are in harmonious balance.

Note how Blackburn emphasized the decorative pattern of the angled gable roofs in the large building. The roofs of the houses have the same inverted "V" submotif. Note how the motif is paralleled on a larger and varied scale in the houses in the foreground.

The Process of Selecting a Compositional Theme

We see at a glance what part of the photograph Blackburn selected as the subject of his painting. Why, then, did he photograph the large coastal and sky expanse, instead of taking a close-up of the houses and large building?

Possibly, he had already decided on the group of buildings and coastal waters as the compositional theme. So, he may have photographed the distant view to help him rekindle his *feeling* of the mood of the low-lying coastal waterways at a later date.

It's also possible that he hadn't decided at the time. Perhaps he took the photograph to study the various compositional possibilities. Maybe he even asked himself questions as you did in Project 20.

By comparing Figures 137 and 138, we see that he eliminated the telegraph poles, shifted the position of the houses, changed and simplified some of their shapes, and rearranged the waterways to balance the composition. Most important, in vitalizing the composition, he made certain to eliminate the feeling of empty space.

The Lesson to Be Learned

The process of *selecting* a composition is endless. The key is to find a point of interest. Even a photograph such as Figure 137, which at first may hold little or no interest—and has the added problem of empty space—can lead to an infinite number of compositions. Project 20 gave you some idea of that.

Some beginners are inclined to give up at the start. How often I've heard the complaint, "I can't even find anything interesting to paint." Or, "Maybe, I ought to buy a book on design." You may pick up pointers from such a book and perhaps a good deal of information about the language of design, but I translate such remarks by beginners differently. I think they're still looking for the picturesque, believing that if they can only find it, the composition will evolve more easily.

But the selection of a subject should not be confused with the development of a composition. The composition doesn't need to tell a story or even have a figurative subject. Art goes beyond the portrayal of real objects, provided the artistic qualities we've been discussing are integrated into a sound, unified structure.

There's no substitute for the actual labor of creating a composition. The point of interest arrives during the struggle as you suddenly realize that esthetic meaning comes from *seeing relationships*—when you've abstracted the essence of art, whether the subject is figurative or nonfigurative.

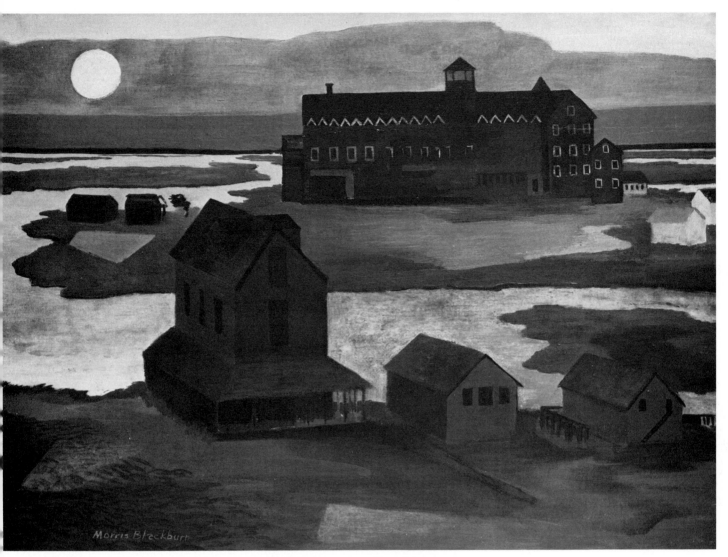

Figure 138. *Morris Blackburn: Red Summer Sunset. Oil on canvas, 25″ x 30″ (635 x 762 mm). Photo: W.W. Norton and Company, Inc., New York. The problem of the large empty sky in Figure 137 has vanished here. Even the questionable wide-open space in the foreground has been reduced to interesting proportions, complementary to all other spatial relationships. Overall, light and dark relationships are in harmonious balance.*

Texture and Line

8

I've insisted that you avoid line relationships while you concentrated on learning the fundamental spatial elements and relationships. I purposely separated each relationship so that you could *experience the feelings* associated with each one. And I've stressed that each must be related to every other in an interwoven whole.

If we view the complex interrelationships of visual elements as a sequence of building blocks, shape relationships come first. Getting you to *see* one shape in relation to another—getting you to *feel* the space between the areas, getting you to *test* the tension or lack of tension between areas by cropping and masking, always in relation to the whole surface—meant that you could accomplish all this more easily not worrying about line relationships.

Now that you understand such relationships, line relationships can be added. They simply cannot be learned easily in reverse order because line involves spatial considerations.

The same is true with textural relationships. Although they could not be excluded completely, maybe now you'll understand why I've restricted the media and techniques of your projects to the barest minimum—charcoal. By using charcoal, you acquired the textural element almost automatically, while you concentrated on mastering shape and tonal relationships.

Why Textural and Line Relationships in the Same Chapter?

Textural and line relationships are discussed together because they are often interwoven. At this point in the book, it's easier to explain both relationships by comparing them in the same illustrations. Yet texture and line each generates its own distinctive mood and feeling.

Texture

Texture, like color, affects us strongly. But unlike color, textural qualities can be explored by touching. Close your eyes and slide a sheet of charcoal paper between your fingers to feel the roughness of the surface. Note, however, that with eyes opened, you see the roughness by looking at the paper closely. And you can have a really pleasurable experience when you use a charcoal stick broadside across the paper. By being careful to vary the pressure, you can bring out the sensuous character of the surface with lights and shadows as the charcoal touches the grain of the paper.

There's a wide range of textural responses possible in painting depending upon the surface qualities. Canvas can have a variety of weaves, from fine to coarse or, still coarser, burlap; or there's the very smooth surface of a composition board or wood panel.

Then, there's the textural response from the quality of paint applied as well as the very act of painting. There are a variety of brushstrokes, from heavily loaded brushes with sweeping strokes to short strokes of broken color. You can use scumbles over a dried layer of paint, that is, applying the brush gently, say, with a lighter pigment, so that the underlying colors are covered unevenly, thus disclosing both layers of color. By contrast, thin transparent and translucent glazes of color offer opportunities for subtle textures suggesting, perhaps, gossamer, weightlessness, and other delicate sensations.

Other unique qualities of texture are possible depending on how you use the palette knife. Opaque paint may be spread thickly, smoothly, or as highlights. You may use the palette knife for scraping and lifting paint or for incising, although a nail is sometimes more effective.

Collages offer other possibilities for significant textural expression. Plate 13 is only one example.

The addition of sand, cement, gesso filler, glass, fibers, or any equivalent to the surface of a painting support is still another approach.

All these examples fall into a general class of texture. They relate to *actual* surfaces that give us the visual equivalent of tactile sensations. These come from the reflections of one or another form of light and shadow.

But there's another class of textures which affects us, too. The *imitation* in paint of actual textures as in Plate 5. Note how the grain in wood is depicted, as well as the design of wallpaper.

One of the most effective ways of communicating profound textural qualities is in painting visual impressions of tiny round, square, triangular, or other geometric shapes; or quick strokes of dashes, hooks, zigzags, twists, stripes, or crosshatches; or even blurs, smears, stains, or spots. These are the specific or irregular visual marks found in nature and in manmade objects.

Whichever form or combination you use, take care to show the vitality and richness of textures with *restraint*. There must be a balance of textures in relation to shapes, tones, colors, and lines.

Beginners often get carried away with excitement and misuse a palette knife. They use it, laden with paint, as a vehicle for strong expression, but lose sight of color relationships in the process.

That's one reason I advocate starting to paint with flat colors, so that you first learn what sensitive, harmonious color relationships mean. Then, later, you're more inclined, as you learn to use texture, to control it with discretion. Texture is related to the *surface*, and must be treated and understood as a separate, distinct element of composition.

Line

Every person becomes acquainted with line in childhood. Yet, line relationships are often not understood in composition and need to be approached with the same care and caution as texture does.

I've discouraged the use of line, until now, for two reasons: first, it has a tendency to destroy shape relationships unless controlled. Those who use line without training don't realize that line *divides* space. What they *don't* see is the unstructured effect of line in relation to the whole surface.

The second reason why I've discouraged the use of line until now is that it requires special and constant practice that is based on a conscious visual awareness of what makes it a sensitive instrument.

Let's begin with Figure 67 (page 69). We discussed this Japanese drawing in Chapter 3 in connection with negative space. This time, however, study it through a magnifying glass. This way, you'll see the great variety of expressive lines for which the

drawing is famous.

They range from very thin, light lines to intensely black thick ones. Some are long, others are short, and still others are mere dots. Note the delicate feathery lines in contrast with the strong sharp lines of varying thicknesses and shapes. Note particularly the straight vertical, both as line and shape motif, balanced against the curve, both as line and shape motif.

What unifies the lines is the dominant oval shape motif of the Zen priest, together with the light and dark tonal relationships. The same is true, more or less, of the fowl. There's a resonance to the whole drawing, with no echoes out of tune. The spacing between the comparatively few lines is unique. There's not the slightest feeling of monotony. And, as we explained earlier, the positioning of the priest and fowl in open space, in relation to the entire surface area of the paper, is just about perfect.

But there's more. We must be aware of the expressive *movement* of the lines. Each line records not only the form of the subject, but its movement. The many curved lines keep moving dynamically through space. With the help of tonal values, we feel the density and weight of the lines that make the subject come alive.

Note how the calligraphic lines form patterns in various parts of the drawing to convey textural qualities. While line dominates this drawing, texture plays a definite role.

The Dominance of Line

In Figures 139 and 140, we have two examples of line and texture. Texture is there, but in both cases line dominates. Study these two carefully with a magnifying glass.

Figure 139, by the 17th-century Chinese painter Hung-jen, is entitled *The Coming of Autumn*. What a difference in feeling between it and Figure 67! In the huge drawing of ink on paper, the towering vertical mountains, supported by slender, tall trees, appear to reach higher and higher in the sky. The feeling of height is tremendous in this composition.

How was it done? Your experience

Figure 139. *(Right) Hung-jen: The Coming of Autumn. Ink on paper, 48 1/8″ x 24 3/4″ (1,222.4 x 629.1 mm). Honolulu Academy of Arts, Honolulu, Hawaii. This is an excellent example of line and texture, with line dominating. The feeling for height is tremendous. Study this with a magnifying glass.*

Figure 140. *(Above) Morris Graves: Black Waves. Tempera on Chinese paper, 27″ x 54 1/4″ (685.8 x 1,378.1 mm). Albright-Knox Art Gallery. Buffalo, New York. Greatly influenced by the Orient, Graves shows his sensitivity for line and texture. As in Figure 139, line predominates, yet we're aware of the textural support. Study this carefully with a magnifying glass.*

Figure 141. *(Opposite page) Elie Nadelman: Man on a Horse. Ink on paper, 12 1/2″ x 7 3/4″ (317.8 x 197.3 mm). The Metropolitan Museum of Art, New York. In comparison with Figures 139 and 140, texture dominates slightly over line here. The distortion and abstraction of the man on the horse call attention to Nadelman's unique line, which is strongly felt. Notwithstanding, the textural qualities dominate the scene, and shape relationships are not overlooked.*

in cropping should provide a clue. Although this drawing was *not* cropped, the paper is *twice* as long as its width. The vertical dimensions are almost overpowering. However, this in no way detracts from the extraordinary skill shown in the spacing.

The tall mountain at the upper right occupies the largest single area. Its shape is matched throughout with semblable variety. Even the negative space is one vital geometric shape, which when viewed upside down, mirrors the tall mountain. In contrast, there is the unusual "S" submotif, as the water cascades in zigzag fashion to and across the foreground. But, there's still another reason for the great feeling of height: *contrast in scale.* A small object, like the house, in relation to the tall mountain, tends to make the latter seem still taller.

While the vertical lines give validity to the rigid rocks, the lines themselves are delicate, subtle, and sensitive. In counteraction to the uncompromising mountains, other lines in the trees supply rhythmic movement, making a ballet of the trees. Observe how the latter are grouped, repeated, and delightfully spaced. Starting with the largest trees at the lower left, your eye moves to the clump of trees at the lower right. Then it continues on directly above to a smaller group and, finally, across to the left side, where smaller and smaller groups keep appearing in the distance.

The Chinese artist of Figure 139 had a more difficult task rendering line than did the Japanese artist of Figure

67. The latter had a wide range of calligraphic strokes and tonal variety, while the former limited himself to a small variety of strokes and a narrow range of tonal values. Yet, with much less maneuverability he didn't create the slightest feeling of monotonous repetition.

Texture is present among the trees and leaves and in the assemblage of dots and markings, and there's a fineness of it throughout. However, line predominates.

The contemporary American artist Morris Graves, greatly influenced by the Orient, shows his sensitivity for line and texture in his tempera painting on Chinese paper, called *Black Waves* (Figure 140). Here, too, line predominates, yet we're aware of the textural support.

The Dominance of Texture

Figure 141, a drawing of ink on paper by the late American artist Elie Nadelman, is quite different. Here the scale tips slightly toward the dominance of texture over line. The distortion and abstraction of the *Man on a Horse* call attention to Nadelman's unique line that is strongly felt. Nevertheless, the textural qualities dominate the scene.

The short but continuous vertical lines, from the neck of the horse downward, change into textural patterns, with the varied light tones blotted for emphasis. The same is true where the contrasting horizontal lines in the man's leg make another textural pattern. But the most easily discer-

Figure 142. *Russ Thompson: Poor Room Rich Room. Collage, acrylic, ink. 16″ x 12″ (406.4 x 304.8 mm). Collection of Mrs. Eileen Thompson, New York. Thompson combines his free line with textural squiggles in a collage. The dark area is a cutout from a magazine illustration, yet he has very cleverly camouflaged the edges, turning them to advantage in an imaginative way. The textured background in varied light tones strengthens the overall feeling that texture is stronger here than line.*

nible textural pattern is the cross-hatching of the greater part of the drawing.

Shape relationships are not overlooked either. Note how the circular textural pattern in the foreground repeats some of the same pattern in the dark background. Both are resonances of the main curve motif of both horse and man.

In Figure 142, contemporary American artist Russ Thompson combines his free line with textural squiggles in a collage entitled *Poor Room Rich Room*. The dark area is a cutout from a magazine illustration. Yet he has very cleverly camouflaged the edges. In fact, he has taken advantage of them in an imaginative way. The textured background in varied light tones strengthens the overall feeling that texture is stronger in authority here than line.

However, in Figure 143, there is little room for question. Here, texture is in full command. Its full impact is felt, with merely an assist from line. This is a 15th-century Iranian miniature, *War of the Birds*. You can almost hear the violent shrieks as the dark birds are attacked on all sides. The movement is swift. The shape motif is a large circular sweep of birds, assisted by the lower branch of the tree at the left. It looks like a large wheel with two black birds at the hub.

As you squint one eye and look at the picture from the left side, you get the full effect of closure—dark shapes spaced to form a large wheel with two birds in the center. The opposing birds, lighter in tone, with an assist from the surrounding shrubbery, form smaller circles or ovals within and outside of the major circular shape.

Even the large tree on the right helps by being curved, pointing as a signpost to the main action. It also balances the circle of dark tones on the left. Block it out to test its importance in relation to the remaining darks. You'll find that it's essential.

But the vital tension-pull of the two dark forms at the lower right is the key to the tautness of the composition, keeping the swirling action of the rest of the painting within the bounds of the frame. Use the blocking-out test here, too. Without these dark areas to balance the tonal values, the whole composition would collapse.

Although textural patterns cover most of the picture, the different markings are actually few in number. I mention this because most beginners do not pay enough attention to the use of markings. Yet, the possibilities and rewards they offer are great.

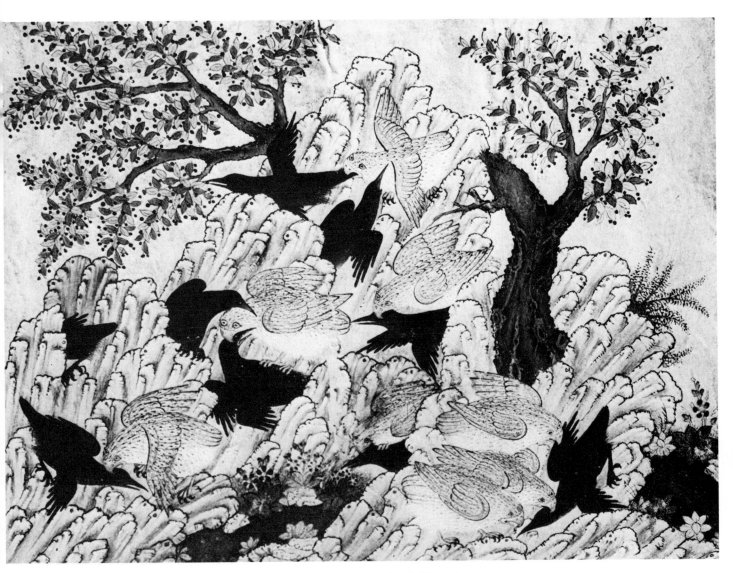

Figure 143. War of the Birds, *miniature from the 15th-century manuscript, Kalila and Dimna. Gulistan Palace Library, Teheran, Iran. Here, texture is in full command, with merely an assist from line. The shape motif is a large circular sweep of birds, aided by the lower branch of the tree at the left. The vital tension-pull of the two dark forms at the lower right is the key to the tautness of the composition.*

Project 22: Controlling Line and Texture

The purpose of Projects 22–24 is to give you some experience in controlling line and texture.

Until now, the use of line was discouraged, and textural use was limited drastically. If you've carried through the projects in sequence, you're probably well-grounded in the fundamental two-dimensional shape relationships and light and dark value relationships. And you've probably given color relationships your special attention. Be careful, therefore, not to give less attention to these fundamentals as you approach this assignment. If you've learned one thing about controlling composition, it's that your self-discipline is deepening. It should become still more rigorous and, as a result, give you still deeper satisfaction. Your greatly improved compositions will justify it.

Now, you're really ready to broaden your range of media.

Figures 144 and 145 are two quick sketches for the painting *Tree* by the American artist Loren MacIver. I'm not sure whether she saw the tree from her balcony, but in Figure 145, only the iron railing and tree remain. Note that both line and texture are included. The texture has both dots as tree markings and an actual ironwork design.

Your assignment is to make something sensitive out of such limited objects.

Draw Limited Objects in a Variety of Ways

Your instructions are as follows:

Figure 144. *Loren MacIver:* Study for Tree. *Pencil on paper. This is one of two quick sketches for the painting (Figure 146). I think, but I'm not sure, that MacIver saw the tree from her balcony.*

Figure 145. *Loren MacIver:* Study for Tree. *Pencil on paper. Here only the iron railing and tree remain. Note that both line and texture are included—dots as tree markings and an actual ironwork design.*

1. Using a 5B black pencil, do a few freehand sketches of your own version of a tree behind a railing.

2. After you've checked them out for shape and tonal relationships, do another. This time in more detail. Emphasize the *textural markings* and minimize the lines.

3. Next, do the same thing, but accent the *lines* and minimize the textural markings.

4. *Change the medium.* Use an artist's fountain pen or a crowquill pen and black India ink—the pens are recommended for flexibility. You will need a #3, 7, 9, and 12 soft camelhair brush (sable, if you can afford it) and an 18″ x 24″ (457.2 x 609.6 mm) bond paper pad. (Get one with a fairly smooth surface. It can be used for pencil and Conté drawings as well.)

5 Do two drawings in pen and ink first, emphasizing textural markings in one, then lines in the other.

6. Now, do two more, adding the pen wash. The effects with textural markings and lines can be quite exciting. However, if you're not used to pen wash drawings, you may spoil a few getting used to them. Balancing tonal values may give you a little trouble, but don't let it discourage you. Be bold.

7. Check all drawings, both pencil and ink. Decide which one affects you the most. Check it for possible improvement in shape and tonal relationships; then do one more drawing.

Case History 22: MacIver

Loren MacIver is an extremely sensitive painter, whose flickering and vanishing votive lights, established her as an outstanding American artist.

Figure 146 is the final oil painting of the *Tree*, which has come a long way from the pencil sketches.

In reality, Figure 146 is one large votive light. As she says, "Quite simple things can lead to discovery. This is what I would like to do with painting: starting with simple things, to lead the eye by various manipulations of colors, objects, and tensions toward a transformation and a reward. An ashcan suggests the phoenix; its relics begin a new life, like a tree in spring. Votive lights, flickering and vanishing, become symbols of constancy. . . . My wish is to make something permanent out of the transitory by means at once colloquial and dramatic."

Note how the light and dark tonal relationships are balanced throughout, The railing, unlike in the sketches, is *lighter* in value than the tree. This way, it takes its proper place in the picture without detracting from the tree as the center of interest.

The tree is almost entirely *darker* than the light behind it. This is rather unusual when you compare it with the large tree in Figure 123 (page 143), for example. Trees customarily have *some* light reflections on the surface. But MacIver has reserved the *buds* of the tree as the only areas reflecting light against the glowing background. These buds glow like tiny electric bulbs, enhancing the large burst of light behind the tree. They've been spaced mostly around the edges of the tree. There the various darker grays appear to blend in with the large strong light behind the tree. Finally, the strong light stands out in front of the strong dark behind it.

While MacIver gave so much attention to tonal relationships, observe that she did not overlook the shape relationships. In Figure 144, we can see the beginning of a shape motif emphasizing the oval, and submotifs of the vertical and horizontal. In Figure 145, with the outline of the tree eliminated, the shape motif seems to have shifted somewhat to the diagonals of the branches. Also, the horizontal base in Figure 144 has been dropped in Figure 145, giving the sketch a different feeling.

But the final shape motif in Figure 146 is dominantly oval, with muted echoes in the railing design forming a closure of ovals. Note the latter as a group also forms a closure of the horizontal, repeating the submotif above it. The second submotif is the repeated vertical in the railing. By squinting, you'll find several long vertical branches that MacIver subtly introduced in the tree.

And now we come to the *pièce de résistance*. At first glance, the painting appears to be composed of a variety of lines—thin lines, thick lines, dark and light lines, short and long lines, all beautifully spaced.

Then we begin to see two textural patterns of tree branches. One large web of tiny branches is interwoven in an upward curved sweep from the lower left to the lower right. Directly above the railing, in the center of the painting, we see a second textural oval pattern distinctly different in feeling: almost like irregularly shaped diamonds, encased in heavier outlined darks, glowing with incandescent brilliance.

This is a good example of a painting giving equal effect to both line and textural relationships.

Figure 146. *Loren MacIver: Tree. Oil. Photo: Art News, New York. Note how the light and dark tonal relationships have been balanced throughout and how the geometric oval shapes the main motif. This is a good example of giving equal effect to both line and textural relationships.*

Project 23: Varying Line and Texture through Different Media

Now that you've tried your hand at line and texture, we're going to aim for greater *variety* of experience through more changes in media.

For this assignment, start off with two preliminary quick pencil drawings by the American artist Lyonel Feininger of *Ruins on Cliffs* (Figures 147 and 148). Note how he progressed from a very rough sketch to a much more carefully designed drawing; although still a preliminary sketch, the drop of the cliff is more clearly indicated. Also, a rise has been added at the left, suggesting still greater height. Note the roof of a house at the left of the ruin, indicating the rest of the house is at a lower level. All this leaves the large area of negative sky as a problem to be solved. Finally, note how the ruin has been simplified through line rather than texture as in Figure 147.

Your objective is to personalize the scene, changing it in any way you desire. However, in the process of using line and texture, don't lose sight of the need for balancing shape and tonal relationships.

Personalize the Scene

Your instructions are as follows:

1. Make a freehand drawing with a 5B black pencil on 18″ x 24″ (457.2 x 609.6 mm) paper. Close the negative areas with geometric shapes relating to the dominant motif or submotif.

2. After checking it thoroughly, do another drawing, this time with pen, ink, and wash. Take your time to balance light and dark values. Set up tension-pulls, if you can. Be careful to balance lines and textures with variety to unify the entire surface.

3. After an interval, try for a third type of drawing, this time in *line* with a *bamboo pen* (they come in various sizes and are inexpensive). Used boldly and freely, the bamboo pen offers you an excellent opportunity to register your expressive individuality.

Since you cannot really make significant corrections in spatial relationships with it you may need to repeat this kind of drawing many times until the relationships fall into place intuitively. Consider yourself lucky if you manage to produce *one* well-balanced drawing from 25 trials. Don't be disheartened during the process—it's like trying to hit a bull's-eye. The only chance you have for success is to check each drawing carefully before you attempt another. But equally important, you must learn to be completely at ease within and *make no conscious effort* to succeed. If this puzzles you, read Herrigel's *Zen and the Art of Archery* or W. Timothy Gallwey's *The Inner Game of Tennis*.

4. If you get tired and wish a rest, make a barely faint tracing of the contours of your best pencil or pen and ink drawing—the one with the best shape relationships. Go over the lines with a crowquill pen, varying them as sensitively as you can. Look closely at Figure 139 to get some idea of the quality of line I refer to.

5. On an 18″ x 24″ (457.2 x 609.6 mm) canvas, paint the surface with three unequal horizontal bands of related colors, using acrylic or casein paint. Keep the colors flat and untextured. When dry, trace an outline of your best spatially related drawing in this series over the whole. Make color adjustments to clarify the subject matter to your liking. In painting one color over another, maintain a sensitive relationship of all colors, including adjacent ones. Disregarding subject matter, balance the whole in light and dark relationships, using a brush with loaded pigment. Allow some of the underlying colors to show through. Continue the same process with more color over color to adjust warm and cool relationships. If results are unsatisfactory, work for intensities to muted tone relationships. Finally, strengthen textural relationships with a palette knife for stone masonry and rock formations. Be careful not to overdo it. Add lines with care and variety wherever necessary.

Figure 147. *(Right) Lyonel Feininger: Ruins on Cliff. Pencil, 5 1/2″ x 8 3/4″ (140 x 222.7 mm). The Museum of Modern Art, New York. This is the first of two preliminary pencil drawings. Compare it with Figure 148. Note further development of the composition in Figures 149–151.*

Figure 148. *(Bottom right) Lyonel Feininger: Ruins on Cliffs. Pencil, 5 1/2″ x 8 3/4″ (140 x 222.7 mm). The Museum of Modern Art, New York. Although still a preliminary sketch, the drop of the cliff is more clearly indicated. Also, a rise has been added at the left, suggesting still greater height of the cliff. All this leaves the large area of negative sky as a problem to be solved. Compare with Figures 147, 149–151.*

11 . 7 . 28

11 7 28

Case History 23: Feininger

Lyonel Feininger, an American-born artist (1871–1956), studied painting in Germany, became enamored with the Cubism of Picasso and Braque during his stay in Paris, and returned to Germany to teach at the famous Bauhaus with the nonobjective innovator Kandinsky and the mystical, childlike painter Klee.

Feininger's form of Cubism, while not profound, was unique. As you can see from Figures 147 and 148, he usually started with a drawing from nature—either a landscape, seascape, or some form of architectural structure.

In the pen and ink drawing, *Ruin by the Sea, II* (Figure 149), we're able to study how he recreated the scene in angular intersecting lines and planes. Note how carefully he broke up the surface into rhythmic two-dimensional geometric shapes. In this, as in most of his work, the charged diagonal is dominant, with vertical and horizontal submotifs to stabilize the movement.

Observe his use of short, pulsating lines that he combined into a textural pattern to balance the whole.

In his charcoal drawing of *Ruin by the Sea, II* (Figure 150), we can really appreciate the textural effect of charcoal as he unified the light and dark relationships. The ruin is very carefully rendered here. So much so, that if isolated upon a cliff as in Figure 148, the total effect would remain almost academically realistic without the textured Cubistic lines and areas.

Observe how the textured lines and areas use *closed* geometric shapes, rhythmically related to the whole. Finally, study how Feininger added his comparatively few lines so subtly. The drawing, of course, is more textural than line.

In his oil painting, *Ruin by the Sea* (Figure 151), we feel the full impact of Feininger's form of Cubism. Again, the strong diagonal motif dominates the scene, stabilized by the counteracting dark vertical motif at the left and supported by the horizontal submotif. The diagonal crisscrosses the surface, creating large triangular patterns. Note how both line and texture are now delicately and subtly subdued—and how Feininger developed an individualized style of Cubism by painting with thin glazes of color to effect transparent light.

Figure 149. *Lyonel Feininger: Ruin by the Sea, II. Pen and ink, 11 1/2″ x 15 7/8″ (292.4 x 403.7 mm). The Museum of Modern Art, New York. Feininger recreated the scene (Figures 147-148) in angular intersecting lines and planes. Note how carefully he broke up the surface into rhythmic, geometric shapes. In this, as in most of his work, the diagonal is dominant, with vertical and horizontal submotifs stabilizing the movement. Compare with Figures 150–151.*

Figure 150. *Lyonel Feininger: Ruin by the Sea, II. Charcoal, 11 1/2″ x 17″ (292.4 x 431.8 mm). The Museum of Modern Art, New York. Here we can really appreciate the textural effect of charcoal as Feininger unified the light and dark relationships. The ruin is very carefully rendered. So much so, that if isolated as in Figure 148, the total effect would remain almost academically realistic without the textural Cubistic lines and areas.*

Figure 151. *Lyonel Feininger: Ruin by the Sea. Oil on canvas, 27″ x 43 3/8″ (685.8 x 1,101.9 mm). The Museum of Modern Art, New York. Here, we get the full impact of Feininger's form of Cubism. Again, the strong diagonal motif dominates the scene, stabilized by vertical and horizontal submotifs. Note how both line and texture are now delicately and subtly subdued. Compare with Figures 147 to 150.*

Project 24: Improvising with Texture and Line

In this final project, I expect you to go all out and express yourself in texture and line with all the vigor and freedom at your command.

For this assignment, I've chosen Figure 152 as a starting point. This is a pen and ink drawing by the French artist Jean Dubuffet, called *Cow* from the series *Cows, Grass, Foliage*. Although it may look like a child's drawing, this *is* the work of a serious adult artist with "a grotesque sense of humor," to quote A.H. Barr, Jr., former director of the Museum of Modern Art in New York City.

The reason for choosing it is, first, to show that there is no limit to the way painters express themselves in art; and second, because it's an example of *arbitrary* textural markings that bear no relationship to the actual subject.

Your assignment is to improve it with your own brand of texture and line. While doing so, let your subconscious nudge you to improve the open negative area and all other rhythmic relationships.

Express Yourself

Your instructions are as follows:

1. Do a freehand pen and ink drawing of Figure 152 *without* the texture. To loosen up *look* at Figure 152 while you're drawing, but *not* at your paper. As you draw, make a *continuous outline without lifting the pen.* Use a crowquill or fountain pen.

2. When you've completed it, take a moment to look at the result as a whole. How do you react to it? Does it please you? Are you amused? Does it

intrigue you enough to go on with it? Or do you think the whole idea is ridiculous? Of course, it's possible you may be so stunned, shocked, or disgusted at this point that you're immobilized. I hope not, for unless you're emotionally involved, assignments in texture and line are meaningless. Dubuffet draws and paints for himself, to give himself satisfaction. He's not trying to poke fun at anyone nor does he approach his work with tongue in cheek. On the contrary, he has a mania and passion for what he does.

3. If you don't wish to continue on this, look over *all* your work since you started the first project and choose one drawing that you wish to repeat freely in texture and line. Then let yourself go in any medium you wish.

4. If you're prepared to continue with this assignment, you must drop *all* inhibitions and conventional thinking. The potential for fantasy and inventiveness is within you, ready to be released. The quality and degree are unknown and can't be measured, no doubt varying with each of us. There's no excuse to be bound by old ways, negative thoughts, or conditions. Instead, start with your *dissatisfactions.* If you're inwardly discontented, it's a *good* sign. We don't know what our level of greatness is, but we do know that something within us will not accept anything less than the full expression of our possibilities. Fortunately, we have the power to change and act.

5. Use a combination of every tool at your command to continue with step 1: charcoal, bamboo pen, crowquill pen, fountain pen, and brushes. Take your chances and let it all happen. If

the ink runs or the bamboo pen doesn't leave the mark you hope for, forget it. Don't give it a second thought. Let the flaws fall where they may. Continue without corrections of any kind. The only proviso is to time yourself. Finish it within ten minutes.

6. Only after you've completed the drawing should you sit back, satisfied that you've expressed yourself fully. You'll have plenty of unexpected surprises, for the results may go beyond entertainment to serious drama. You'll find meanings and qualities in your work that you've never experienced before. These should leave you with a feeling of excitement and an urge to try another one soon.

7. This is a good time to take stock. Should you have an overwhelming passion for line and texture, I suggest that you study books in your library on the Chinese and Japanese art treasures as well as the Iranian and Indian miniatures. There are also chapters on line and texture in my earlier book, *The Creative Way to Paint*, which give further hints and clues. The subject is endless; methods and techniques are varied and, while easy to understand, require practice. What counts most, however, is your attitude in reaching for a total, esthetic experience.

Figure 152. *Jean Dubuffet: Cow, from the series Cows, Grass, Foliage. Pen and ink, 12 3/4" x 9 7/8" (324.3 x 251.3 mm). The Museum of Modern Art, New York. Although it may look like a child's drawing, this is the work of a serious artist with a "grotesque sense of humor." It's an example of arbitrary textural markings that bear no relationship to the actual subject matter.*

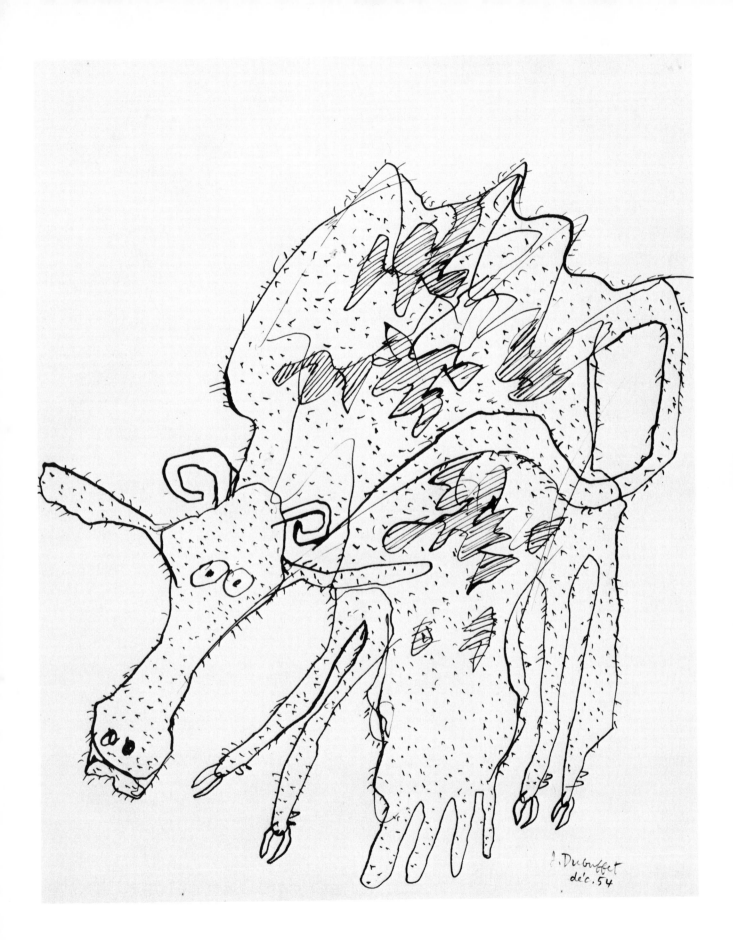

Case History 24: Dubuffet

French artist Jean Dubuffet is one of the most provocative and original painters of the last generation. He concerns himself with the coarse and ugly manifestations of what appear to be inexperienced and badly executed paintings.

If he's turned his back on what is generally called "good taste," it in no way detracts from his brillance as a mature artist. It's in his "excesses" that we feel the degree of his powerful expressiveness.

While Figures 152–154 may appear outrageous to some people, they're quite mild in comparison with some of his repulsive subjects. Yet, his paintings are prized and hung in all the large museums throughout the world.

His exemplary effectiveness and imagination in expression and application of texture and line concern us here. He uses sand, plaster, pebbles, twigs, cement, asphalt, and even mud that usually leave a raised, pastelike textured surface. Lines. on this surface, are scored or scratched with a sharp instrument, a palette knife, or even the other end of a brush.

Without his innovative use of textures and textural relationships—as well as crudely used lines—I doubt whether his paintings would have the impact intended.

I chose Figure 153 Cow from the Cow, Grass, Foliage series, in wash, pen, and ink to show Dubuffet's improvement in composition over Figure 152.

Note, first, how his cropping and closing of negative space enhance the composition. Observe, second, how he makes effective textural use of light and dark tonal relationships. See, finally, how in blending the latter, there's greater feeling in his linear relationships.

Now, let's compare Figure 153 with Figure 154, The Cow with the Subtile Nose, a painting in oil and duco on canvas. Observe how he relates two different kinds of textural surfaces next to each other: the rough, scratchy treatment of the negative areas alongside the blotchy variety of textural spots in the cow.

Conclusion

Now, we've come to the end of the training that's either overlooked or not emphasized in art education to the degree it should: the discipline to see and consider what takes place on the two-dimensional frontal, surface, or picture plane. Usually priority is given to the illusion of three dimensions.

Dubuffet ignores the illusion of three dimensions in his paintings, yet succeeds so admirably without it. He says, "The purpose of painting is to ornament surfaces, and it therefore takes only two dimensions into consideration and excludes depth."

While that position may be good enough for Dubuffet, most of the work illustrated in the book indicates depth through overlapping planes or perspective.

Figure 153. (Right) Jean Dubuffet: Cow, from the series Cows, Grass, Foliage. Wash, pen and ink, 8 7/8" x 11 7/8" (225.9 x 302.1 mm). The Museum of Modern Art, New York. This shows Dubuffet's improvement in composition over Figure 152. First, note how his cropping and closing of negative space enhance the composition. Second, note how he makes effective textural use of light and dark relationships. Third, note how in blending the latter, his linear relationships gain greater feeling. Compare with Figures 152 and 154.

Figure 154. (Bottom right) Jean Dubuffet: The Cow with the Subtile Nose. Oil and duco on canvas, 35" x 45 3/4" (889 x 1,162.5 mm). The Museum of Modern Art, New York. Dubuffet relates two different kinds of textural surfaces next to each other—the rough, scratchy negative areas alongside the blotchy spots in the cow. Note how he ignores the illusion of three dimensions, yet succeeds so admirably without it.

Illusion of Three Dimensions

9

Now you're ready to branch out in all directions. But keep one thing in mind. No matter in what direction your personal form of art leads you, always continue to strive for the perfection of a unified structure.

So far, you've concentrated exclusively on learning to integrate the visual elements on the two-dimensional surface without considering the illusion of three dimensions. The great advantage of not having to contend with the latter *at the same time* as you work on the former will become more obvious as you realize the extent of the task ahead.

Books on Three-Dimensional Illusion

To understand the many ways artists have conceived and rendered the illusion of volume, depth, space, and perspective is really to study the history of art throughout the world.

Millions of words have been written about art. It has so many sides that art books only give facets—rich, glittering facets and nuances, but never enough to explain the unending complexities of interacting relationships. To give you some idea of the number of art books and publications in print, the Stanford University art library has nearly 90,000 volumes and the New York Public Library well over 100,000. A fascinating life's work awaits you, for there's no question that schools and books prepare us to appreciate *actual* works of art, whenever the opportunities arise to see and study them.

Where do you start? Your librarian can be of great help. Look at the index for art references to space, depth, volume, and perspective, for example. Remember that practically all books on art history discuss the use of space. In Helen Gardner's *Art Through the Ages*, I counted over sixty references to individual masters and their approach to space.

I've already mentioned Rudolph Arnheim's *Art and Visual Perception* for a psychological viewpoint. For the beginner who wants a simple explanation and example of how abstraction is used to depict invisible forces,

phenomena, and ideas in relation to the illusion of three dimensions, I recommend *Layman's Guide to Modern Art* by Rathbun and Hayes. For the more sophisticated, I've chosen two books at random: Peter Owen's *Painting, the Appreciation of the Arts* and Guido Ballo's *The Critical Eye*. They should be studied slowly, for they require close attention.

Thoughts about Perspective

Many amateur painters, trained in traditional schools, still believe that the more accurate the ability to reproduce the optical illusion of perspective, the more artistic the result. Not so. By all means, learn perspective, but remember that it has its limitations in the creation of art, as the great masters of the Renaissance discovered.

Figure 155 by Piranesi is an example of both aerial and linear perspective. Aerial perspective creates the illusion of spatial depth by imitating atmospheric changes. This is based on the principle that as objects recede toward the horizon, they become hazier. Their contours appear to grow less distinct, as we can clearly observe in Piranesi's etching.

Linear perspective is concerned with diminishing the size of objects and decreasing spatial intervals as they recede. Parallel lines appear to converge at the horizon point. These relationships are also clear in Figure 155.

But perspective comes to a dead end or runs out of the picture unless it's modified and controlled. In Figure 155, the perspective of the road easily leads the eye out of the picture. Piranesi introduced the trees at the left foreground, as well as the pyramid, as a countermovement. Even the skillful placement of the buildings prevents the perspective from getting out of hand.

Figure 155 has a mood that is pleasing and readily felt. Why then didn't Piranesi stop? Why did he change the etching? At the later stage (Figure 156), it has an entirely different mood. The delicateness of the landscape in

Figure 155 is lost. The clue is in the title: *The Pyramid of Caius Cestius with the Porta S. Paulo*. Obviously, he was not happy with the status of the pyramid in the earlier stages of the etching.

He not only heightened, widened, and darkened the pyramid, giving it more prominence, but left no question about its *volume*. The latter is weak in Figure 155.

You may prefer the mood in the earlier stage of the etching. To fully appreciate Figure 156, do *not* become inveigled by *comparing preferences* of mood; study the figure by itself at a later time. You'll appreciate (although you may not and need not like) its dynamic mood.

Note how Piranesi added horizontal darks at the top edge of the pyramid to prevent it from leading the eye out of the picture. Also, notice how the new height of the pyramid effects closure in the negative space, strengthening the latter. An additional geometric triangle, created in the sky area to the right, increases the rhythmic pattern of the two triangles in the pyramid. Finally, the addition of a tree on the lower right further vitalizes the swing of the contrasting arc submotif.

A Thought about Volume

The novice, trained to render the illusion of three-dimensional volume with light and dark gradations, as in Figure 156, may not realize that there are *other* means available to depict volume.

Cézanne did it by using the principle of overlapping planes, in a new approach to color. He spaced colors to heighten their vibrating effect, by which they seem to move forward or backward. Not only color, but lines,

Figure 155. *(Above right) Giovanni Battista Piranesi: The Pyramid of Caius Cestius with the Porta S. Paulo. Etching, state I. Photo: Prints Division, The New York Public Library, New York. The mood here is pleasing and readily felt. Why, then, did Piranesi change the etching? Compare it with Figure 156.*

Figure 156. *(Right) Giovanni Battista Piranesi: The Pyramid of Caius Cestius with the Porta S. Paulo. Etching, state III. Photo: Prints Division, The New York Public Library, New York. Piranesi not only heightened, widened, and darkened the pyramid, giving it more prominence, but left no question about its volume. By comparison, the latter is weak in Figure 155.*

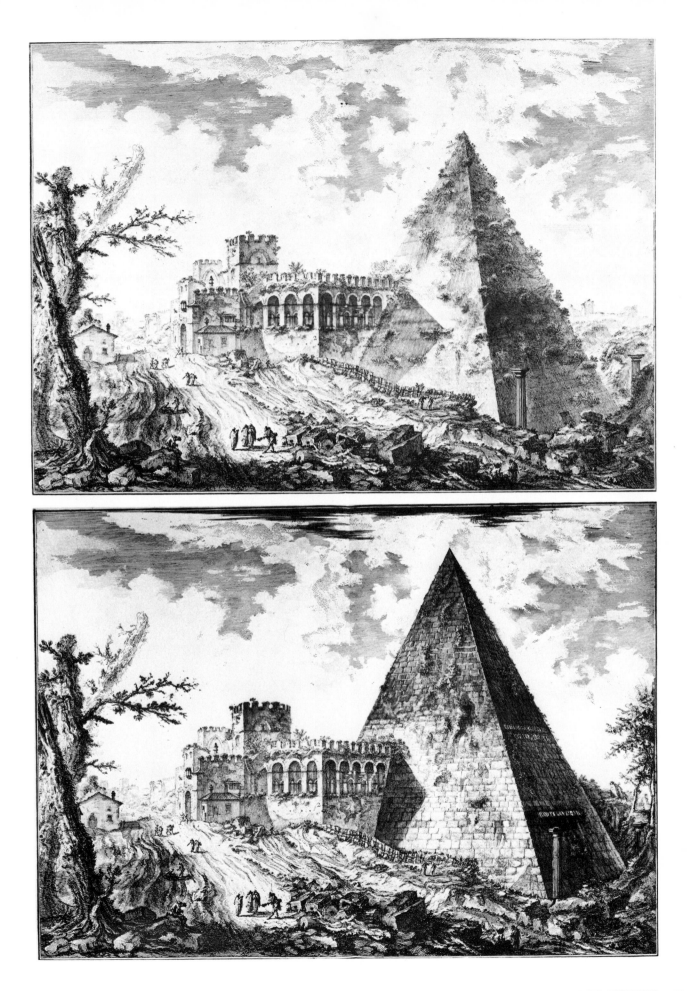

tones, shapes, and space were completely integrated to create three-dimensional volume. This concept is not easy to grasp or, for that matter, to explain in a few words. You'll find several chapters on this and other three-dimensional factors discussed and illustrated in my earlier book, *The Creative Way to Paint*.

Line

Let me give you an example of how the illusion of three-dimensional volume can be felt merely by using *line*. Study Figure 157, *Dwarf of Murad III as Planet Mars*, a 16th-century Persian line drawing. Is there any question of the volume of the protruding stomach or the volume in the shoulders and arms? These effects have been created without light and dark shading or color. There's no perspective indicating spatial depth, yet three-dimensional volume is felt. In addition, three-dimensional space is sensed by the overlapping planes.

Overlapping Planes

Most of the illustrations in the book show the illusion of three-dimensional space and depth by means of overlapping planes. Figure 158 is a good example of this.

Wherever one figure is partly behind another, we accept the illusion of depth—yet this phenomenon has nothing to do with perspective. In Figure 157, line creates the *volume* in the figures, aided by a minimum of light and dark tones and some texture. However, just as volume infers space, so does overlapping of figures.

So, you can see that the same two-dimensional shapes lying flat on the surface of the drawing are planes in depth wherever they overlap. I hope now you'll be able to work alternately on the two-dimensional surface, controlling that first, before checking the same planes for the illusion of three-dimensional depth.

Other Spatial Systems

As you continue your studies, you'll appreciate that many ancient civilizations were extremely advanced scientifically, philosophically, and artistically. Artists organized their conceptions of space differently then—with their minds, not their eyes.

It has taken our present civilization time to accept that in their own way they painted just as well as we do now (and some believe, much better). Actually, great art of all periods survives because it not only represents the vital spirit of its times, but expresses *universal* values.

There are many ways of producing genuine art. However, no drawing or painting showing the illusion of three dimensions can be produced as a work of art unless two-dimensional rhythmic relationships are first worked out.

A Final Note on Two-Dimensional Negative Shapes

I must caution you to approach spacing in two dimensions with special care and alertness. Let down and doublecheck, especially the negative space.

To help you grasp what I'm getting at, let's discuss four sets of examples. The first two sets illustrate what I've been emphasizing throughout the book. The last two sets, I hope, may raise your consciousness to a new level of sensing spatial relationships.

Let's start by comparing Figure 159, *The Mystic Marriage of St. Catherine* with a study of it in Figure 158. It's not difficult to see how Anthony Van Dyck improved the composition by raising the figures nearer the top edge to eliminate the feeling of empty space. The lines breaking up the area of negative space at the top of Figure 158 show that he was aware of the problem, and raising the figures was an effective solution.

By comparing Figure 161, *War*, with a lithograph of it in Figure 160, we can appreciate Henri Rousseau's magnifi-

Figure 157. Dwarf of Murad III as Planet Mars. *Persian, late 16th century, Istanbul. Drawing, 5 1/2″ x 4 1/4″ (140 x 108.1 mm). Fogg Art Museum, Harvard University, Cambridge, Massachusetts. The illusion of three-dimensional volume can be felt here merely by the use of* line, *instead of light and dark shading or color.*

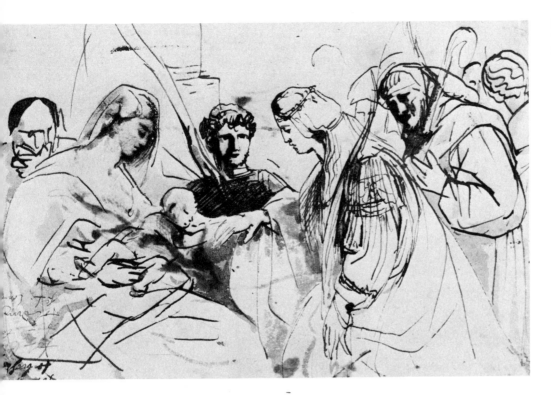

Figure 158. *(Left) Anthony van Dyck:* The Mystic Marriage of St. Catherine. *Pen and brush in brown, 158 x 237 mm. The Pierpont Morgan Library, New York. Line creates the volume in the figures, aided by a minimum of light and dark tones and some texture. Just as volume infers three-dimensional space, so does the overlapping of figures.*

Figure 159. *(Below) Anthony van Dyck:* The Mystic Marriage of St. Catherine. *Oil on canvas, 121 x 173 cm. Prado, Madrid. Compare Figure 159 with 158. Van Dyck improved the composition by raising the figures to the top edge to eliminate the feeling of empty space in the negative area.*

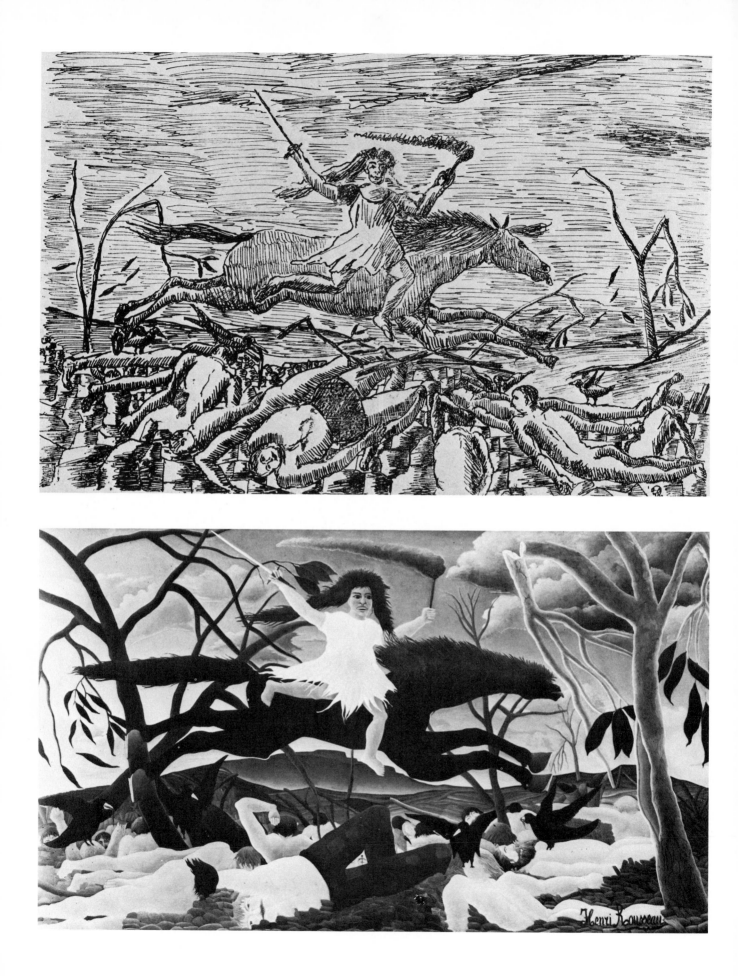

cent handling of negative space in a landscape with trees. While Figure 161 is obviously superior, the lithograph was produced *after* the painting. In experimenting with a medium new to him, he forgot all about the importance of relating the negative space to the rest of the composition. Nevertheless, the comparison serves as a good lesson.

But the most important lesson can be learned from the next two sets of illustrations. They show that cropping a picture or, rather, reducing the negative space to bring it into balance with the rest of picture is *not a pat formula.*

Note Figure 164, *Virgin and Child,* by the Italian painter Luca Signorelli, of the 15th–16th centuries. This painting is in its restored state. It was tampered with by cropping—by being folded under the frame (Figure 162)— thus reducing the negative area. The negative area was further reduced by darkening the upper part of the sky and adding halos, trees, and curls to the Child as well as a more ornamental hair style to the Virgin. These embellishments accommodated the flowing lines of two scarves, one rendered by textured dots. Study these changes in Figure 162. (Figure 163 shows the painting, unfolded to its original size, before it was cleaned and restored.)

The negative sky area in Figure 162 may appear in harmony with the rest of the painting. But if you look closer, you'll see that the very essence of Figure 164 was destroyed by the changes. Its sensitivity and clarity are gone. The solidity of the whole, so delicately related in two-dimensional shapes and tonal values, has crumbled. For example, the large shape at the lower left, which forms an integral part of the total structure, has vanished. And with it the sensitive rhythmic relationship of curves at the lower left with the curve at the top of the puffed sleeve and the beautiful line of the curved bodice edge directly above

Figure 162. *Luca Signorelli:* Virgin and Child. *Oil and tempera on paper, before cleaning and restoration. Walker Art Gallery, Liverpool, England. This shows how Figure 164 looked after being tampered with. First, it was cropped by folding under the frame, thus reducing the negative area. Then, the negative area was reduced further by darkening the upper part of the sky and adding halos, trees, curls to the Child, and a more ornamental hair style to the Virgin. The negative sky area in this more compact composition may appear in harmony with the balance of the painting, but the very essence of Figure 164 was destroyed by the changes.*

Figure 160. *(Above left) Henri Rousseau:* War. *Transfer lithograph, printed in black, 8 3/4″ x 13″ (222.7 x 330.2 mm). The Museum of Modern Art, New York. Compare Figure 160 with 161. Experimenting with a medium new to him, Rousseau forgot all about the importance of relating the negative space to the rest of the composition.*

Figure 161. *(Left) Henri Rousseau:* War. *Oil on canvas, 44 3/8″ x 75 3/4″ (1,127.3 x 1,924.5 mm). Louvre, Paris. Comparing this with Figure 160, we can appreciate Rousseau's magnificent handling of negative space in a landscape with trees.*

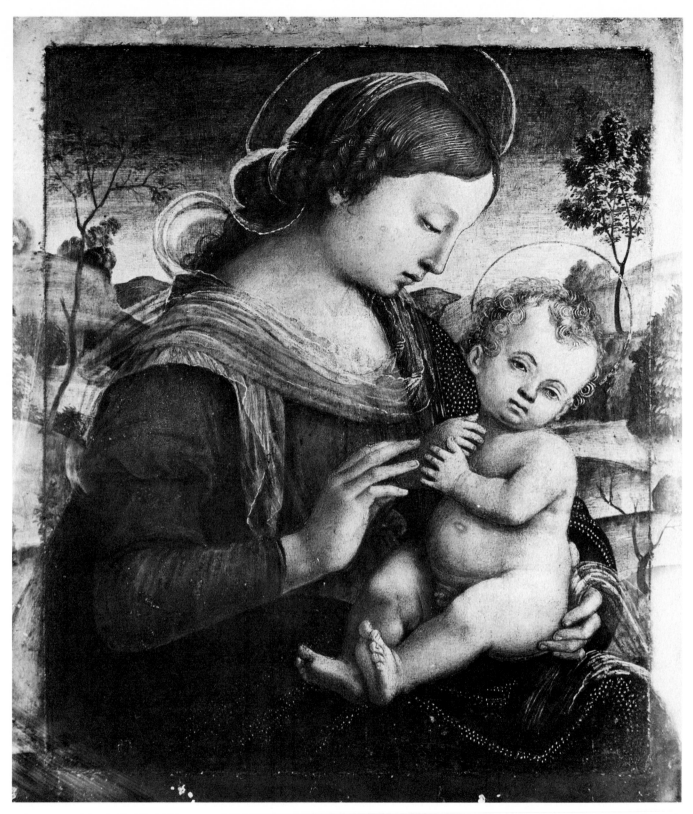

Figure 163. *This shows Figure 162 unfolded to its original size before it was cleaned and restored (Figure 164).*

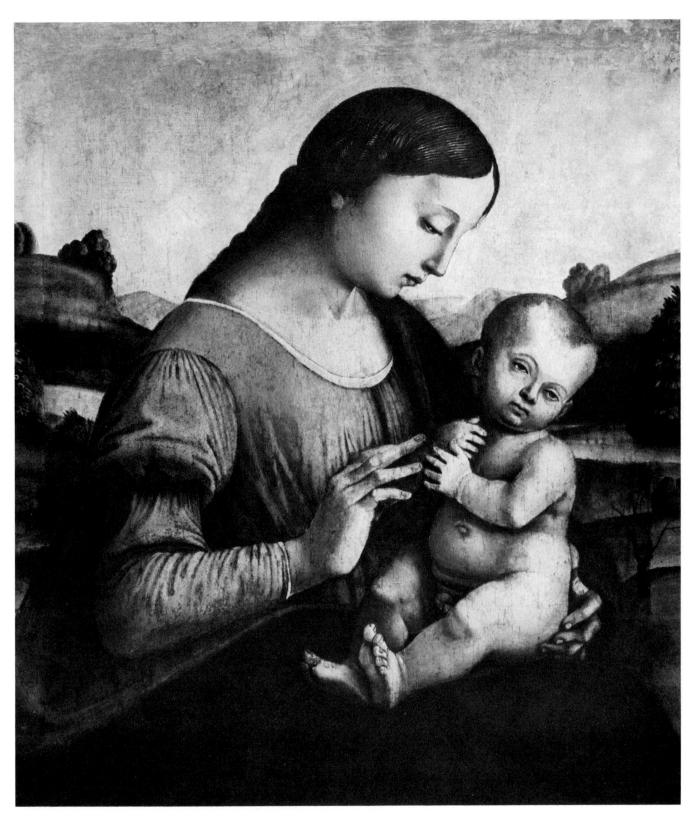

Figure 164. *Luca Signorelli: Virgin and Child. Oil and tempera on paper, 59 x 50.1 cm. Walker Art Gallery, Liverpool, England. A delightfully composed work of art has come back to its own in comparison with Figure 162, where unfortunate changes were made with no understanding of artistic qualities. Here the painting's sensitivity and clarity are restored as well as the solidity of the whole, so delicately related in two-dimensional shapes and tonal values. Note that the form of the sharply knuckled fingers of the Virgin and the subtle hairline of the unadorned Child add to the unique character of the painting.*

Figure 165. *Rembrandt van Ryn: Titus Reading. Oil on canvas, after restoration (70 x 64 cm). Kunsthistorisches Museum, Vienna. Compare with Figure 166. Observe the nuances in contrasting value relationships as a result of the restoration of more of the arm rest and, especially, of the fingers of both hands and the enlarged area of the book. All the foregoing is enhanced by the addition of more space on four sides. With more negative space available, the visual field appears to expand as the eye takes advantage of the extra space.*

it. Also the curve of the head and the small curved hairline. Even the form of the sharply knuckled fingers of the Virgin and the subtle hairline of the unadorned Child, which add to the unique character of the painting, were reduced to cosmetic mediocrity, conforming to conventional tastes of the time. And there's much more for you to discover by yourself.

Evidently, no one was aware that the negative space in the sky in Figure 164 was structured with great care. The large triangular motif, with the bottom edge of the painting as its base, establishes a corresponding triangle with most of the left edge and a good part of the upper edge of the painting. The negative sky area, supported by closure, is an important part of the triangle, which includes the land area below.

There are a number of other rhythmic triangles within this soundly structured painting. For example, one tiny rhythmic triangular shape, between the Child's head and the Virgin, was obliterated in Figure 162 by the dotted scarf—with no awareness of its spatial importance.

What about the tonal relationships of this extremely sensitive painting? Observe how the contrast of the dark shape of the Virgin's hair against the surrounding light areas holds all other light and dark relationships in balance. At the same time, the left edge of the descending braid of hair, helped by closure above, locks the triangular negative shape into place. From a two-dimensional viewpoint, there's no spatial need to tamper with the negative space. To sum up, a delightfully composed work of art has come back into its own.

In the final set, compare Figure 165 with 166. Figure 165, *Titus Reading*, is a painting by Rembrandt of his son. It was cropped by being folded under the frame in Figure 166.

By reducing the area of negative space, such cropping may give the appearance of a more solidly organized composition. Even the light value in the upper left may seem to harmonize the overall tonal relationship. I asked the Kunsthistorisches Museum in Vienna about this light and was told to pay no attention to it. The light was exaggerated by the photographer in error.

Compare Figures 165 and 166 when your mind is more or less blank. You'll conclude that the tonal relationships in the restored painting show much more assuredness, ease, and expressiveness in their balance. As a result of restoration, observe the nuances in

contrasting value relationships in the enlarged arm rest and book area as well as in the fingers of both hands.

The addition of more space on all four sides enhances the composition. The very compactness of the negative area in Figure 166 constricts the feeling of space between Titus's eyes and the book he holds. Compare the area in Figures 165 and 166 a few times. In Figure 165, with more corresponding negative space available, you'll see that the visual field appears to expand as the eye takes advantage of the extra space.

In Figure 166, the cropped negative space at the right destroys the distinctive slant of the shape motif. Notice that the body of Titus is tilted more diagonally in Figure 165 by its

asymetrical position on the canvas. In Figure 166, it's more central and static. The effect of Rembrandt's original positioning of Titus creates a tension-pull between his head and the lower-right corner. This vitalizes and unifies the structure of the whole painting, including the negative space.

All you've learned in developing new habits of visual perception and integration of compositional elements on the two-dimensional surface plane cannot be reduced to a routine. Keep growing by testing, weighing, blocking-out as many drawings and paintings as you can—upside down, right side up, sidewise—so, little by little, your judgment of rhythmic relationships will become more sensitive—and so will your work.

Figure 166. *Rembrandt van Ryn:* Titus Reading. *Oil on canvas, before restoration. Kunsthistorisches Museum, Vienna. Figure 165 was cropped here by being folded under the frame. By reducing the area of negative space, the composition may appear to be more solidly organized. However, the very compactness of the negative area constricts the feeling of space between the eyes of Titus and the book he holds, and the cropped negative space at the right destroys the distinctive slant of the shape motif and the tension-pull between the head and the lower-right corner.*

Artist Index

Page numbers in boldface indicate illustrations.

Subject Index

See Artist Index for artists whose work is illustrated in this book.

Edited by Susan Davis
Designed by James Craig and Bob Fillie
Set in 9 point Medallion by Publishers Graphics, Inc.
Printed by Halliday Lithograph Corp.
Bound by A. Horowitz & Son